MATERNITY RIGHTS IN BRITAIN
The Experience of Women and Employers

The Policy Studies Institute (PSI) is Britain's leading independent research organisation undertaking studies of economic, industrial and social policy, and the workings of political institutions.

PSI is a registered charity, run on a non-profit basis, and is not associated with any political party, pressure group or commercial interest.

PSI attaches great importance to covering a wide range of subject areas with its multi-disciplinary approach. The Institute's 40+ researchers are organised in teams which currently cover the following programmes:

Family Finances and Social Security
Health Studies and Social Care
Innovation and New Technology
Quality of Life and the Environment
Social Justice and Social Order
Employment Studies
Arts and the Cultural Industries
Information Policy
Education

This publication arises from the Employment Studies programme and is one of over 30 publications made available by the Institute each year.

Information about the work of PSI, and a catalogue of available books can be obtained from:

Marketing Department, PSI
100 Park Village East, London NW1 3SR

MATERNITY RIGHTS IN BRITAIN

The Experience of Women and Employers

Susan McRae

with a Foreword by W W Daniel

POLICY STUDIES INSTITUTE
100 PARK VILLAGE EAST, LONDON NW1 3SR

The publishing imprint of the independent
POLICY STUDIES INSTITUTE
100 Park Village East, London NW1 3SR
Telephone: 071-387 2171; Fax: 071-388 0914

ISBN 0 85374 524 2

A CIP catalogue record of this book is available from the British Library.

1 2 3 4 5 6 7 8 9

How to obtain PSI publications
All book shop and individual orders should be sent to PSI's distributors:

BEBC Ltd
9 Albion Close, Parkstone, Poole, Dorset, BH12 3LL

Books will normally be despatched in 24 hours. Cheques should be made payable to BEBC Ltd.

Credit card and telephone/fax orders may be placed on the following freephone numbers:

FREEPHONE: 0800 262260 FREEFAX: 0800 262266

Booktrade Representation (UK & Eire)
Book Representation Ltd
P O Box 17, Canvey Island, Essex SS8 8HZ

PSI Subscriptions
PSI Publications are available on subscription.
Further information from PSI's subscription agent:

Carfax Publishing Company Ltd
Abingdon Science Park, P O Box 25, Abingdon OX10 3UE

Laserset by Policy Studies Institute
Printed in Great Britain by BPCC Wheatons Ltd, Exeter

Acknowledgements

The programme of research upon which this book is based was funded by the Department of Employment (DE), the Department of Social Security (DSS) and the Equal Opportunities Commission (EOC). In addition, resources to develop the report to primary sponsors for publication were provided by the Leverhulme Trust. PSI is very grateful to these bodies and to the liaison officers who represented the DE, DSS and EOC over the lifetime of the study. These included Barbara Ballard, Dennis Brooks and Jenny Wight from the Department of Employment; Patrick Hennessy, Alison Matthews and Julia Chilvers from the Department of Social Security; and Karen Clarke, Ed Puttick and Mary Black from the Equal Opportunities Commission. PSI is also grateful to Peter Brannen and Hazel Canter from the Department of Employment for chairing the Steering Committee for the project. Neither the selection of the information provided nor the references drawn from it may necessarily be taken to reflect the views or opinions of any of the organisations that funded the research or the people that represented them. The content of the report is the responsibility of the Policy Studies Institute.

The author could not have carried out the research to its final conclusion without the help received from many colleagues within PSI. Computing assistance was provided by Karen MacKinnon. The report was prepared for publication by Karin Erskine and Clare Morgan. Michael White answered a steady stream of questions. PSI's Director, WW Daniel, provided his considerable knowledge and expertise at every turn.

Finally, PSI is particularly grateful to the Department of Social Security for providing access to its child benefit register for doing the sample of mothers and for providing help in carrying out the survey of mothers; and to the women and employers for their cooperation and magnificent response to the surveys.

Contents

Foreword

The publication of the second PSI Report on maternity rights a decade after the first is for me a source of great personal pleasure. The original Report was itself particularly satisfying because of the originality of the research design; because the results raised the level of the debate about maternity rights in public policy; and because the Report stood throughout the 1980s as the authoritative source of information and analysis about the impact of maternity rights upon working mothers and their employers. Now PSI is able to up-date that earlier Report on the basis of new, extended and refined surveys of mothers and employers that have been so effectively carried out and written up by Susan McRae. The publication of the present Report is particularly pleasing because it demonstrates the extent of change over the past decade.

First and foremost, there has been a continued sharp rise in the proportion of mothers who return to work shortly after having a baby. In 1979 we were struck by the extent to which economic activity among women who had recently had a baby had increased during the 1970s. That trend continued to a marked degree during the 1980s. By 1988, nearly one half (45 per cent) of women who were in work when they became pregnant were back at work within eight or nine months of having a baby. A further one fifth were looking for work. By the end of the 1980s it had become the norm for working women to be economically active again within nine months of having a baby.

Secondly, and perhaps more strikingly, there was an even more marked increase in the number of mothers who return to full-time work. In the previous decade, if mothers went back to work soon after childbirth, they generally returned to part-time jobs. In 1979, for

instance, nearly two-thirds of women who were working full-time when they became pregnant went back to part-time jobs. In 1988 they were nearly as likely to return to full-time jobs as they were to part-time ones. Over one fifth of women who were full-time employees at the time of pregnancy were back in full-time work within eight or nine months of the birth. That figure compares with 7 per cent in 1979.

Thirdly, and perhaps associated with the increase in full-time working, there was a rise in the number of women who go back to the same employer, doing the same or a similar job and working similar hours. Previously, there had been a tendency for the desire for a part-time job to result in women going back to work for a different employer following pregnancy. About 35 per cent did so in 1979. More recently, three-quarters of full-time employees during pregnancy who returned to work continued to work for the same employer.

Fourthly, and perhaps most significantly, it appears that women no longer suffer the same drop in occupational level and hourly rates of pay following pregnancy that they previously endured. Traditionally, if women continued to do paid work over the childbearing and childrearing years they often moved to part-time jobs in the lower paid small firm sector. Such moves often also involved downgrading in the level of skill at which they worked as well as a decline in their earning power. Now it seems that women tend to maintain their job and earnings levels in their post-childbirth jobs. Doubtless that tendency is largely accounted for by the increased extent to which women are continuing to do the same full-time job for the same employer. If the change proves to be a permanent one, then it may represent the removal of one of the most important sources of inequality for women at work.

These are four major changes. The extent of the overall change that they represent may be summed up by the way in which, over a period of less than 20 years, the proportion of women who are economically active within eight or nine months of having a baby has increased from less than 10 per cent to about two-thirds. The change is likely to have important implications for roles and relationships within the family; for childcare practices and the provision of childcare; for fertility and population trends; and for the distribution of income as between households and families in the community.

Qualifications to the picture of major change

Two qualifications need immediately to be made about the picture of major change in the extent to which women continue to do paid work after they have babies and in the types of jobs that they do. First, there remain large differences in the experiences of different categories of women. Perhaps the sharpest contrast lies in the experiences of women employed in the public sector compared with women in the private sector.

Women employed by health authorities or education authorities or local authorities or the civil service are about twice as likely to continue working as women employed by substantial businesses or small firms. The contrasts in the proportions returning to the same employer, doing the same job and working full-time are even greater. In each instance, public sector employees are about three times more likely to do so than private sector employees. Moreover, it is clear that whether the employer is public or private is the principal source of variation. There are remarkably few variations within sub-sectors of the two major sectors. In general terms, whether a woman is employed by a major company or a small firm, she is similarly less likely to continue working than her public sector counterparts. Equally, women from all parts of the public sector are much more likely to do so, in similar proportions. The contrast between the public and private sectors permeates our results. It is clear that the distinction is one of the principal sources of variation in the terms and conditions under which women are employed. That is particularly so for contractual maternity rights and arrangements. The differences are reflected in striking contrasts in occupational behaviour following childbirth.

The second qualification we have to make about our findings on the rate at which women return to work shortly after having a baby is that we cannot say how far our women will be able to maintain throughout the baby's childhood the pattern of working they have initially established. That is to say, there is no way of knowing from our present findings how far the women who return to full-time work, doing the same job with the same employer will be able to continue to do such jobs permanently, as different demands and pressures arise. Earlier research has suggested that women who continue in full-time work often find the demands of the job become too much for them in combination with the demands of primary responsibility for the child and other household responsibilities. In consequence, they tend to

move to part-time working or give up working altogether, for at least a while. On the other hand, our present findings show that much has changed since that earlier research was carried out. We hope to be able to carry out further research on the women in our survey to establish how far they do, in practice, sustain the patterns of working that they establish soon after the birth of the baby.

Other significant changes

In addition to the major changes revealed by the report there have also been other important changes. First, we are able to conclude with confidence that the number of women who take time off work for ante-natal care during the period of their pregnancy has grown substantially. Our previous study showed that, according to the accounts of employers, opportunities for time off work for ante-natal care were remarkably low. That was especially true for lower occupational levels in the manufacturing industry. We now find that 68 per cent of all women who work during pregnancy take time off work for ante-natal care and that is true for 84 per cent of women who work full-time. The pattern for women working in the manufacturing industry is similar to the average. The implication of the overall picture is that the introduction of the statutory right to time off work for ante-natal care in *1980* has had a substantial impact upon behaviour, although it has clearly had less impact in hotels and catering than elsewhere.

Secondly and more generally, there is clear evidence that both women employees and employers are more aware of maternity rights legislation, are more familiar with the legislation and have adjusted to its implications. For instance, women are making much more use of the right to reinstatement. Many more women now give their employers formal notice that they will be returning to their jobs following their pregnancy. More than twice as many give notice of return and go back to the same employer after they have had their babies.

Our initial PSI study of maternity rights found no positive association between the right to reinstatement and the extent to which women actually went back to work. We concluded that, although working women derived identifiable benefits from the right to reinstatement, the right did not at that time contribute to the rate of return to work. The present study suggests that that pattern may have

changed. Women who qualify for the right to reinstatement are now more likely to continue to work, although the association falls just short of statistical significance when other stronger influences, like qualifying for contractual maternity pay, are taken into account. But it is likely that greater familiarity with the right and a greater predisposition to return to full-time work has meant that it now has more impact upon working patterns.

Employers have also adjusted to the legislation. Even in 1980, when maternity rights legislation was new, fewer than one in every five private sector employers reported that they had been caused any problem by any aspect of maternity rights legislation. By 1989, that figure fell to fewer than one in every ten. The reduction occurred despite the much greater use that women were making of the right to reinstatement and despite the greater complexity that had been introduced into the administration of maternity pay.

Some things remain much the same

Perhaps the most surprising feature of the findings to me are some of the things that have not changed. Women are returning to work in much larger numbers after having a baby. They are especially more likely to be returning to full-time jobs with the same employer. And yet little more seems to have been done by employers to encourage them to return to work. There have been some imaginative innovations to help women continue to work over the childbearing and childrearing years during the 1980s, such as job-sharing and career breaks, but these are concentrated in the public sector and are not widely available to women generally in the private sector. There has been remarkably little growth, for instance, in the coverage of contractual maternity pay and extended rights to reinstatement. That is certainly the case in view of the amount of activity that there has been on sickness pay in the private sector, and sickness pay is often seen to be akin to maternity pay; and of the indications there are of demand on the part of employers for women to return to work.

Women's accounts of the facilities available to them from their employers to help them continue working and of the arrangements made for care of the infant when they are at work are remarkably similar to their accounts ten years previously. The demand among women for improved child care facilities, for more flexible working arrangements and for enhanced maternity rights has increased

substantially. Even in 1979, the extent to which mothers used the open-ended invitation at the end of the questionnaires to express their wishes on these matters was unprecedented in my experience and knowledge of postal surveys. By 1988 the volume of demands had increased still further.

My own view of the overall pattern of findings is that it is likely that the principal influence upon them has been a major cultural change among women, that has been accelerating steadily over the past twenty years. Women have increasingly wanted not only to continue working over the childbearing and childrearing years but to continue to do jobs that use their abilities and qualifications and provide rewards that are consonant with their worth in the labour market. They have increasingly been able to fulfil their wishes because there has been a growing demand among employers for people to do the jobs that women have traditionally done, and especially for able, qualified office and other non-manual workers. Employers have been able to satisfy their need for such workers largely through the rising aspirations of women workers and have found little reason to provide added inducements for mothers of young children to continue working. In short, employers have been able to meet their need for more women to return to work simply because a steadily increasing number of women want to return.

W W Daniel
March 1991

Tables

Figures

Summary of main findings

Women's economic activity before the birth
Fifty-five per cent of the women covered by the survey had been in paid employment twelve months before the birth. This represents only a slight increase in the proportion of women in work one year before the birth as measured by the 1979 PSI survey of women (Daniel, 1980) and corresponds to *General Household Survey* estimates of the economic activity of women with dependent children.

Seventy-eight per cent of first-time mothers were in work twelve months before the birth compared with just over one third of women having their second or subsequent child. The large majority of first-time mothers had been in full-time employment before the birth; the majority of women having second or subsequent children had held part-time jobs (Table 2.1).

Occupational level
The survey provided clear evidence of a shift upwards in women's job levels since the 1979 PSI survey. By 1988, the proportion of women employed in junior non-manual work had dropped by 10 per cent, while the proportion employed in intermediate jobs had increased from 21 to 29 per cent, and in managerial jobs from 1 to 3 per cent. There was also a slight increase in women's representation in skilled manual jobs and a corresponding decrease in semi-skilled and unskilled manual work (Table 2.5).

Type of employer

There remained a tendency for women's higher-level white-collar occupations to be concentrated in public sector employment, and women's private sector employment to be predominantly in manual or in sales occupations. Seventy per cent of women who had professional jobs during pregnancy, and 65 per cent of those who had associate professional and technical jobs, worked in the public sector (the former for education or local authorities; the latter for health authorities) (Table 2.10).

Industrial sector

Over 70 per cent of women operatives and 65 per cent of women in craft and related manual jobs had been employed in manufacturing. Over 80 per cent of professionals and associate professionals – and 70 per cent of women in personal and protective service jobs – had worked in other services. One in five managers and administrators worked in distribution, hotels and catering.

In relation to women's full-time employment during pregnancy, 'other services' (which tends to equate with the public sector) may be characterised as having largely encompassed women who had non-manual jobs, with a significant proportion of women in higher-level and professional jobs. The finance and banking sector included mainly women who had non-manual jobs, but largely at the clerical and secretarial level. Manufacturing and distribution, hotels and catering tended to include women who had been employed in both non-manual and manual or sales jobs, but in both sectors the latter jobs formed the majority (Table 2.13).

Women who had never worked before the birth

Seventeen per cent of women surveyed had never worked in Britain before the birth. These women were, on average, younger and less well qualified. They were more likely to have not yet married but, if married or living as married, were more likely to have an unemployed partner. Further, these women had more children than the other mothers; they were more likely to have been in receipt of one or more state benefits around the time of the birth; and they included a disproportionate number of women from minority ethnic groups, particularly Pakistani and Bangladeshi women (Table 2.2).

Among all women who had not worked, childcare was the most common reason given for being out of the labour market. Almost half of the young white mothers, however, had not been in jobs before the birth because they had been, in effect, waiting to take up paid work: 13 per cent had been unable to find work; 17 per cent had not yet finished their education; 18 per cent had been on government work or training schemes.

In contrast, ethnic minority mothers were much more likely to have been out of the labour force caring for children (42 per cent) than waiting to enter it after finishing their training or education (Table 2.3).

The large majority of mothers who had never worked before the birth of their recent baby remained out of employment some eight or nine months after that birth. Only 8 per cent had taken up jobs by the time of the survey. A further 17 per cent reported that they had expected to be in work and were looking for jobs.

Women who stopped working shortly before or after becoming pregnant

Five per cent of women in work twelve months before the birth stopped working shortly before or soon after becoming pregnant. These women were substantially older than the women who remained in work while pregnant: 46 per cent of the first group were over thirty, compared with 34 per cent of the latter. One half of the women who stopped working shortly before or after become pregnant had been employed part-time twelve months before the birth, and they tended to be more likely than women who remained in work during pregnancy to have worked on a temporary basis or to have been self-employed (Table 2.4).

Self-employed women

One hundred and twenty-five of the women covered by the survey were self-employed before the birth of their recent baby; all ran small establishments, generally in the service sector. Just over half of self-employed women took time off work for antenatal care, compared with two-thirds of women employees. Ten per cent had already stopped working before they felt it necessary to attend antenatal clinics, and the remainder made their appointments for non-working hours.

Six self-employed women (5 per cent) left work earlier than originally intended: two because of their working conditions, four because of illness. Forty-three per cent had received Maternity Allowance upon leaving work; 12 per cent, however, had encountered some problem associated with maternity pay. Of these, half reported that they were ineligible because they had made insufficient National Insurance contributions and half reported they had experienced delays in payment from the DSS.

Flexible working arrangements
The survey of women suggested that there had been little overall change in access to flexible working arrangements since the 1979 PSI survey, except where a new type of arrangement had been introduced, such as career break or retainer schemes. Part-time working arrangements remained the most commonly reported facility for flexibility (Table 2.14).

The proportion of women who reported help with childcare, including workplace nurseries or creches, increased by only 1 per cent over the decade. In 1988, 4 per cent of women reported that their employers provided some form of help with childcare. Help with childcare is generally available across the public sector; there was, however, no improvement in the provision of childcare help among private sector employers.

Any improvements in the provision of flexible working arrangements tended to benefit women in the public sector, particularly those who worked in the civil service. Sixty-one per cent of women civil servants had access to part-time working hours compared with only 19 per cent in 1979. Women civil servants were more than twice as likely as other women in the public sector to report having access to career break schemes, and overwhelmingly more likely to have flexi-time arrangements available.

Managers' accounts of the flexible arrangements that they provided differed substantially from those indicated by the survey of women (Table 2.15). This suggests that there may be differences in the availability of different types of arrangements for different categories of women within the same workforce. A gap may also exist between the awareness of working women of the arrangements that are available to them, or might be available if they asked, and the

arrangements that employers, in principle, provide or would be prepared to provide, if asked.

Employers' problems with maternity rights
Maternity rights legislation was *not* a central concern for employers; complying with its provisions may occasionally have caused operational inconvenience, but seldom gave rise to major difficulties.

One per cent of employers in the public sector and none in the private sector spontaneously mentioned maternity rights legislation when asked about the main general problems currently facing them (Table 3.1).

In response to a direct question, the proportion of private sector employers who reported problems associated with maternity rights legislation almost halved over the decade, from about one in five in 1980 to a little over one in ten in 1989 (Table 3.3).

Public sector respondents were twice as likely as those in the private sector to report having had any problems associated with maternity rights legislation over the past few years. But, overall, the larger the workplace, the more likely employers were to have experienced problems associated with maternity rights, independently of sector (Table 3.4).

Pregnancy-related disputes
The incidence of disputes with an employee over issues related to maternity rights as reported by private sector employers increased over the decade, but there was no increase in the proportion of disputes that went to an Industrial or Social Security Tribunal (less than 1 per cent). Disputes tended to be more common in larger workplaces; public sector workplaces were more likely than private sector ones to have reported a dispute (Table 3.5).

Seven women reported that they had brought a complaint of unfair dismissal owing to pregnancy to an Industrial Tribunal. They represented less than 0.5 per cent of women employees during pregnancy. Two women brought complaints related to the right to reinstatement.

Job loss because of pregnancy
Seven per cent of women employees who remained in work after becoming pregnant lost their jobs earlier than they had intended: 1 per

cent because they were dismissed or otherwise eased out of their jobs; 3 per cent because of working conditions thought not to be suitable while pregnant; and 3 per cent because of pregnancy-related illness (Table 3.7).

There was an almost direct relationship between low skilled work and the likelihood of women ending their employment prematurely through dismissal, unsuitable working conditions or illness.

One per cent of women employees reported that they were dismissed or otherwise forced to leave their jobs prematurely because they were pregnant. Many of these women had less than six months of service and the large majority had less than the two years of service needed to qualify for protection from unfair dismissal owing to pregnancy (Table 3.7).

Arranging alternative work for pregnant employees

Eighty-five per cent of women in work during pregnancy whose employment did not end prematurely experienced no change at all in their jobs. The most common change among those who experienced some change was a move to cleaner or lighter work, especially among women who had been employed in manual or sales jobs and in manufacturing or wholesale and retail distribution.

Employers in the public sector were substantially more likely to have arranged alternative work for a pregnant employee. Forty-one per cent of public sector employers had arranged alternative work either recently or in the past compared with 24 per cent of private sector employers (Table 3.10).

Employers in larger establishments were more likely to have arranged alternative work than those in small establishments, regardless of sector or, within the private sector, whether the workplace was an independent enterprise.

Eight per cent of employers reported that they had been caused problems in arranging alternative work.

Public sector employers were more likely to have had problems arranging alternative work for a pregnant employee, in particular because of the unavailability of alternative work. Within the private sector, independent enterprises had more problems arranging alternative work for a pregnant employee than workplaces which were part of a larger organisation.

Supervisory and junior professional/technical jobs presented the greatest problem in arranging alternative work during pregnancy.

Time off work for antenatal care

Over 80 per cent of women who had been in work on a full-time basis took time away from work for antenatal care (Table 3.11). Nine per cent of full-time workers had arranged their appointments for times outside normal working hours, while 6 per cent were no longer working when the time came to attend antenatal clinics. Women who had been employed full-time in the hotel and catering trades were particularly unlikely to have taken time off work for antenatal care. Only just over one half of these women took time off for antenatal care.

Women who had been in work on a part-time basis were much less likely to have taken up their entitlement to time off (Table 3.12). Fewer than one in three part-time workers took time off work for antenatal care, generally because their appointments were made for times outside normal working hours. Part-time workers in manufacturing were substantially less likely than most other women to have arranged time away from work for antenatal care.

Four per cent of women employees taking time away from work for antenatal care experienced some difficulty obtaining this time off (Table 3.13). Women in less skilled jobs were more likely generally to have experienced such problems. Women employed by the health authorities, in both manual and non-manual work, were particularly likely to have experienced problems getting time off work for antenatal care.

Maternity Pay

Eighty per cent of women in employment during pregnancy received some form of maternity pay, generally Statutory Maternity Pay (65 per cent) or Maternity Allowance (14 per cent) (Table 4.4). Eleven women received only maternity pay due under their contract of employment.

Differences in the *type* of pay received were marked. Statutory Maternity Pay and contractual maternity pay formed a greater part of the pay received by women in non-manual jobs. Women in sales and manual jobs were more likely to have received Maternity Allowance.

Women in private small firms were much less likely than women either in the public sector or in larger private sector workplaces to have received any pay at all, and the least likely to have had any contractual maternity pay (Table 4.7).

Twenty per cent of the women in work during pregnancy received no maternity pay. Women who received no pay generally reported that they had been deemed ineligible because of insufficient National Insurance contributions.

One third of sales workers and personal and protective service workers received no pay at all, compared with about one in ten professional, clerical and secretarial workers. Women in unskilled jobs were the least likely to receive maternity pay: only just over one half received any pay from whatever source.

Only about two-thirds of second-time mothers and less than half of those having their third or subsequent child received maternity pay from any source, compared with 89 per cent of first-time mothers. The main shortfall for women with more than one child came in the receipt of Statutory Maternity Pay.

Statutory Maternity Pay

Sixty-nine per cent of employees during pregnancy received Statutory Maternity Pay.

Women who had been employed in distribution, hotels and catering were much less likely to be eligible for SMP than other women. This is largely accounted for by the experiences of women who had worked in the hotel and catering trade, of whom fewer than half received Statutory Maternity Pay (Table 4.9). However, it is important to note that our measure of entitlement for maternity pay may have been prone to some error, especially in reference to the expected time of birth (from which eligibility for maternity pay is calculated) and the actual time of birth. When designing our questionnaire, we asked women about stopping work in relation to the actual date of the birth of their baby. Our questionnaire was sent to women some eight or nine months after the birth, and we considered that they would be more likely to remember how many weeks before the *actual* birth that they had stopped working than to remember when they left work relative to the week in which they *expected* to give birth. Accordingly, we anticipated a certain degree of imprecision in any analyses which depended upon the expected week of confinement.

Moreover, some women in work during pregnancy will have found it necessary to stop working earlier than intended because of illness. And although these situations are covered by the regulations governing Statutory Maternity Pay and thus women who would be otherwise eligible for maternity pay should remain eligible, we would expect to find a discrepancy between the proportion receiving SMP and the proportion eligible to receive it.

Calculations based upon the qualifying requirements for SMP and women's responses to our questionnaire suggest that one in ten employees appeared to have been entitled to receive SMP, but did not do so (Table 4.9).

Three per cent of women who received Statutory Maternity Pay reported having had problems associated with the payment.

Fourteen per cent of employers reported having had difficulties over the introduction of Statutory Maternity Pay, usually increased paperwork (Table 4.1).

Forty-five per cent of employers currently view Statutory Maternity Pay as either good or satisfactory; almost two-thirds of employers approve of Statutory Maternity Pay (Table 4.2).

Higher-rate Statutory Maternity Pay
Forty-two per cent of women employees received higher-rate SMP. Those in professional and associate professional occupations were the most likely to have received higher-rate SMP, and those in personal and protective service occupations and unskilled manual work the least likely to have done so (Table 4.16). Occupational variations tended to reflect differences in job tenure.

Women in small firms were substantially less likely than other women to have received higher-rate SMP.

Women in the hotel and catering trades were the least likely to have received higher-rate SMP in comparison with other women. When women who had been employed in hotels and catering received higher-rate SMP, their average weekly payments were low in comparison with all other women, but especially in comparison with women who had worked in finance and banking. Women from the financial sector benefited from the highest average payment levels (Table 4.17).

Our analyses suggest a marked gap between eligibility for higher-rate SMP and receipt of the payment. Twenty-seven per cent

of women who appeared to fulfil the qualifying conditions for higher-rate SMP reported that they did not receive the payment (Table 4.19). The most marked shortfall between eligibility and receipt of higher-rate SMP was found among women who had worked in independent private sector firms (Table 4.20).

Maternity Allowance
Fourteen per cent of women in work during pregnancy received a Maternity Allowance (Table 4.4).

Women in sales or manual jobs were the chief recipients of Maternity Allowance, largely because their hours of work and continuous service records meant that they did not fulfil the qualifying conditions for Statutory Maternity Pay (Tables 4.5; 4.6).

Fewer than one half of self-employed women in work during pregnancy received a Maternity Allowance.

Eighteen per cent of women who received Maternity Allowance had had problems associated with maternity pay, especially delays in payment (Table 4.3).

Contractual maternity pay (CMP)
From our survey of women, we estimated that 14 per cent of women employees received maternity pay as a result of collective or contractual agreements with their employers (Table 4.29). This appears to be a slight increase in the numbers receiving CMP since the 1979 PSI survey when 10 per cent of women reported that they had received maternity pay in excess of the statutory minimum six weeks' payment.

Evidence from our survey of employers also suggests that there has been a modest increase in the proportion of private sector employers who provided contractual pay benefits from 2 per cent in 1980 to 4 per cent in 1989.

As in 1980, private sector establishments with arrangements for contractual maternity pay tended to be workplaces which were part of larger organisations and the majority employed 100 or more people.

The large majority of CMP schemes were in the public sector. Over half of the public sector workplaces covered reported having arrangements for CMP. These workplaces accounted for 90 per cent of workplaces that reported having arrangements for CMP.

Consequently, women who had been employed in the public sector were substantially more likely to have received CMP than other women in our survey of mothers. Over three-quarters of women who received CMP had worked in the public sector, 58 per cent as managers or administrators, professionals and associate professionals. Women who had been employed in small firms were substantially less likely to have received CMP.

Just over one half of the contractual maternity pay schemes reported by employers included a period of full pay which ranged from two to twenty-six weeks. One in five schemes were based on some variation of the statutory eighteen-week period.

Just over one quarter of women who received CMP had full pay for the entire duration of their maternity pay period. Thirty-five per cent had part full pay, for an average duration of seven weeks. Thirty-three per cent had no periods of full pay. Three per cent had received a lump sum payment.

Just over one half of employers reported that women had left their jobs soon after fulfilling the contractual obligations associated with CMP. Just under half of this number reported that they had been caused some difficulties by the departure. Workplaces that experienced such difficulties accounted for one quarter of all workplaces with arrangements for CMP.

Maternity absence
Almost half of all employers reported that certain jobs represented potential sources of difficulty when their incumbents took maternity leave (Table 5.27). Public sector managers were more likely than respondents in the private sector to report that certain jobs were likely to cause difficulty during maternity absence.

The level of job cited by employers as representing potential sources of difficulty during maternity absence rose over the decade, reflecting women's increased participation in higher-level occupations. The jobs most likely to cause difficulties during maternity absence were at the supervisory and junior professional/ technical level. The main difficulties associated with maternity absence focused on the need to find temporary replacements, in particular for specialist and senior jobs.

The right to reinstatement

The proportion of women who met the statutory requirements for reinstatement increased from 54 per cent of women employees in 1979 to 60 per cent in 1988 (Table 5.1).

Women in higher-level non-manual employment were substantially more likely to have met the statutory requirements than other women. Women in sales occupations were the least likely to meet the statutory requirements for reinstatement (Table 5.3). In particular, women who had been employed in smaller private sector enterprises during pregnancy particularly were much less likely to have had the necessary hours and service.

Women employed in distribution, hotels and catering were particularly unlikely to qualify for reinstatement, as had been the case in 1979. In manufacturing, however, women's chances of qualifying had improved over the decade: in 1988, 62 per cent of women in manufacturing had qualified compared with less than half in 1979.

Reported qualification for reinstatement

Sixty-six per cent of women reported that they had the right to return (Table 5.6).

Women in the public sector were more likely than their private sector counterparts to report a right to return. In particular, women who had been employed in smaller private sector enterprises during pregnancy were much less likely to have had either a contractual right to return or an informal arrangement with their employer. In very small firms, those with ten or fewer employees, only 48 per cent of women reported having had such right (Table 5.8).

Women employed in hotels and catering were considerably less likely than their counterparts in wholesale and retail distribution to have satisfied the hours and service requirement, largely through part-time working hours, but more often gained the right through contractual or informal agreement. Women in wholesale and retail distribution together with women in manufacturing were the least likely to have had the right in the absence of statutory qualifications (Table 5.8).

Part-time employment and qualification for reinstatement

There was widespread agreement among respondents to the survey of employers that women could return to work on a part-time basis if they

wished to do so. Eighty-four per cent of public sector workplaces reported that women could come back part-time, together with 76 per cent of workplaces in the private sector that were part of larger organisations and 72 per cent of independent private sector enterprises.

Eighteen per cent of women who worked fewer than eight hours a week, and one quarter of women who worked for between eight and sixteen hours a week, reported that they had the right to return to work despite not fulfilling the statutory requirements.

Notification of return

Since 1979, the proportion of women employees who gave notice of return nearly doubled. In 1979, 26 per cent of employees during pregnancy notified their employers of their intention to return to work after childbirth; in 1988, the proportion was 47 per cent (Table 5.15).

Almost three-quarters of *women who qualified for the right* gave formal notification of their intention to return as compared with fewer than one-half in 1979 (Table 5.16).

Women at all job levels were more likely to have given notice in 1988 than in 1979. Those in higher-level non-manual and professional jobs remained substantially more likely to have done so than other women, but there was a marked increase in the rate of notification among women employed in routine non-manual jobs.

Women in the public sector were markedly more likely than their private sector counterparts to have given notice.

Variations in the level of notification according to occupation and type of employer tended to be less pronounced when only those women who qualified for the right to return were taken into the analysis.

Fulfilment of notifications to return

One half of women who gave notice of return fulfilled their notifications. In 1979, 63 per cent of women who gave notice did not return to work with their previous employers (Table 5.19).

Women who had worked in the civil service or for health, education or local authorities were much more likely than other women to have fulfilled their notice to return. Within the private sector, women who had been employed in small firms were more likely to have returned to their previous employers than women in larger businesses. Women in private sector establishments with more

than 100 employees were particularly unlikely to have fulfilled their notification, relative to women in other size workplaces (Table 5.21).

Qualification for reinstatement and levels of return
In 1979 there was little or no difference in the rate of return as between women with and without the right to return. In 1988, women with statutory entitlement were markedly more likely to have returned to work, to have returned full-time, to have returned to their pre-birth employers and to have returned to their previous or similar job (Table 5.22).

Problems associated with the right to return
Four per cent of women who gave formal notice of return had experienced problems with their employers over their right to return to work following childbirth, generally over what job they would do upon their return (Table 5.32). Women managers and professionals were the most likely to had problems with their employers associated with reinstatement.

Six per cent of employers reported difficulties associated with a woman's right to return to work following childbirth (Table 5.25).

Public sector employers were more likely to report having experienced difficulties associated with reinstatement than were private sector employers.

Independent of sector, the larger the workplace, the more likely for there to be problems associated with reinstatement.

The primary problem associated with reinstatement focused on replacements for a temporary absence (Table 5.26).

Returning to work
Twenty-eight per cent of all women surveyed were in work within eight or nine months after the birth. An additional 18 per cent were seeking work (Table 6.1). This compares with 15 per cent in work and 9 per cent seeking work among all women who had babies in the early spring of 1979.

Forty-five per cent of women who had worked during pregnancy were in work within eight or nine months after the birth, and 20 per cent were seeking work (Table 6.2). In 1979, of all women who worked during pregnancy, 24 per cent were in work again within eight

or nine months of the birth and a further 14 per cent were looking for jobs.

There was a narrowing of the gap in rates of return to work between women who had been employed part-time or full-time, relative to the findings of the 1979 PSI survey of women.

Women who were employed on a full-time basis before the birth were substantially more likely to have remained in full-time work after childbirth than was the case in 1979. Women employed full-time were almost equally likely to have returned to full-time jobs (21 per cent) as they were to have returned to part-time jobs (22 per cent).

Characteristics of women in work after the birth
Just over one in ten women changed employers upon their return to work. This was particularly the case for women who had worked for less than eight hours per week (Table 6.18). One half of the women who worked part-time after the birth changed employers upon their return to work, compared with just over one in five women who returned to work on a full-time basis.

The large majority of women who remained with their pre-birth employers returned to the same, or a similar, job. Only 3 per cent of women who went back to the same employer had changed to a new job on returning.

The fewer hours women worked before the birth, the more likely they were to continue working after the birth. Women tended to have returned to the same, or similar, hours of work as they had worked before the birth.

Women who had been employed in higher-level non-manual work were more likely to return to work and more likely to remain with their pre-birth employers. They were the most likely to work full-time after the birth, and to remain in their pre-birth job (Table 6.19).

Differences among women in relation to returning to work become less marked when the proportions who were seeking work are taken into account. In no category were less than one half of women economically active (working or seeking work). In many instances as many or more women were looking for work at the time of our survey as already held jobs (Table 6.20).

Over 60 per cent of women whose pre-birth job was in the public sector had returned to work. Over half had returned to their pre-birth employers. In contrast, less than one third of women in the private

sector were in work after the birth and fewer than one in five had returned to their previous employers (Table 6.22). When the analysis was confined to establishments with fewer than twenty-five employees, the greatest contrasts in women's return to work behaviour remained those between the public and private sector.

Almost three-quarters of women who received contractual maternity pay had returned to work within eight or nine months of the birth. Over two-thirds had returned to their pre-birth employer, largely to the same or a similar job. Over one third had returned full-time (Table 6.23).

Looking for work

Our analyses show a considerable gap between women's desire to work after childbirth and their opportunities in the labour market. This gap was particularly apparent in the private sector. One in five women not in work after the birth were looking for jobs at the time of our survey, rising to almost one in three who had previously been employed in the private sector (Table 6.22).

Statistically significant influences on women's return to work after childbirth

Logistic regression analysis was undertaken to establish the significance of various influences on women's return to work behaviour (Table 6.25). This allowed us to take account simultaneously of continuous variables such as hourly pay and age, and categorical variables such as education, number of children and occupational level. Other influences taken into account included number of years in the labour force and in the last job held before the birth, qualification for statutory reinstatement, type of employer, hours of work, and whether women received maternity pay.

The results of our analyses showed a statistically significant relationship between women's return-to-work behaviour and hourly pay, educational qualifications, contractual maternity pay, type of employer and number of children. The more highly paid a woman was in her pre-birth job, the greater were the chances she would return to work after the birth. The chances of returning to work among women in the public sector, women who received contractual maternity pay and women with higher-level educational qualifications were greater than those of women in other sectors, with lower

qualifications and who did not receive contractual maternity pay (Table 6.25).

Occupational change over childbirth
The amount of occupational downgrading after childbirth among women who were employed previously in full-time higher-level non-manual and professional occupations appeared to have been minimal, and may have lessened since the 1979 PSI Survey and 1980 *Women and Employment Survey.* The large majority of women in these occupational groups maintained their occupational level after returning to work whether that return was on a full-time or a part-time basis.

The majority of women who had been employed full-time in clerical and secretarial jobs before the birth maintained their occupational level upon returning to work on a full-time basis. A substantial amount of downgrading was found among those who returned part-time.

The majority of women who returned full-time among those employed in sales or as manual workers before the birth went back to jobs in the same occupational group. There was substantial mobility between sales and manual jobs among those who returned on a part-time basis. It appears that there may be a common labour market among these occupational groups for women who wish to return to work on a part-time basis.

Childcare arrangements
Childcare arrangements varied according to whether the mother worked full-time or part-time after the birth. For each group of women the same three usual carers were cited most frequently: fathers, grandmothers and childminders. Childminders were cited by 36 per cent of women in full-time work, but only 16 per cent of part-time workers. Fathers were cited by 51 per cent of part-time workers, but only one in five women in full-time employment (Table 6.27).

The majority of women had to make childcare arrangements for only one child (77 per cent of full-time workers; 57 per cent of part-time workers. The majority of part-time workers arranged childcare in ways that did not require cash payments. However, most women in full-time work (63 per cent) paid for such care (Tables 6.29 and 6.30).

Suggestions for change
About two-thirds of women said that there were changes they would like to see to make it easier for them to return to work after having a baby. About two-thirds of employers said that things were fine as they were.

Changes women would like to see
Nine per cent of the women covered by our survey took the opportunity to say that, in their view, no changes were needed. Twenty-eight per cent made no response at all, leaving blank the pages provided for them to write about any changes they wanted.

Women who worked as professionals and associate professionals were more likely to have suggested that changes were needed and, together with managers and administrators, were more likely to have made suggestions for change. Nonetheless, just over 60 per cent of women who had been employed in sales and manual occupations provided suggestions as regards changes they would like to see to make it easier for them to continue working after childbirth.

Childcare facilities
As in 1979, improved childcare facilities were the single most important change women wished to see, whatever their occupational level (Table 7.1). Proportionately more women employed in higher-level non-manual and professional work said that they wanted better and more extensive facilities for the care of their children, but the issue was also of considerable importance to women in other occupations.

Women who had worked during pregnancy were concerned especially with improvements to workplace childcare facilities. This was particularly true for women whose pre-birth jobs had been in the three higher-level non-manual categories (Table 7.3).

Maternity rights legislation
There was a demand for improved maternity rights, especially for an extension to the period of maternity absence (Table 7.4). Women who had not returned to work by the time of the survey were particularly likely to want a longer period of maternity leave.

Women in work after the birth as clerical and secretarial workers, or in craft, sales and personal and protective service occupations were

generally unlikely to have reported that they wanted longer maternity leave in comparison with women employed as professionals and associate professionals.

Flexible working arrangements
There was a demand for more flexible working arrangements to help women combine childcare with paid work.

One in five women wished to see changes in the organisation of work that would help them to continue working after having a family. Nine per cent wanted to see employers introduce more flexible working hours, while part-time employment (6 per cent) and job-sharing arrangements (5 per cent) were mentioned by just over one in ten women.

Changes wanted by employers
Twenty-nine per cent of employers reported that there were changes they would like to see in maternity rights legislation to make things easier for them (Table 7.5). The change most commonly wanted concerned women's right to return to work after childbirth. Thirteen per cent of workplaces mentioned a change related to reinstatement.

Respondents were concerned about the right in various ways. Six per cent wished to see the introduction of a requirement which would ensure that women gave a definite commitment to return. Four per cent wanted the reinstatement period to be reduced. Two per cent wanted to abolish the right completely. One per cent wished to see arrangements that would penalise women for a failure to return.

Negotiations with unions or staff associations over issues
concerning the employment of women
Eighteen per cent of workplaces where there was a union or staff association had had negotiations concerning the employment of women (Table 7.6).

Public sector workplaces were substantially more likely than those in the private sector to have reported that negotiations had taken place on issues specifically concerned with the employment of women. Workplaces where negotiations had taken place tended to be larger ones, especially in the private sector. Help with childcare was the one single issue which stood out as regards the subject matter of any negotiations in the public sector.

Fathers' time off work around the time of a birth

Forty-one per cent of women said that they would like to see more opportunities for fathers to take time off work around the time of a birth, rising to 46 per cent of women in work during pregnancy (Table 7.7).

About one half of the workplaces covered by the survey of employers reported that male employees were able to take time away from work around the time of a birth (Table 7.8). Of these, 60 per cent reported that time off was granted at management's discretion rather than being embodied in collective or contractual agreements.

There has been relative stability over time both in the extent to which fathers took time away from work and as regards variations by occupational level.

The large majority of women reported that their husbands or partners took time away from work either during the pregnancy or around the time of the birth. Seventy-seven per cent of men who were in work at the time of the birth took time off work at or after the birth. Twenty-four per cent had taken time off work during the pregnancy.

The most common form of leave taken by fathers was holiday time. This was unchanged from 1979 when just less than one half of the men taking leave used part of their holiday entitlements. In 1988, just over one half had taken holiday leave (Table 7.10).

Nine per cent of women reported that their husbands or partners had taken paid paternity leave.

1 Introduction

Women in Britain comprise almost half of the country's labour force and all of its mothers. In 1987, there were just over 8 million women of childbearing age in employment; during the year, 4.5 per cent of these women gave birth to babies.[1] But unlike their counterparts of some two or three decades ago, nearly half of these women were back in work within eight or nine months after the birth; by some five years later, the chances are that almost all of them will have re-entered the labour market.

It is the purpose of maternity rights legislation to protect the physical well-being and employment of women around the time of childbirth. The legislation recognises both the demands of motherhood on individual women and their families, and the benefits motherhood provides to society as a whole. It assumes that in its absence women's opportunites would be curtailed and their chances for equality with men diminished.

This report presents the results of two national surveys which investigated the operation of maternity rights legislation in Britain in 1988-9. The first survey covered 5,000 women who had babies in December 1987 or January 1988; the second covered 500 of the employers of those women who had been in employment one year previously. Employed mothers have five rights under British law: the right not to be dismissed on grounds of pregnancy; the right to time off work for ante-natal care; the right to a period of absence for maternity, and to reinstatement after this absence; and the right to

maternity payments during the period of absence.[2] The first study of the impact of maternity rights legislation on women and employers was carried out nearly a decade previously; the present report looks both backward in time towards that study in an attempt to measure change, and forward to the 1990s when it is increasingly likely that women will play an even greater role in Britain's economic life.

In this chapter, we provide a brief overview of women's labour force participation in the 1980s and prospects for the 1990s in order to highlight some of the themes which the main body of the report addresses. The primary aim of the report is to explore women's and their employers' experiences of maternity rights legislation. Initially, however, we provide a context within which these experiences may be viewed. In addition, the study design, fieldwork results and some characteristics of both mothers and employers are outlined as a further step towards the building of a framework for our subsequent analyses of maternity rights.

Women in the labour market in the 1980s and 1990s
The 1980s in Britain brought highly changeable opportunities for women in the labour market. The marked post-war growth in women's employment, which saw their participation rate rise from 35 per cent in 1951 to over 60 per cent by 1975, had levelled off by the end of the 1970s. Between 1979 and 1981 total employment among women fell, with the loss of full-time jobs continuing well into 1984. From 1981 until 1986, unemployment and employment grew simultaneously as part-time jobs in the service sector replaced full-time jobs in manufacturing as new sources of employment. Registered unemployment among women peaked at over one million in 1986; unregistered unemployment is likely to have encompassed a further million. Self-employment among women, often part-time, increased by over 300,000.[3]

The affinity between women and part-time employment meant, however, that the demand for women in the labour market rose throughout the decade. Virtually all employment growth during the 1980s came through the creation of part-time jobs – jobs which are overwhelmingly taken up by women. The number of full-time jobs held by women began to increase towards the end of the decade and reached its 1980 level during 1988. Nevertheless, part-time jobs dominated women's labour market opportunities. Part-time

employment is projected, moreover, to account for over two-thirds of an expected 1.7 million new jobs over the years to 1995 (IER, 1988).

Also fuelling the demand for women's skills and experience at the end of the decade was the recognition – by government, employers and other concerned groups – of an impending and dramatic change in the composition of the labour supply. Forecasts suggested a drop in the number of young people available to employers over the first half of the 1990s of about 20 per cent, representing a loss of half a million workers. During these years women are expected to be the most likely source of new labour force entrants, and it is anticipated that they will account for about 80 per cent of a predicted 1.1 million new workers. It is forecast that women aged 25-44 years, returning to work following breaks for childcare, will make up the largest single group among these new labour force entrants (IER, 1988).

The entry of ever-increasing numbers of women into the labour market in order to satisfy labour supply needs is not inevitable, however – although it is highly probable. Women in Britain continue to assume primary responsibility for the care of children and other dependants, in addition to carrying the major burden of running the home. About two-thirds of married women with pre-school age children – and over 80 per cent of lone mothers with children under five – make these tasks their main work and do not have paid jobs, while mothers with pre-school children who do go out to work tend largely to work on a part-time basis.

However, women's labour force participation increases with the age of their youngest child. By the time this child has reached sixteen or older, almost three-quarters of all women hold down paid jobs in addition to their domestic responsibilities (GHS 1987:156). The proportion of women working full-time also increases as children grow up, and by the time their youngest child has reached sixteen, working mothers are twice as likely to be in full-time as in part-time jobs (ibid.).

These figures suggest that there is considerable scope for increases in the labour force participation of women; they also indicate the main inhibition to any such increase: childcare. Childcare provision in the UK is based upon a mix of public, private and voluntary sector facilities. However, the UK provides much less public childcare than most other European countries. It provides care for 1 per cent of children under age three and the equivalent of full-time care for about

3

one-quarter of children aged three to school age (Cohen, 1988). Moreover, between 1983 and 1989, employer-provided childcare facilities were taxed as a benefit-in-kind. The evidence suggests that the current level of childcare provision constrains as many as 500,000 women from entering the labour force (Metcalf and Leighton, 1989).

In consideration of the increased importance of women in the labour market, and to promote equality between men and women, some employers began early in the 1980s to take steps to help women more easily accommodate paid employment with domestic obligations. Thus by the second half of the decade, career break schemes, flexible working arrangements such as job-sharing, flexi-time, and term-time working, and workplace nurseries had been introduced – albeit in a piecemeal and patchy way. By the end of the decade, the recruitment and retention of women employees had become an enormously fashionable issue. The reality for the bulk of women, however, seemed little changed and innovations which were designed to keep women in employment over their child-rearing years continued to be available to only a limited number of women (Metcalf, 1990).

The rate at which women return to work following the birth of a baby has been increasing rapidly. By the end of the 1970s about one quarter of mothers who were in work when they became pregnant returned to work within eight or nine months of having a baby (Daniel, 1980) Ten years later, the proportion of new mothers back in work had nearly doubled, while the rate of increase in women's return to full-time work had trebled.

All the indications are that the trend for mothers to return to work quickly after childbirth will continue during the 1990s as a result of the changing demographic composition of the labour supply, and could well accelerate. This may add up to little less that a social revolution, with profound implications for roles and relationships within the family; for childcare practices and the public provision of childcare; for fertility and population trends; and for the distribution of income as between households and families in the community. The study of maternity rights legislation comes, then, at a highly opportune time.

Context and design of the research
The research project upon which this report is based encompassed two
national surveys: a postal survey of women who had recently given
birth and a telephone survey of employers known to have employed a
woman who had recently stopped work in order to have a baby. The
purpose of the research was to examine the operation and effects of
maternity rights provisions from the dual perspectives of employee
and employer, and to investigate women's employment experiences
over childbirth.

In large measure, the project was designed to replicate research
carried out by the Policy Studies Institute in the late 1970s (Daniel
1980; 1981a; 1981b).[4] As might be expected with the passage of
almost 10 years, issues which had assumed importance in the initial
project seemed of less interest at the time of replication and hence were
dropped from the later investigation. Conversely, issues were
introduced which had not had the same signficance in 1979 as they
appeared to have in 1988, and in this way the research project was
extended. The most prominent new issue concerned the recruitment
and retention of women employees. Ultimately, however, the two
projects adopted much the same methods and perspectives and
confronted many of the same issues and problems.

The advantage of replicating a previous study lies in the reliable
up-to-date information collected about changes over time. Replication
allows a high degree of confidence that measured differences between
the current and earlier findings on maternity rights legislation
represent evidence of real change. However, although valuable
information may be gained through replication, limits exist on the
extent to which causal explanations are able to be advanced for
changes in the operation of the legislation. Such changes will have
occurred at the same time as a host of other changes – in the legislation
itself, in the pattern of women's labour force participation, in society
as a whole – each of which may have had an effect on the behaviour
of women or their employers.

Not least of the many changes that have occurred over the decade
is the likelihood of greater familiarity with the general principles of
maternity rights provisions on the part of women employees, trade
unions and employers. In 1979/80 – the time of the Daniel surveys –
maternity rights legislation was still new: the right to reinstatement
after childbirth and protection from unfair dismissal on grounds of

pregnancy were introduced only in June 1976; maternity pay was introduced only in April 1977. Thus, the earlier project undertook to examine the operation of legislation with which many women and employers would be unfamiliar. Ten years on, we judged that this unfamiliarity would be abated to a considerable degree and thus more was taken for granted in the design of the surveys. The favourable response to both surveys, as presented below, leads to the conclusion that this judgement was correct.

The introduction of maternity rights and benefits in the 1970s had also been surrounded by controversy that remained alive during the 1980s – with employers' interest groups, on the one hand, arguing that the legislation went too far and would harm the interests of women through employers' reluctance to hire women of childbearing age, and women's interest groups, on the other hand, arguing that the legislative provisions did not go far enough and were well below the provisions made in some other western European countries. For both sides to the controversy, the right to reinstatement was a prime focus of dispute (see Daniel, 1980:2-3).

The context within which the research was conducted in 1988-9 was very different. Maternity rights legislation, although considerably altered, was by now relatively familiar to women and employers alike and, if not entirely free from controversy, then at least a less contentious issue than it had been a decade earlier. Employers were beginning to recognise the possible impact of demographic trends that would see a marked shortage of young people over the first five years of the 1990s and an increase in the number of women with family obligations in the labour market.

This changed context is reflected in the findings presented in this report, as may be illustrated by brief reference to women's right to return to work after childbirth – a highly contentious issue in the late 1970s and early 1980s. The research carried out in 1980 by Daniel suggested that the *idea* of being required to keep women's jobs open for up to 40 weeks appeared more onerous an obligation than did the *actuality* of doing so (despite considerable rhetoric indicating otherwise). Our current findings would appear to bear out Daniel's suggestion, by showing that a decade of familiarity has resulted in a marked *decrease* in the proportion of employers reporting problems with maternity rights legislation, despite a considerable *increase* in the proportion of women taking up their right to return to work. In 1980,

for example, 14 per cent of employers reported difficulties concerned with the right of reinstatement; by 1989 this had fallen to just over 5 per cent, even though the proportion of women who gave formal notice of return had grown over the decade from 41 per cent to 72 per cent. In 1989, over 90 per cent of employers said they had never been caused any problem by a woman exercising her statutory right of return. Similarly, over 90 per cent of women reported that they had had no difficulties with their employers over the right.

This is not to suggest that the operation of maternity rights legislation was trouble-free for either employee or employer. Indeed, there was an increase in the extent to which disputes concerned with maternity rights had arisen over the decade, although the proportion of disputes resulting in legal action remained tiny. Furthermore, the Equal Opportunities Commission receives a steady stream of inquiries from women who find the regulations and requirements governing maternity rights onerous and over-complex. As is discussed in Chapter 4, Britain is one of only two European countries to attach continuous service conditions to maternity rights legislation, and these vary as between eligibility for maternity pay and for maternity absence.

But one inference which might fairly be drawn is that, more than a decade beyond the introduction of rights and benefits for pregnant women in employment, this legislation has become institutionalised into employers' practices and ways of running their establishments, and although its provisions may cause problems from time to time – as does any piece of legislation – the legislation itself no longer carries any special threat or burden.

Details of the survey of women
As outlined, the primary aim of the research was to examine the operation and effects of statutory provisions for pregnant women in employment through surveys of employers and of women who stopped working to have a baby. Following Daniel's initial survey, we began our inquiries with a nationally (Great Britain) representative survey of mothers of new babies. The source of the sample was Department of Social Security (DSS) child benefit records. A random sample of 7,704 women who had had babies in December 1987 or January 1988 was generated by the DSS in Newcastle.[5] Following checks on the sample carried out to identify and remove inappropriate

cases, 7,680 questionnaires were mailed to the mothers in September 1988, some nine to ten months after the birth of their babies.[6]

The procedures followed for the preparation and posting of the questionnaires matched those found to be successful in the 1979 PSI survey of mothers: code numbered address labels for the sample were prepared by the DSS, while PSI supplied the Department with stamped, sealed, code numbered envelopes enclosing numbered questionnaire schedules. The Department attached the addresses and posted the schedules. In addition, each mailing to the mothers contained a stamped reply envelope and an introductory letter from the DSS which stressed that neither completion nor failure to complete would affect entitlement to benefits.

A record was kept in PSI of the serial numbers of questionnaires returned by the mothers. These numbers were forwarded to the DSS in Newcastle where the list of names and addresses was updated in preparation for reminder letters. Two reminders were sent out by the DSS at three-to-four week intervals, with a new questionnaire schedule and multi-lingual translation of the follow-up letter enclosed with the final reminder.[7] These procedures ensured complete confidentiality of the DSS benefit records. At no time did researchers have sight or knowledge of the names or any other identifying details of the individuals in those records.

The response to the survey was good in view of the complexity and length of the questionnaire. Four thousand nine hundred and ninety-one (4991) questionnaires were returned completed and usable, a gross response rate of 66 per cent (Table 1.1). The schedule was 39 pages long, broken into eight colour-coded sections. The content was detailed and inevitably complex owing to the issues with which we were concerned and the range of occupational experiences of the mothers themselves. We were covering all educational and occupational levels. Nonetheless, the quality, coherence and consistency of information were good. Particularly gratifying was the fact that so many mothers took the time to give us their views in the final two open pages of the schedule. In short, we asked women a great many questions about matters of obvious interest to them and received a wholly satisfactory response to our efforts. In the following section we consider whether the respondents were generally representative of the population from which they were drawn.

Table 1.1 Response to the survey of women

	Number	Per cent
Questionnaires returned		
- completed and used for analysis	4,991	66.0
- unusable/duplicated	15	0.2
- blank	45	0.6
Not returned	2,506	33.2
Post Office unable to deliver	123	
Total initial mailing	7,680	100.0

Characteristics of the women

This section provides detailed information about the social and personal characteristics of the women who responded to the survey, one of the aims being to establish how representative these women were compared with women in similar circumstances in terms of number of children, age, marital status and so on. Secondly, we wish to show how these women differed – if in fact they did – from the women who responded to the 1979 PSI maternity rights survey. In fulfilling these two aims, we begin to provide the framework needed for the subsequent analyses of women's experiences of maternity rights legislation – a task that is completed in Chapter 2 which focuses upon mothers' economic activity before the birth of their recent babies.

Birth order and number of children

We are able to compare the frequency of first births relative to second or subsequent births among the women who responded to our survey against both the full sample drawn from the DSS birth records and the survey of mothers carried out by PSI in 1979. Our achieved sample of mothers divides almost evenly between women who had recently had their first child and those who had had their second or subsequent child, and matches the DSS full sample almost exactly. The three sets of figures are presented in Table 1.2.

Proportionately more first-time mothers are included in the 1988 survey than was the case in 1979. As the proportion of first-time mothers in the 1988 achieved sample is identical to the DSS full sample (in 1979 it differed by only 1 per cent), the contrast with the

Table 1.2 Number of children in achieved sample compared with the DSS
full sample and the 1979 PSI survey

Column percentages

Number of children	1988 PSI survey	Full DSS sample	1979 PSI survey
One	48	48	43
Two	32	32	38
Three	13	12	13
Four or more	7	8	5
	100	100	100
Base number:	4,991	7,704	2,414

earlier survey seems unlikely to be due to response bias. This suggests
that either there has been an increase in the number of women
becoming mothers for the first time or that the sample of mothers
drawn by the DSS may have some unusual features, one of which
appears to be a larger than expected proportion of first-time mothers.
Unfortunately, determining which of these explanations might be true
is not a simple task.

Published statistics indicate that of all live maternities in 1988, 41
per cent were first births and 59 per cent second or subsequent births.[8]
However, these proportions relate only to births *within marriage*,
which in 1988 accounted for about three-quarters of all live births. It
seems probable that many women giving birth outside marriage will
be having their first child – a suggestion which is given added
plausibility by the fact that 63 per cent of single mothers in 1988 were
under age 25 (one quarter were under 20). Fifteen per cent of the 1988
achieved sample had not yet been married; 10 per cent of these women
did not live with the father of their new child. It is certain that these
women will be contributing to our apparently high proportion of
first-time mothers: over 60 per cent of the women in our survey who
lived without husbands or partners had had first babies, compared with
46 per cent of women who were married or living as married. They
are unlikely, however, to account for all of the increase in first-time
mothers. And indeed, confining our analysis to women who were
legally married at the time of the survey reveals that they too

10

comprised disproportionately more first-time mothers (45 per cent) than the national statistics would lead us to expect. It seems, then, to be the case that the women who gave birth in December 1987/January 1988, from among whom our sample was drawn, differed slightly from women in similar circumstances in that they were more than usually likely to be having a first baby.

Whatever the explanation for the relatively high proportion of first-time mothers, it is a considerable benefit for our research. These mothers are the most likely to have been in employment during pregnancy, and to have been in full-time employment. Thus they are the women most likely to qualify for maternity rights and benefits. In having a slightly larger proportion of first-time mothers, we thus gain a slightly larger proportion of women with work histories most relevant to our concerns. If it is also the case that, in other major respects, the women in our survey are representative of women in similar circumstances, then a seeming quirk of nature becomes a bonus for analysis.

However, before passing on to establish how representative the mothers in our achieved sample are in other respects, it is of passing interest to point out that they are remarkable for another feature of their maternities: twelve of them accounted for 4 per cent of all of multiple births involving triplets or higher during 1987 and 1988.[9] In 1987 there were 134 sets of triplets or higher order births; in 1988, there were 170 such sets. The year 1988 was itself remarkable, with the highest number of multiple births recorded since information was first collected. Seventy-seven of our mothers had multiple births: 65 twins, 7 triplets and 5 sets of quads. Although this has been the source of some considerable surprise among both PSI researchers and our DSS colleagues, the small number of mothers involved means that they represented fewer than 2 per cent of our total sample of mothers and had no significant influence on the overall pattern of our findings.

Age
The average age of the women who responded to our survey was 27.7 years. The age composition of our sample differs slightly from the national picture, as shown in Table 1.3, and is skewed towards older mothers.

Nationally, 37 per cent of women having babies in 1988 were under age 25, compared with 28 per cent of the women responding to

11

Table 1.3 Age distribution of achieved sample compared with OPCS data
 for live births and age of mother

Column percentages

Age	PSI 1988 survey	OPCS* 1988
Under 20 years	5	9
20 to 24 years	23	28
25 to 29 years	37	35
30 to 34 years	25	20
35 to 39 years	8	7
Over 40 years	2	1
No information	1	-
Average age	27.7	27.2

Base: All women

* Source: Tables 1.9 and 2.23 Live births by age of mother, *Social Trends 20*, 1990,
 pages 28 and 45.

the PSI survey. We have no way of knowing whether this reflects
non-response bias, or whether the full DSS sample from which our
mothers were drawn included a disproportionate number of older
mothers. In any event, the differences are not great and are unlikely to
make a significant impact on the overall pattern of our findings.

Table 1.4 Number of children in achieved sample by age of mother

Column percentages

	All	16-20	21-24	25-29	30-34	35-44	45+
One	48	86	62	49	35	26	(1)
Two	32	13	29	36	37	29	–
Three	12	(3)	7	11	19	22	(1)
Four+	7	(1)	2	5	9	22	(4)
Base:	4,991	388	989	1,823	1,254	495	6

() denotes actual number

Table 1.4 gives details of the number of children the mothers had at the time of the survey in relation to their age. As might be expected, the younger the mother the more likely she was to be having her first child. About one-quarter of the oldest mothers were also first-time mothers, however, reflecting the continuing trend towards later maternity. In 1941, 30 per cent of all births were to women under age 25; by 1971 this had risen to 47 per cent before decreasing to 37 per cent by 1988. Concomitantly, the average age of married women at first birth has risen from 24.3 years in 1964 to 26.5 years in 1987 (*Population Trends*, 1988).

Marital status and household composition

The legal marital status of the mothers who responded to our survey is presented in Table 1.5 which also shows household composition. DSS files do not include a record of mother's marital status but a comparison with birth statistics for all live births in England and Wales shows that about 75 per cent of all live births occur within marriage (77 per cent in 1987; 74 per cent in 1988). This compares reasonably well with our sample of mothers, among whom 79 per cent reported that they were legally married. We cannot in any event be more precise. Our information on marital status (and indeed household composition) relates to a period some eight or nine months after the birth. It is possible that within that time period some new marriages occurred, while others broke down. It is sufficient that our achieved sample does not differ markedly from the national picture.

Table 1.5 Legal marital status and household composition

Row percentages

	All	Husband/ partner	Own children	Partner's children	Other adults	Other children
Married	79	99	93	1	4	1
Single	15	36	87	1	25	7
Separated	3	7	95	1	15	1
Divorced	3	44	93	4	5	1
Widowed	(7)	(2)	(7)	(1)	(1)	–

Base: All women

() denotes actual number

With the inclusion of household composition in Table 1.5, the extent of cohabitation may be observed. In all, 85 per cent of women were either married or living as married; 10 per cent of single women lived without a marital partner as did 4 per cent of widowed, divorced and separated women. This varies a little from the 1979 PSI survey when 94 per cent of respondents were married or living as married. As fewer than 5 per cent of the 1979 sample were unmarried mothers without partners, the contrast between the two surveys is likely to be accounted for by an increase in the number of births to young single women.

Readers will note from Table 1.5 that 7 per cent of the married new mothers in our survey, and as many as 13 per cent of mothers who had never been married, reported that their own child or children were not living in the same household as themselves. This is unlikely to be accounted for by adoption – mothers were selected for inclusion in the survey on the basis that they were in receipt of child benefit payments, hence they were at least nominally responsible for the child. It may be that some of the younger, single mothers had asked their own mothers or other relatives to take responsibility for the day-to-day care of their new babies or conceived of both themselves and their babies as being part of their parents' households. Clearly, general ideas about what constitutes a household can differ from official definitions and there is scope for different interpretations to have been put upon the question which may account for what appears to be a rather odd finding.

Ethnic group

In order to encourage women from minority ethnic groups to complete and return our questionnaire, a multi-lingual translation of the covering letter from the DSS was sent to all mothers as part of the final reminder. We received returns from just over 280 women from ethnic minorities, distributed across Britain's various minority ethnic groups in proportions which correspond closely to national figures. Nonetheless, the actual number of ethnic minority respondents is small and this should be borne in mind when considering calculations based on their experiences. Table 1.6 compares the results of the PSI survey with information for Britain about women of differing ages and ethnic backgrounds.

Differences in number of children among women from differing ethnic backgrounds are presented in Table 1.7. This shows that women

from ethnic minority groups tend to have more children and that is particularly true of Pakistani and Bangladeshi women. As will be seen in the next chapter, that pattern is associated, as would be expected, with lower labour force participation among the women concerned.

Table 1.6 Minority ethnic group by age

	PSI survey All ages	16-44	All women+ 16-29	30-44
Black[†]	2	2	2	1
Indian	2	2	2	2
Pakistani/ Bangladeshi	1	1	1	1
Chinese	*	*	*	*
Other	1	1	1	1
Base:	4,991	11,326	5,855	5,471

+ calculated from Haskey, 1988.
† By the designation 'black' we mean to indicate women of Afro-carib and black African descent.[10]
* less than 0.5 per cent.

Table 1.7 Number of children in relation to ethnic groups

Column percentages

	White	Black[†]	Indian	Pakistani	Bangladeshi	Others
One	49	51	51	32	(2)	53
Two	33	33	23	14	(1)	34
Three	12	5	17	22	(3)	5
Four+	6	11	10	32	(4)	8
Base:	4,600	76	83	50	10	64

() denotes actual number.
† By the designation 'black' we mean to indicate women of Afro-carib and black African descent.[10]

Details of the survey of employers
Our survey of employers was carried out in June and July 1989 and
covered both private and public sector workplaces. As with the survey
of mothers, a primary aim was to replicate PSI's earlier work (Daniel,
1981a) and thus to establish any changes in employers' experiences
of maternity rights. Accordingly, we were interested in the extent to
which employers had experienced difficulties arising from the
statutory requirements and how they had coped with any such
problems. We wished also to examine the extent to which employers
provided additional maternity benefits on a voluntary basis and to
determine if these were intended to encourage women to remain in
paid work over their childbearing years. We were particularly
concerned to identify sources of variation in employers' experiences
of maternity rights legislation, especially in relation to size of firm,
workplace size and sector of the economy.

Following the design of the initial PSI survey, we included a
question in our survey of mothers which asked women who had been
in work during the twelve months before their baby's birth to record
the name and address of their most recent employer. This gave us a
sampling frame of workplaces in proportion to the number of women
they employed who were likely to have a baby in twelve months time.
By choosing a sample of employers who we knew had recently
employed at least one woman who had had a baby soon afterwards
and avoiding employers who had had no recent experience of women
stopping work for childbirth, we felt we would be making best use of
our time and resources. But because we chose the mothers' survey as
our source of employers, the sample of employers was not nationally
representative of all workplaces in proportion to number of
employees. Rather, it over-represented employers of women
compared with employers generally; in particular, it over-represented
employers of women of childbearing age. In sum, as was the case in
1980, our sample of employers can be taken to be a nationally
representative sample of workplaces selected with a probability *in
proportion to the number of women they employ of childbearing age.*

In general, the approach taken in the earlier PSI survey again
worked well. The majority of mothers recorded the names and
addresses of their most recent employer in a way that made it possible
to trace the employers; when approached, a satisfactory number of
employers agreed to be interviewed; familiarity with the issues under

consideration among the employers meant that few of our questions went unanswered. Nonetheless, in adopting methods similar to the 1980 survey of employers, we also accepted similar distinctive features of the sample. First, and as we have pointed out, the sample was not representative of all employers but had certain special characteristics. Secondly, because we ensured that every workplace covered in our survey had recently employed a woman who stopped working to have a baby soon afterwards, we are likely to overstate the extent to which employers – and especially small employers – experience any difficulties associated with maternity rights.

We calculate that an employer of as many as ten *women* will experience one woman stopping work for childbirth about once every three or four years.[11] In general, an employer of ten *people* will experience a woman stopping work to have a baby once every eight or nine years (on the assumption that 43 per cent of employees are women). Accordingly, the small employers included in our survey will have employed a woman who stopped work for childbirth much more recently than is generally the case for small firms. Despite this concentration upon small workplaces who were most likely to have had problems, such firms were much less likely than larger employers to have reported any difficulties associated with maternity rights. Indeed, the larger the workplace, the more likely employers were to have experienced problems with maternity rights, inde- pendently of the sector of the economy within which the employer was located.

In principle, a third limitation of our sample design may have been that we would have excluded any employers, and especially small employers, who had chosen not to hire women of childbearing age because of the regulations and obligations associated with maternity rights. The findings of the 1980 survey suggested that it was unlikely that such reluctance had more than marginal implications; the emphasis on skill shortages and the retention of women's skills by employers in the late 1980s suggests a further diminished likelihood of maternity rights legislation creating blockages to the growth of employment.

In one particular we were able to extend and strengthen the 1980 PSI survey. Because of restrictions on sample size, the 1980 systematic survey was confined to 300 employers in the private sector. Additional semi-structured discussions were carried out with 28 public sector 'head offices' and six line managers in public sector workplaces

covering similar ground to the systematic survey of private sector employers. This approach allowed broad general comparisons to be made between private and public sector employers, which revealed few differences in their experiences of maternity rights.

The financial resources available in 1988/9 permitted an extension of the survey to cover 500 employers. Consequently, public sector employers were included in the survey on the same basis as those in the private sector. This meant that in both sectors the main focus of attention was the actual workplace at which the mother had been employed before childbirth. Because of the centralisation of policy and decision-making in public sector organisations, we felt that there was a strong possibility that the information we sought about specific workplaces might not be available from workplace respondents. In these cases (and in similar cases in the private sector), the information was sought from a second (or third if necessary) respondent away from the workplace in question but in relation to that workplace alone.[12]

The inclusion of public sector workplaces in the 1989 survey has consequences for our comparison with the earlier PSI survey of employers. In 1980 Daniel reported, for example, that 18 per cent of all employers surveyed had experienced some difficulty associated with maternity rights. In 1989 the comparable proportion was 13 per cent of all employers, but only 10 per cent of *private* sector employers – the true equivalent to the 1980 survey – and 20 per cent of those in the public sector. Our comparison *over time* reveals, in other words, that the proportion of (private sector) employers who reported having had recent problems associated with maternity rights has been cut in half; while our survey of *employers in 1989* reveals that public sector employers were twice as likely as their private sector counterparts to report having had recent problems associated with maternity rights. Adding public sector workplaces to the survey of employers has greatly strengthened it. Care must be taken, however, to ensure that comparisons over the decade are made between equivalent employers.

Fieldwork results and sample composition
Our survey of employers was carried out by telephone on the basis of names and addresses recorded by women who responded to our survey of mothers. Over three-quarters of the women in work twelve months before their recent baby's birth provided information about their last employer. Although our main interest was with the employers of

women who had been in work during pregnancy, we chose women in work twelve months before childbirth as our starting point for sample selection for two reasons. First, the twelve-month date was far more precise than the date of conception. Secondly, we wanted to allow for the possibility that some women stopped working before pregnancy in the hope or expectation of pregnancy. In the event, we found that a small proportion of women in work twelve months before their baby's birth had withdrawn from employment shortly before or just after becoming pregnant and we discuss these women in more detail in the next chapter. Table 1.8 summarises our fieldwork results.

Table 1.8 Summary of fieldwork results, survey of employers

	Public sector	Medium/Large businesses	Small firms	Total	%
Total addresses drawn	314	399	184	897	
Untraceable addresses	42	39	30		
Sample issues	272	360	154	786	100
Sample achieved	188	219	95	502	64
Interview refused	39	80	47	166	21
Not available in time	36	43	11	90	11
Incomplete interviews and other reasons for non-response	9	18	1	18	4

Note: The nature of the employer is taken from the descriptions given by women in the survey of mothers.

Choosing women in work twelve months before the birth of course yielded many more employers' names and addresses than were needed. We wanted to draw a sample of 500 employers together with a 'back-up' sample of 250, in order to achieve 500 completed interviews. Employers were selected from the survey of mothers on the basis of equal probability within four workplace size bands.[13] Our information about the employers came from women's answers to questions which identified workplace size, whether their last employer had been in the public or private sector and, if the latter, whether the employer had been 'A large or medium sized company/business/chain/factory' or 'A small firm/office/shop/factory'. For the purposes

of our sample selection, workplaces were stratified according to number of people employed, to ensure that the achieved sample included sufficient establishments in each size category for analysis in relation to size. Within each size band, every third employer was selected from a listing of the mothers' serial number. Because of untraceable addresses, a further 111 employers were randomly selected to provide adequate backup for the achieved sample.

Overall, we achieved a 64 per cent response rate, which compares with the 65 per cent response to the 1980 PSI survey of employers. There was a clear tendency for the response rate to be better among public sector employers (69 per cent), and to be poorest among workplaces with fewer than 25 employees in both sectors (47 per cent).

The samples achieved in each category were restored to their proper proportions, as indicated by the survey of women, by applying weighting factors as appropriate. In consequence, the sample upon which tables are based may be taken to be workplaces or establishments across the whole of the economy selected with probability proportionate to their propensity to employ women of childbearing age. Details of the weighted and achieved samples are provided in Table 1.9.

Table 1.9 Weighted and achieved samples of employers

| | Workplace size | | | |
	1-24	25-99	100-499	500+
Public sector				
Number in survey of mothers	231	240	179	227
Sample issued for survey of employers	72	74	55	71
Sample achieved (number)	34	49	40	65
Weighted sample base (number)	48	54	38	53
Private sector				
Number in survey of mothers	683	378	343	233
Sample issued for survey of employers	189	121	119	85
Sample achieved (number)	90	84	88	52
Weighted sample base (number)	117	72	72	48

In the tables throughout the report we show, first, the weighted bases upon which percentages were calculated and, secondly, the unweighted bases which represent the number of workplaces in that category that were actually interviewed. As is often the case with weighting, however, the percentage points would have varied only rarely by more than one or two points whether we had taken the weighted or the unweighted bases for purposes of analysis.

Table 1.10 Women's job levels: the survey of mothers and the survey of employers compared

Column percentages

Job level+	Mothers' Survey full-time	part-time		Employers' Survey full-time	part-time
Managers/ administrators	9	3	Middle/Sr Mgement/ Professional	10	5
Professionals	10	9	Supervisor/Jr. Professional/		
Associate prof.	13	12	Technical	26	25
Clerical/ secretarial	35	21	Clerical/ secretarial	34	26
Craft & skilled manual	5	3	Skilled manual	7	4
Sales	8	14	Sales	5	11
Personal & protective services	9	18			
Plant & machine operatives	7	5			
Other occupations	4	14	Other manual	18	29
No information	1	1			
	100	100		100	100
Base*:	1,935	820		54,247	23,839

* The mothers' survey is based on women in work 12 months before the birth; for the employers' survey it is workforce information from 427 workplaces from whom workforce information was obtained, weighted to represent all workplaces.
+ For description of the classification schema used see Appendix.

Table 1.10 compares the level of the last job held by the women in work twelve months before the birth with workforce details obtained from the employers. It provides an opportunity for assessing how far there was reliability between the pictures derived from the two different sources. Clearly the pictures are not identical. In particular, the survey of women included more women in semi- and unskilled manual work than were reported to be among the employers' workforces; conversely, proportionately more women junior professionals and supervisors were reported among the employers' workforces than by the women themselves. But generally the match is fairly good, in view of the differences in the definition of occupational categories used in the respective surveys (see Appendix).

Table 1.11 provides comparisons based on industrial sector between the survey of mothers, the survey of employers and the 1987 Census of Employment.[14] Again the match between the two PSI surveys is not perfect but the overall pattern is broadly similar. The industrial distribution of employers covered in our survey reflects the general industrial distribution of women employees fairly well. But there are differences between the composition of the sample of mothers and the national picture of women's employment across the various industries.

Table 1.11 Industrial sector: (a) survey of mothers; (b) survey of employers; and (c) 1987 Census of Employment

Column percentages

	All women in work 12 months before the birth	Survey of Employers (weighted)	Census of Employment
Other services	47	39	43
Manufacturing	17	15	14
Distribution	16	24	24
Finance and banking	13	12	12
Other industries	7	10	7
Base number:	2,768	502	–

Table 1.12 provides further information about the composition of the sample of employers by breaking down the main industrial groups by public and private sector, and within the private sector, by type of enterprise. The industrial grouping 'other services' overwhelmingly comprises public sector employers, whereas manufacturing, distribution and banking and finance largely consist of private sector employers. With workplace size, the categories shown in Table 1.12 are the main sources of variation explored in relation to the survey of employers. (See Appendix for a description of the Standard Industrial Classification used in Tables 1.11 and 1.12.)

Table 1.12 Industrial group of employers by sector of economy

Column percentages

	Other services	Manufac- turing	Distri- bution	Banking/ finance	Other industries
Public sector	87	4	3	–	31
Private sector	13	95	97	100	69
Part of group	6	52	66	60	43
Independent	7	43	31	40	26
Base: All workplaces					
Weighted	197	76	120	60	49
Unweighted	187	83	119	60	53

The final aspect of the survey of employers to be examined here reflects the sample design adopted for the survey. Table 1.13 shows the proportion of women employed by our sample according to workplace size and industrial sector. As outlined earlier, the design of our survey meant that the workplaces covered were more likely to employ women than is the case generally. On average, 58 per cent of the people employed at the workplaces we surveyed were women, compared with only 43 per cent of the labour force as a whole. Moreover, as in the 1980 PSI survey, smaller workplaces tended to employ a larger proportion of women, reflecting in part at least the disproportionate representation of women in other services and distribution, hotels and catering.

Table 1.13 Proportion of women employees: (a) all women and (b) women working part-time as a percentage of total workforce

Percentages

	(a) All women	(b) Part- time	1980
All workplaces	58	18	59

			Base	
			Weighted	**Unweighted**
By workplace size				
Public sector				
Under 25 employees	80	27	48	34
25-99 employees	69	26	54	49
100-499 employees	72	19	38	40
500 employees or more	61	25	53	65
All public sector	**62**	**24**	**193**	**188**
Private sector Part of group workplaces:				
Under 25 employees	69	22	54	41
25-99 employees	58	23	40	46
100-499 employees	54	12	51	62
500 or more employees	55	9	38	40
All part of group	**55**	**11**	**183**	**189**
Private sector Independent workplaces:				
Under 25 employees	64	27	63	48
25-99 employees	55	11	32	37
100-499 employees	56	10	21	26
500 or more employees	51	19	10	11
All Independent	**54**	**15**	**126**	**124**
All private sector	**54**	**12**	**309**	**313**
By industrial sector				
Other services	65	26	197	187
Manufacturing	49	6	76	83R
Distribution	59	23	120	119
Finance & banking	60	11	60	60
Other industries	40	10	49	53
Base: All workplaces	**58**	**18**	**502**	**502**

Table 1.13 also shows that on average women working part-time accounted for 18 per cent of the people employed at the workplaces we covered. In the private sector, the proportion of women part-timers corresponded to women's representation overall, with smaller workplaces more likely to employ greater proportions of women part-timers. In the public sector, however, little difference existed between workplaces by size and, not surprisingly, the public sector was found to be the largest employer of part-time women workers.

Table 1.13 shows the same general pattern that existed among employers in the 1980 PSI survey and tends to confirm the proposition put forward then, and now, that the employers in our survey were much more likely than employers generally to have had some experience of maternity rights legislation. The sample composition we achieved was, in other words, much as would have been expected of one selected with probability proportionate to the number of women employees of childbearing age. The significance of this in 1980, and now, is that if we found that these particular employers had had few problems with maternity rights then the same conclusion could be taken to apply with greater force to employers generally.

Notes

1. Our calculation of 4.5 per cent refers to the proportion of women of childbearing age who had given birth in 1987 and is based in part upon our own survey results which suggest that 53 per cent of women having babies in 1987 had been in paid employment before the birth (see Chapter 2). There were just over 680,000 births in 1987 (*Population Trends 58*, Winter 1989, Table 9): our estimate of the number of women of childbearing age is calculated from the *Labour Force Survey* 1987, Table 5.9.

 If we base our calculations on the total number of women in the labour force (10.2 million in 1987), then the proportion of women who gave birth in this year is reduced to 3.5 per cent. In 1979, comparable calculations suggested a birth rate of 3.6 per one hundred women in employment.

2. Employment rights for expectant mothers are set out in the Employment Protection (Consolidation) Act 1978, and amended by the Employment Act 1980, the Employment Act 1982 and the Social Security Act 1986.

3. Sources for the description of changes in women's employment over the 1980s include Tables 1.1 Working Population, 1.4 Employees in Employment and 2.5 Unemployment Age and Duration for 1979-88 in the *Employment Gazette*; Joshi, 1985; *Labour Force Survey*, 1987; *General Household Survey*, 1987.

4. Throughout the present report we refer to the initial survey of mothers carried out by Daniel as the '1979 PSI survey', and to its companion survey of employers as the '1980 PSI survey'. We trust that the context will make it clear to which survey we refer at any particular time.

5. More precisely, the sample was drawn from women who were in receipt of child benefit in September 1988 in respect of babies born to them in December 1987 or January 1988.

6. This time lapse was chosen so that the limit would have passed for taking up the reinstatement right for those who had qualified and wanted to exercise it. This limit is 29 weeks after the birth of a baby.

7. The languages included Hindi, Urdu, Punjabi and Gujarati.

8. It should be noted that although the sample of mothers was drawn from among women who had their babies in December 1987 and January 1988, we refer only to birth statistics from 1988 for ease of presentation. The figures for 1988 do not differ greatly from those published for 1987. It should also be noted that statistics for Scotland are not included in these figures. The source for the birth statistics used in the chapter is *Birth Statistics, England and Wales*, OPCS, 1988.

9. We are unable to distinguish between babies born in December 1987 and those born in January 1988. Failing to think of any compelling use we might make of the exact date of the baby's birth we chose not to code this information, although it was collected from the mothers.

10. The categories shown in the table mirror those used in the questionnaire schedule. At the time we were constructing the schedule, various tests were being conducted in anticipation of the 1991 Census in order to determine which was the best way to ask about ethnic origin. The version we used was taken from one of these test questions.

11. Here we based our calculations on the proportion of all women likely to have a baby in any given year, or 3.5 per cent rather than on the proportion of women of childbearing age as at the beginning of this chapter.

12. Overall, 15 per cent of employers were unable to give details about the number of employees at the relevant workplace. This comprised 25 per cent of all public sector workplaces covered in the survey, but only 9 per cent of all private sector workplaces. In the main, we lack information, in both sectors, about larger workplaces, especially those with 500 or more employees. We frequently were unable to obtain the desired information because it was sought in relation to the occupational distribution of men and women employees *at the workplace* and this was either not available or, more often, would cost too much time and hence resources to obtain. Prior to contacting the employers we had obtained from the survey of mothers a rough estimate of workplace size. We sent all employers with 100 or more employees advance notice of our survey, including our request for information about workplace size and occupational distribution. It would seem that the larger private sector employers either keep better employee records than their public sector counterparts or, at the least, have greater opportunities for gathering this information. For analytical purposes, where workplace size data were missing information from the mother was used as a substitute.

13. The four size bands were as follows: 1-24 employees; 25-99 employees; 100-499 employees; 500 or more employees.

14. Figures from the Census of Employment were calculated from Table 5, Employees in Employment, *Employment Gazette*, October 1989, pp.545-53.

2 Women's economic activity before the birth

In this chapter we complete the framework needed for our analysis of the operation of maternity rights legislation by providing details both of the jobs the women in our survey had held during pregnancy and of their employers. First, however, we describe the employment status of all of the women in our survey before their recent baby's birth. Our particular interest was, of course, with mothers who had worked during pregnancy, and especially with those who had worked as *employees*. This was the case because only such women are directly affected by many aspects of maternity rights legislation. But we were interested also in obtaining some information about the employment backgrounds of all the women in our survey for two reasons. First, we wanted to measure the extent to which there had been changes in the economic activity levels of mothers in the period leading up to childbirth since the initial 1979 PSI survey, including changes in the proportion of women who stopped working in the expectation or with the intention of becoming pregnant. Secondly, we wished to examine changes in the types of jobs done by women as a result of their becoming mothers. The first of these issues is the focus of much of what follows in the present chapter; the second is discussed in Chapter 6.

Working status of all women 12 months before the birth

We began our inquiries about the women's working status by establishing if they had ever held paid employment in Britain before their baby's birth. All those who had done so were asked to give details about the last job they had held before the birth; women with more than one child were also asked for details about the last job they had held prior to the birth of their first baby. Women responding to these questions were subsequently asked whether they had been in work during the twelve months immediately before the birth, and those who had been were asked to provide additional information about their last job and, of course, their experience of maternity rights. Figure 2.1 presents the results of these inquiries by categorising the mothers in the survey according to employment status before their recent baby's birth.

Figure 2.1 Working status of all women before the birth of their recent baby

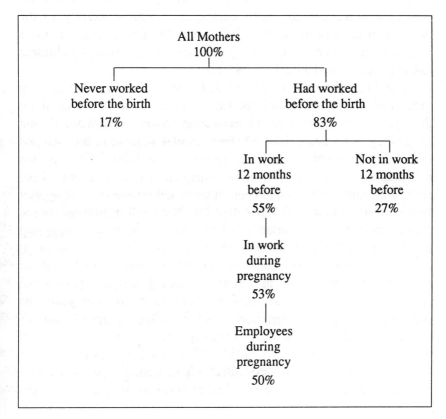

The first two groups shown in Figure 2.1 are mutually exclusive: 17 per cent of mothers had never held a paid job in Britain before the birth; 83 per cent of mothers had at some time been in paid employment. The proportion of women who had never worked is surprisingly high. Many of these mothers were quite young, reflecting the strong link uncovered in the 1980s between unemployment and early motherhood (Penhale, 1983). Although unemployment had fallen markedly by the late 1980s, there were still almost 400,000 16-25 year old women registered as unemployed in 1987 (*Employment Gazette*, June 1987:S25), some of whom appear to have responded to our survey. Further details of these women are given later in the chapter.

Figure 2.1 subsequently divides all mothers who had ever held paid jobs into two exclusive groups: mothers who were in work during the year before their baby's birth – just over half of the whole survey – and mothers whose last jobs had been more than one year before the birth. The proportion of mothers in our survey who had been in work one year preceding the birth corresponds almost exactly to the proportion in work in the 1979 PSI survey (54 per cent) and to GHS estimates of the economic activity of women with dependent children (54 per cent in work) (GHS, 1987:156).

The final divisions presented in Figure 2.1 distinguish the two groups of mothers who will be the focus of most of our attention throughout the remainder of the report: women in work during pregnancy, who comprised 53 per cent of the sample; and women *employees* during pregnancy, who made up exactly half. These results reflect those in the 1979 PSI survey fairly closely. At that time, 4 per cent of all mothers who had been in work left before or shortly after becoming pregnant, and 2 per cent had been self-employed. Some characteristics of the women who left work shortly before becoming pregnant are given later in the chapter.

Further details of women's working status twelve months before the birth are presented in Table 2.1 which also continues our comparison with 1979. As might be expected, in both years the presence of other children was the chief influence upon women's employment status before the birth of their recent baby. Seventy-eight per cent of women who had had their first child in 1988 had been in work twelve months before the birth compared with just over one third of women who had had their second or subsequent child. But if the

Table 2.1 **Working status of women 12 months before the birth according to number of children at the time: 1979 and 1988 compared**

Column percentages

		All	None	One	. Two	Three or more
				Number of children		
In work						
12 months	1988	55	78	37	34	25
before	1979	54	85	30	30	32
In work						
During	1988	53	74	35	32	23
pregnancy	1979	48	77	26	24	25
Not during	1988	3	3	2	2	1
pregnancy	1979	4	4	4	6	5
Full-time						
12 months	1988	39	67	13	8	10
before	1979	37	75	9	7	10
Part-time						
12 months	1988	16	10	23	25	15
before	1979	16	9	20	23	20
Employee						
12 months	1988	53	75	35	31	23
before	1979	52	82	28	28	28
Self-employed						
12 months	1988	3	3	2	3	2
	1979	2	2	1	2	2
Base:	1988	4,991	2,417	1,611	620	334
All women	1979	2,414	1,030	894	317	130

general *pattern* of participation remains the same over the two surveys, there have nevertheless been some changes.

We noted earlier that there was only the smallest variation in the proportions of each survey in work one year before the birth (55 per cent compared with 54 per cent). In 1988, however, proportionately *fewer* first-time mothers and proportionately *more* women with one or two children at the time of their new baby's birth, were in work than had been the case in 1979 (but fewer mothers with three or more children). The relative decrease in the proportion of first-time mothers

31

in work before the birth reflects the high incidence of joblessness among the youngest mothers of the survey, and creates a pattern that carries through the whole of Table 2.1. In comparison with 1979, the 1988 survey included fewer first-time mothers who had been in full-time employment, and fewer employees twelve months before. In contrast with 1979, there was an increase in 1988 in those engaged in both part-time work and *full-time* work among the mothers of one and two children prior to their new baby's birth (although not among mothers of three or more children).

But despite these differences from the 1979 survey, the general pattern of women's working status remained the same over the decade: the large majority of working women having their first child had held full-time jobs before the birth; the majority of women having second or subsequent children who were in work before the birth had held part-time jobs.

Mothers who had never worked before the birth
Over 800 (17 per cent) of the mothers who responded to our survey had never held a paid job in Britain before the birth of their recent baby. The particular focus of our research, on maternity rights legislation, tends to eliminate women without paid employment from our analyses. But it seemed important not to lose sight of the fact that one in six of our mothers had never worked – especially at a time when more and more women are entering the labour market. Therefore, we provide some details about the personal and economic circumstances of these women, and contrast their circumstances with those of the much larger group of women who had been in work during pregnancy.

Women who had never worked (in Britain) prior to their recent baby's birth were, on average, younger and less well qualified; they were more likely to have not yet married, but if married or living as married, were more likely to have an unemployed partner. Further, these women had more children than the other mothers; they were more likely to have been in receipt of one or more state benefits around the time of the birth; and they included a disproportionate number of women from minority ethnic groups, particularly Pakistani and Bangladeshi women. Table 2.2 summarises the differences between women who had never worked and women who had been in work during pregnancy.

Table 2.2 Some characteristics of women who had never worked prior to the birth compared with women who had been in work during pregnancy

Column percentages

	Never worked before the birth	In work during pregnancy
Married/living as married	66	90
- husband unemployed	28	3
Birth was first child	33	69
Ethnic minority group	17	4
No qualifications	55	16
Average age	25.4	27.9
- % under age 25	48	25
Received at least one state benefit*	62	37
Received more than one state benefit*	28	9
Base number	828	2,635

* includes Family Credit, Income Support, unemployment, payment from Social Fund.

It seemed reasonable to assume that differences might exist in the experiences of women who had never worked when ethnic background and age were taken into account. Accordingly, Table 2.3 summarises the reasons for being out of the labour market given by women who had never worked. The table categorises women according to ethnic group and distinguishes between women under the age of twenty-five. Separating women in this manner revealed findings of some interest.

For example, among all women who had not worked, childcare was the most common reason given for being out of the labour market. Nearly half (46 per cent) reported that they had not worked before their recent baby's birth because they had been caring for another child. But when age and ethnic group were taken into account, childcare became a less marked reason for not working among ethnic minority women under age 25 than was the case for white women of this age group. Indeed, personal preference and unemployment appeared to have been

Table 2.3 Women's reasons for never having been in paid work in Britain before the birth of their recent baby

Column percentages

	All white women	All minority ethnic women	White women aged under 25	Ethnic minority women aged under 25
Preferred not to work	7	13	6	15
Caring for children	48	42	34	20
Unemployed	9	13	13	15
On government training or work scheme	10	1	18	4
In full-time education	9	6	17	9
Disabled/ill	3	3	3	4
Caring for other dependant	1	2	1	–
No particular reason	7	7	7	11
Other reason	6	10	5	13
No information	6	7	3	9
Base: all women who had never worked*	686	142	340	54

* The columns are confined to the women whose characteristics correspond with the column headings.

as important as childcare for explaining why young ethnic minority mothers had never worked before their recent baby's birth.

More than twice as many young ethnic minority women as young white women had chosen not to work before the birth. For young white women, particularly on government work schemes, such as YTS, and in full-time education, these were equally important reasons for not working, and much more likely to explain their absence from the labour market before the birth than personal preference.

The large majority of mothers who had never worked before having their recent baby remained out of employment some 8 or nine months after that birth. Only 8 per cent had taken up jobs by the time of the survey. A further 17 per cent, however, reported that they had expected to be in work and were looking for jobs. Just over 12 per

cent hoped to find part-time jobs; the remainder were either looking for full-time work or had no preference.

Among the majority who remained out of work after the birth of their baby, a clear preference for women's traditional caring role was expressed. Almost two-thirds (62 per cent) of those who had not worked before or after the birth reported that the reason they had stayed out of employment was that they preferred to care for their children themselves. In contrast, just less than half (48 per cent) of their counterparts who had been in work during pregnancy gave this reason for having not yet returned to work after their baby's birth. Nonetheless, the majority of women who had not worked before the birth hoped to be in work at least by the time their youngest child reached school age. Almost one-quarter expressed uncertainty about their future employment plans, however, which no doubt reflected their inability to find work in the past.

Women who stopped working shortly before pregnancy
In both 1979 and 1988, the surveys of mothers revealed a number of women who had given up work at some point during the three months immediately prior to becoming pregnant. In 1979 these women represented 8 per cent of all women in employment during the twelve months prior to their baby's birth; in 1988, the proportion fell to 5 per cent.[1] In both surveys, the largest single reason given by women to explain why they stopped working was that they were preparing to have a baby. Illness, redundancy and voluntarily leaving were the other main reasons given.

Relevant to our research focus on maternity rights, an essential consequence of the decision taken by these women to stop working when they did was that they retained no possibility of qualifying for the right to return to their previous employers after childbirth or the right to receive statutory maternity pay after having left work to have a baby. This perspective is, of course, narrow in relation to all the considerations that will be in the minds of women as they prepare for motherhood. It is unlikely, therefore, that a concern with the loss of their maternity rights and benefits will have figured largely in these mothers' calculations. But by stopping work when they did, these women fall out of our sight: our analyses of women's experiences of maternity rights are based upon women known to have been in employment during pregnancy, as we have already noted. Before

leaving them altogether, however, it is worth exploring whether they differed in any way from women who remained in work while pregnant.

In the event, there were no, or only slight, differences between the two groups of women in terms of marital status, household composition, husband/partner's employment status, level of qualifications or ethnic group. Differences did arise in regard to age, number of children and employment status.

Women who left the labour market shortly before or immediately after becoming pregnant were substantially older than the women who remained in work while pregnant: 46 per cent of the first group were over thirty, compared with 34 per cent of the latter. Concomitantly, 41 per cent of women staying in work, but only 31 per cent of women who left, were aged between twenty-five and twenty-nine. About equal proportions were less than twenty-five.

Perhaps because they were older, more of the women who left work had had their second or subsequent child when surveyed (41 per cent) than those who stayed in work (31 per cent). Consequently, they had more children: over a quarter had two children; 15 per cent had three or more. In contrast, only a fifth of the mothers who remained in work had two children, and only 10 per cent had three or more.

Differences in age and number of children may provide a partial explanation as to why some women chose to leave work just before becoming pregnant while others chose to remain employed. But variations in employment status also existed between the two groups of women in their last jobs before the birth which may have had some bearing on their decisions. The majority of women who remained in employment had permanent, full-time jobs. In contrast, half the women who stopped working were employed part-time, and they tended to work more often on a temporary basis or were self-employed. The differences are summarised in Table 2.4.

It is not possible to know whether these women stopped working before or shortly after becoming pregnant because they were in part-time or temporary jobs, or if they were in these jobs because they were planning or hoping to become pregnant. It seems likely that in some cases the first will have been true and in others the second, though the timing of their departure from work may suggest that the second was more common.

Table 2.4 Differences in work status between women in work during pregnancy and women who left work shortly before/after becoming pregnant

Percentages

Status in last job before birth	In work during pregnancy	Left work
Full-time	71	52
Part-time	29	47
Permanent	90	73
Temporary	10	26
Employee	95	91
Self-employed	4	8
Base number*	2,635	133

* Base includes all women in work 12 months before the birth.

Women in work during pregnancy

We turn now to the group of women who will command the bulk of our attention henceforth: women who were in paid work during pregnancy. We examine the level of jobs these women held while pregnant, the type of employer for whom they worked and the industrial sector in which they worked. Each of these was an influential source of variation in women's experiences of maternity rights in the 1979 PSI survey, and proved to be so again.

Job level

At the beginning of Chapter 1 we outlined some of the major influences on women's employment opportunities during the 1980s. We highlighted the growth and decline of unemployment among women and the continuing steady demand for women's skills in the labour market, particularly on a part-time basis. There have been other influences on women's job opportunities. Over the 1980s, sex discrimination and equal pay legislation was amended and strengthened. Women increasingly acquired a greater share of professional and higher-level qualifications. The occupational structure continued its post-war evolution away from partly skilled

manual jobs and towards higher-level white-collar, professional and managerial jobs. Consequently, over the decade since the 1979 PSI survey, women have had opportunities to move into higher-level occupations in increasing numbers.

For example, a comparison of the 1981 Census 10 per cent Sample and the 1988 *Labour Force Survey* shows a growth of 5 percentage points in women's representation in professional occupations supporting management and a growth of 6 percentage points in managerial occupations, including general management. Other analyses suggest that the growth rate in the representation of women in professional and related occupations was double that of men over the 1980s and seems set to continue increasing (IER, 1988). Further evidence of these trends in women's opportunities can be given through a direct comparison with the 1979 PSI survey of women's job levels during pregnancy (see Table 2.5).

Table 2.5 Women's job levels: the two PSI surveys compared*

Column percentages

		1979	1988
I	Professional	1	3
II	Intermediate non-manual	21	29
IIIN	Junior non-manual	50	40
IIIM	Skilled manual	4	6
IV	Semi skilled	19	17
V	Unskilled	3	4
No information		1	1
		100	100
Base: all employees during pregnancy		1,100	2,514

* classified according to 1970 OPCS/Registrar General Social class classification.

For both surveys shown in the table, women's jobs have been classified according to the 1970 OPCS/Registrar General's six-point social class schema which was used in the 1979 PSI survey (see Appendix).[2] Thus, insofar as it is possible, we are comparing like with

like, and any changes in occupational distribution may be taken as indicative of real changes in women's opportunties over the decade.

The pattern evident in Table 2.5 is well-known: the largest single occupational grouping in both years was in junior non-manual jobs; the smallest groupings were in professional and skilled manual jobs. However, there has been a clear drift upwards in women's job levels since 1979. By 1988, the proportion of women employed in junior non-manual work had dropped by 10 per cent, while the proportion employed in intermediate jobs had increased from 21 per cent to 29 per cent, and in professional jobs from 1 to 3 per cent. There was also a slight increase in women's representation in skilled manual jobs and a similar decrease in semi- and unskilled manual work.

Table 2.6 provides an indication of how representative women in work during pregnancy, as shown in the 1988 survey, were of women in work generally through a comparison with the 1987 *Labour Force Survey* (LFS). We include this comparison in order to support our suggestion that real changes in the distribution of women in the occupational structure have occurred. If we are able to show that the jobs done during pregnancy in 1987 by the women in our survey

Table 2.6 Women's job levels during pregnancy: the PSI 1988 survey and the 1987 *Labour Force Survey* compared

Column percentages

Women's job level		All women in work during pregnancy	LFS 1987
I	Professional	3	1
II	Intermediate non-manual	28	23
IIIN	Routine non-manual	40	40
IIIM	Skilled manual	7	8
IV	Partly skilled	17	19
V	Unskilled	3	7
Not stated		1	–
		100	100
Base number		2,635	*

* The base for the LFS is all women aged 16 and over in employment. Labour Force Survey 1987, Table 5.13, page 23, HMSO, 1989.

tended to reflect the jobs done by women generally in 1987, then we can have more confidence that our comparison with the earlier PSI survey measures genuine increases in opportunities for women. And indeed, the closeness of the comparison as demonstrated by Table 2.6 gives us ample confidence that the jobs held by our mothers during pregnancy did not differ substantially from the jobs held by women generally. Both surveys in Table 2.6 have been classified according to the 1980 OPCS/Registrar General's six-point social class categories. The table shows slightly more women in the PSI survey holding professional and intermediate non-manual jobs and slightly fewer holding partly skilled and unskilled jobs, but this may in all likelihood be accounted for by the differing age distribution of the two surveys and, in particular, the differing representation of young women in work prior to their first baby. Consequently, the changes since 1979 in women's occupation distribution shown in Table 2.5 appear to be real changes, and to reflect an advancement in women's chances in the labour market.

Further details about the job levels of working women in the 1988 survey are given in Table 2.7 which contrasts part-time and full-time jobs and compares women's job levels with those of their husbands or partners.

Table 2.7 also introduces the Standard Occupational Classification (SOC) scheme that is used for our subsequent analyses of women's experiences of maternity rights. SOC was developed to replace both the 1980 version of the Classification of Occupations, used by the Office of Population Censuses and Surveys and others, and the Classification of Occupations and Directory of Occupational Titles (CODOT), used mainly by the Department of Employment. Occupations within SOC are classified with reference to the complexity of job tasks and the training and qualifications needed for the competent performance of these tasks. The Standard Occupational Classification is particularly appropriate for classifying women's occupations because account has been taken of the lack of differentiation in occupational categories, such as junior non-manual workers, in which women are predominant. New occupational categories for clerks, secretaries, nurses and teachers have been included in SOC, and a new group of 'childcare occupations' has been identified. Full details of the occupations included in the major groups that make up SOC are given in the Appendix.[3]

Table 2.7 **Job levels of working women during pregnancy compared with those of their husbands/partners**

Column percentages

	Total	Women Full-time	Part-time†	Men Total
Managers/administrators	7	9	3	16
Professional	10	10	9	13
Associate professionals and technical	13	13	13	9
Clerical/secretarial	31	35	20	8
Craft and related manual	4	5	3	23
Personal and protective services	11	8	17	4
Sales	9	8	14	4
Plant and machine operatives	6	7	5	12
Other occupations	7	4	15	7
Unemployed				3
Inactive				1
No information	—	—	—	3
	100	100	100	100
Base*	2,635	1,866	758	2,392

* all women in work during pregnancy.

† according to women's own definition of working hours.

At the time of writing, there were no national data available on the distribution of women's jobs which used SOC categories, thus we were unable to include comparative information in Table 2.7. But we know from our comparison with LFS data that the jobs done during pregnancy by the working women in our survey do not differ substantially from the jobs done by women generally. Therefore, we can accept that our categorisation of women's jobs using SOC categories provides an accurate reflection of women's location in the labour market. Certainly, Table 2.7 presents an essentially familiar picture: women in part-time work tended to have been in less skilled

jobs than their full-time counterparts, with manual and sales work accounting for over half of working women's part-time jobs during pregnancy but less than one third of their full-time jobs. Indeed very few women in sales or manual jobs had worked on a full-time basis during pregnancy – a difference of some relevance for their experience of maternity rights, as we explore more fully at a later stage.

We are able to compare our findings with the 1980 *Women and Employment Survey* (WES). There were few differences between our survey and WES in terms of the distribution of full-time or part-time clerical, sales or manual jobs. But there were differences in the proportion of intermediate non-manual occupations such as teacher, nurse, systems analyst and other similar jobs. The WES intermediate non-manual categories correspond to two SOC major groups, professional occupations and associate professional and technical occupations. In WES these jobs accounted for 24 per cent of women's full-time jobs and 12 per cent of their part-time jobs – figures which reflect a considerable waste of women's skills in the labour market. In contrast to WES, Table 2.7 shows little difference in the proportions of full-time women (23 per cent) and part-time women (22 per cent) who had been employed in professional or associate professional occupations. This suggests that there have been increased opportunities for women in these particular jobs to retain their occupational position over childbirth and family formation; we return to this issue in Chapter 6.

Table 2.7 also provides an indication of women's job levels relative to those of men through a comparison with the job levels of their husbands/partners. Men were much more likely to have had skilled manual or managerial jobs, and much less likely to have clerical/secretarial jobs or to work in sales or personal and protective service occupations. Table 2.8, however, confirms the strong tendency for like to marry like: over half of the women who had worked during pregnancy in jobs that fell into the OPCS/Registrar General's Social Class I or II were married to (or lived with) men whose jobs also fell into Classes I and II. Similarly, 60 per cent of women who had had manual jobs during pregnancy had manually-employed partners. Women in manual jobs were also considerably more likely than women in higher-level non-manual work to have an unemployed husband.

Table 2.8 Husband/partner's social class according to women's occupational level

Column percentages

Social class of husband/partner		All husband/ partner	Occupational level of women					
			I	II	IIIN	IIIM	IV	V
I	Professional	10	44	14	7	3	5	4
II	Intermediate NM	26	28	37	23	25	14	11
IIIN	Junior non-manual	12	8	13	15	6	8	11
IIIM	Skilled manual	30	15	22	33	38	39	41
IV	Semi-skilled	12	3	8	13	15	17	20
V	Unskilled	3	–	1	3	3	5	7
Unemployed		3	1	2	3	7	6	3
Econ. inactive		1	–	1	*	–	1	–
Not stated		3	3	2	3	3	5	5
Base number**		2,392	80	714	977	151	370	76

Notes: classified according to Registrar General 1980.

* less than 0.5 per cent.

** base includes all women in work during pregnancy who were married or living as married.

Job level proved to be one of the most important sources of variation in women's experiences of maternity rights. Therefore, before turning to the two other major sources of variation we examine in our subsequent analyses – type of employer and industrial sector – we provide one further table which distinguishes the women in our survey according to occupational level. Table 2.9 provides a breakdown of job level by ethnic group. In this instance, all respondents to our survey are included in the analysis rather than only women who had been in work prior to their recent baby's birth, in order to provide supplementary information about differences in economic activity before the birth between women of different ethnic backgrounds.

A number of interesting patterns emerge from Table 2.9. Most obvious are the contrasts in labour force participation between the different ethnic groups shown, and between all women from minority

Table 2.9 Women's job levels by ethnic group

Column percentages

	White	Black†	Indian	Pakistani	Bangla-deshi	Other
Managers/administrators	5	4	5	(1)	–	5
Professionals	7	1	1	(1)	–	3
Associate professionals	10	9	10	–	–	18
Clerical/secretarial	26	21	16	(2)	–	23
Craft and related manual	4	5	13	(3)	–	9
Personal and protective services	10	12	2	–	–	3
Sales	9	3	5	(1)	–	3
Plant and machine operatives	6	7	13	(3)	–	5
Other occupations	6	9	1	(1)	–	5
Not in work	15	29	31	(38)	(10)	27
No information	2	1	2	–	–	–
	100	100	100	100	100	100
Base: All women	4,600	76	83	50	10	64

() denotes actual number

† By the designation 'black' we mean to indicate women of Afro-carib and black
 African descent.

ethnic groups and white women. None of the ten Bangladeshi women,
and only twelve of the fifty Pakistani women who responded to our
survey had been in paid employment before the birth of their recent
baby. And although more women of Afro-carib/black African or
Indian origin had been in work during this time, their rate of
participation was still only about half that of white women. This means
that when we subsequently discuss women's experiences of maternity
rights we shall be referring to a relatiively small number of women
from minority ethnic groups.

Table 2.9 also shows marked differences in occupational level
between ethnic groups. Taken together, minority ethnic women were
noticeably under-represented in professional and sales occupations in

comparison with white women, while women of Indian origin were noticeably over-represented in craft and operative occupations. There appeared, however, to be little difference among the three main groups in terms of their participation in managerial/ administrative jobs.

We turn now to two other sources of variation that proved important in understanding women's experiences of maternity rights and, in doing so, complete our framework of background information about the women in our survey and their employers. Tables 2.10 and 2.11 provide detailed information about the type of employers for whom the mothers in our survey had worked during pregnancy, while Tables 2.12 and 2.13 examine industrial sector in relation to workplace size and job level. The final two tables in the chapter look at the extent to which women's employers offered help with childcare or other flexible working arrangements that might help the parents of small children.

Type of employer
Women's job levels are shown in Table 2.10 in relation to the type of employer for whom they had worked during pregnancy. The main theme of Table 2.10 is that women who had been employed in the public sector tended to have had white-collar jobs, while women who had worked in the private sector tended to have had sales or manual jobs. Our use of the Standard Occupational Classification (SOC) precludes our showing a direct comparison with the 1979 PSI survey in the table, but analyses carried out on the basis of the 1970 OPCS Classification of Occupations show that the *general* pattern in Table 2.10 has changed little over the decade. However, as we would expect from the information about occupational change provided in Table 2.6, there have been some changes within this overall pattern.

In the civil service, for example, there was a marked decline in the proportion of women who had been employed in routine non-manual jobs (from 80 per cent of all women in the civil service in 1979 to 53 per cent in 1988), and an increase in the proportion employed in intermediate non-manual jobs (from 13 per cent to 39 per cent). There was no change in the proportion employed in the civil service as professionals. There was a similar decline in the proportion of women who had been employed in junior non-manual jobs in private sector large and medium-sized workplaces (from 65 per cent to 53 per cent) and a concomitant increase in the proportion employed

Table 2.10 Women's job levels according to type of employer

Column percentages

Job level	Total	Public sector				Private sector			Other	Not stated
		Civil service	Local/ Education authority	Health authority	Nation- alised industry	Large/ medium business	Small firms	Nation- alised industry		
Managers/ administrators	7	33	1	1	2	9	6	8	7	6
Professionals	9	4	47	4	2	3	2	3	8	5
Associate prof.	13	4	8	64	2	4	3	8	10	11
Clerical/ secretarial	32	51	20	11	48	42	33	64	23	25
Craft and skilled manual	4	–	1	1	–	7	7	–	2	9
Personal and protective services	11	2	12	13	4	5	10	8	35	16
Sales	10	1	1	–	15	13	21	–	5	10
Plant and machine operatives	6	2	*	–	6	11	12	8	–	3
Other occupations	7	3	10	7	21	6	6	–	9	13
	100	100	100	100	100	100	100	100	100	100
Base: all employers during pregnancy	2,514	124	353	342	48	867	428	36	208	88

* less than 0.5 per cent

Women's economic activity before the birth

Table 2.11 Women's job levels according to public or private sector

Column percentages

Job level	Total	Public sector	Private sector	Not stated
Managers/administrators	7	6 \	8 \	6
Professionals	9	21 ⟩56	3 ⟩16	5
Associate professionals	13	29 /	5 /	11
Clerical/secretarial	32	22	37	25
Craft and related manual	4	1 \	6 \	9
Personal and protective services	11	10 \	10 \	16
Sales	10	1 ⟩21	14 ⟩46	10
Plant and machine operatives	6	1 /	10 /	3
Other occupations	7	8 /	6 /	13
Base: Employees during pregnancy	2,514	867	1559	88

in intermediate level jobs (from 5 per cent to 14 per cent). But overall, there remains a tendency for women's higher-level white-collar occupations to be concentrated in public sector employment and women's private sector employment to be predominantly in manual or in sales occupations. Indeed, 70 per cent of women who had had professional jobs during pregnancy, and 65 per cent of those who had had associate professional and technical jobs, had worked in the public sector (the former for education or local authorities, the latter for health authorities). Only among managers and administrators (a numerically small group) was there a preponderance of women who had been employed in the private sector, and even here over one-quarter had worked in the public sector (generally in the civil service). This pattern is brought out clearly in Table 2.11 which provides a collapsed version of Table 2.10.

47

Industrial sector
The contrast between the public and the private sectors proved to be one of the most powerful sources of variation in women's experiences of maternity rights. But within private employment, there was substantial diversity among different industial sectors. Table 2.12 initially gives details about the industrial distribution of women in work during pregnancy. It then indicates variations in industrial sector according to type of employer and workplace size.

Table 2.12 shows a familiar pattern. Women who had been employed in small workplaces typically worked for a small shop, hairdresser or cafe. Women who had been employed in manufacturing tended to have worked in comparatively large establishments. This is much the same pattern that characterised the 1979 PSI survey of women, although there were two variations. In the first instance, very small workplaces (under 10 employees) in the current survey were more evenly distributed across all industrial sectors than had been the case in 1979, although distribution, hotels and catering (29 per cent) and other services (38 per cent) predominated in 1988 as they had done

Table 2.12 Industrial sector according to type of employer and size of workplace

Column percentages

| | Total | Private sector | | | Public sector |
		Under 10	10-24	Over 100	
Manufacturing	17	12	19	40	1
Distribution	9	16	11	13	*
Hotels and catering	5	13	11	5	1
Banking/finance	13	13	30	16	3
Other services	47	38	23	16	90
Other industries	7	7	6	12	4
Base: Employees during pregnancy[a]	2,514	375	266	548	867

(a) The total column is all women who had worked as employees during pregnancy. The other columns are confined to women whose workplace characteristics compared with the column headings.

* less than 0.5 per cent.

earlier. Secondly, there was an increase in the proportion of small workplaces in manufacturing, from 6 per cent of all workplaces with fewer than 10 employees in 1979 to 12 per cent in 1988.

Finally, it will be noted in Table 2.12 that Standard Industrial Classification (SIC) 6 – distribution, hotels and catering – is broken into its two main component parts. There is some suggestion that women's employment experiences vary between wholesale and retail distribution on the one hand, and hotels and catering on the other. We have found limited evidence of this in relation to women's experiences of maternity rights, and tend, where appropriate, to present our findings in relation to SIC 6 by showing its two main parts separately. This approach is not taken with the survey of employers because the very small number (23) of employers in hotels and catering rendered disaggregated analyses inappropriate.

A final look at the industrial distribution of women's jobs, this time according to occupational level, is provided in Table 2.13 which

Table 2.13 Women's job levels according to industrial sector

Column percentages

	Total	Manu-facturing	Distrib-ution	Finance/Banking	Other services	Other inds.
Managers/administrators	9	8	17	10	6	10
Professionals	10	3	1	3	20	3
Associate professionals	13	3	2	6	26	5
Clerical/secretarial	35	29	21	75	24	55
Craft and skilled manual	5	17	4	*	2	4
Personal and protective services	8	2	12	*	14	5
Sales	8	8	26	3	3	7
Plant and machine operatives	7	25	6	*	1	6
Other occupations	4	6	10	–	2	4
	100	100	100	100	100	100
Base: Women in full-time work during pregnancy	1,866	360	261	289	802	147

* less than 0.5 per cent

reflects the pattern of variation in occupational levels revealed in relation to our earlier categorisation by type of employer. Table 2.13, however, covers only those women who had been in *full-time* employment during pregnancy.

We include Table 2.13 because of the joint importance of job level and sector of the economy in our analyses of maternity rights. With the additional information provided in Table 2.13 we are able to draw some 'broad brush' comparisons by sector and job level so that when we subsequently refer to differences between women by industrial sector it will be clear that we are also referring to specific groups of occupations. Thus, in terms of women's full-time employment during pregnancy, 'other services' which, as we first saw in Chapter 1, tends to equate with the public sector, may be characterised as largely encompassing women who had had non-manual jobs, with a significant proportion of women in higher-level and professional jobs. 'Finance and banking' refers almost exclusively to women who had had non-manual jobs, but largely at the clerical and secretarial level. 'Manufacturing' and 'Distribution, hotels and catering' tend to encompass women who had been employed in both non-manual and manual or sales jobs, but in both sectors the latter jobs form the majority.

Turning to full-time women workers during pregnancy reveals similar concentrations: over 70 per cent of women operatives and 65 per cent of women in craft and related manual jobs had been employed in manufacturing; over 80 per cent of professionals and associate professionals – and 70 per cent of women in personal and protective service jobs – had worked in other services; almost two out of every three women managers and administrators had worked in the private sector, and one in five in distribution, hotels and catering.

Employment arrangements to help women with children

We asked women who had worked during pregnancy whether their employers made available to people doing their kind of job any of a range of facilities that might help mothers with young children. Table 2.14 provides details of the facilities that we included, the proportions reporting that any of these had been available at their workplace and the variations among public and private sector employers.

The table shows virtually no overall change in access to flexible working arrangements since the 1979 PSI survey, except where a new

Table 2.14 Women's reports about workplace arrangements that might help mothers of young children

Column percentages

	1979	Total	Public sector					Private sector		
			Civil service	Local/ Education authority	Health authority	Nation- alised industry	All public sector	Small firms	Larger business	All private sector
Part-time	39	36	61	32	56	17	45	37	33	35
Job sharing	‡	6	36	18	6	-	15	1	2	2
Flexi-time	12	12	76	14	8	21	21	5	9	8
Career break scheme	‡	4	17	8	5	6	8	1	4	3
Chance to do some work at home	3	4	3	3	1	4	2	9	3	5
Shift work	11	9	3	2	19	2	9	5	12	10
Workplace or other help with childcare	3	4	8	8	8	2	7	3	2	2
None of these	35	36	14	36	28	50	31	46	45	43
Don't know	‡	7	1	6	6	4	5	8	9	9
Not stated	1	1	-	2	*	2	1	1	1	1
Base*:	1,100	2,514	124	353	342	48	867	428	1,131	1,559

‡ not included in 1979.

* All employees during pregnancy.

Note: Totals add to more than 100 because more than one answer was possible.

51

type of arrangement has been introduced, such as career break or retainer schemes. Job sharing, which is shown separately in 1988, may well have been included in women's reports about part-time working hours in the earlier survey. Otherwise, the table presents an almost static picture, with part-time arrangements remaining the most commonly reported facility for flexibility.

There is little in Table 2.14 which suggests that there has been a widespread growth of flexible workplaces over the decade – at least in terms of arrangements to help employees with young children. Two points may be made in relation to this. First, our survey relates to women's working conditions during 1987 and it is possible that there has been a subsequent increase in employers' provision of such facilities. Secondly, although the overall pattern of women's access to flexible arrangements is unchanged, within the public sector the situation for civil servants has undergone considerable alteration.

In 1979 women in the civil service had the least access to part-time working or workplace nurseries and had reported no opportunities for occasional working at home. Since the mid-1980s there have been efforts to improve women's position in the civil service, some results of which are shown in Table 2.14. For example, 61 per cent of women civil servants had access to part-time working hours in 1988 compared with only 19 per cent in 1979. Women civil servants were more than twice as likely as other women in the public sector to report having access to career break schemes, and overwhelmingly more likely to have flexi-time arrangements available.[4]

Moreover, although the proportion of women who reported help with childcare, including workplace nurseries/creches, increased only slightly over the decade, such help is now more generally available across the public sector as a whole rather than concentrated almost exclusively among health authorities, as was the situation in 1979. There was, however, only marginal improvement in the provision of childcare help among private sector employers.

Conditions have improved, then, for women in the public sector and in particular for women civil servants. But whether or not flexible workplaces have a part to play in encouraging more women with young children into the labour market, from Table 2.14 it appears that management, especially private sector management, have been slow to introduce such practices.

When, however, we looked at managers' accounts of the services that they provided, we found a substantially different picture from that indicated by the reports of women (see Table 2.15 compared with Table 2.14). In the private sector, for instance, there was consistency in the respective reports of the provision of childcare facilities but marked differences in reports of the availability of part-time working, job sharing, flexi-time and shift working. Tendencies for managers to overstate, if anything, the services they provide and for women employees to understate the services available to them are to be

Table 2.15 Arrangements made by employers which might help the parents of small children

Percentages

	Total	Public sector	Private sector Part of group	Independent	All private sector
Part-time	77	86	72	67	71
Job sharing	33	59	21	9	17
Flexi-time	46	72	31	29	30
Shift work	23	28	23	16	19
Career break scheme	15	26	11	2	8
Chance to work at home sometimes	6	5	6	9	7
Help with childcare	11	24	3	3	3
of which:					
Nursery/creche at workplace	8	9	1	3	2
Financial help	1	1	2	–	1
Help during school holidays	2	4	–	–	–
Keeps list of minders	*	1	1	–	*
Other	1	4	–	1	*
Base: All employers					
weighted	502	193	183	126	309
unweighted	502	188	189	124	314

* less than 0.5 per cent.

expected, but the differences between the respective reports in Tables 2.14 and 2.15 are much greater than is generally the case. The most plausible explanation is that the women may have answered our inquiries in terms of whether the arrangement or facility had been available to *them personally*, while the managers answered in terms of whether the arrangement or facility was available to *any* women employees. If that is part of the explanation then it suggests that there are wide differences in the availability of different types of arrangement for different categories of women *within the same workforce.*

In addition, it may well be that there is a substantial gap between the awareness of working women of the arrangements that are available to them, or might be available if they asked, and the arrangements that employers, in principle, provide or would be prepared to provide, if asked.

Notes

1. These proportions vary from those discussed in references to Figure 2.1 because the base here is all women in employment 12 months before the birth, while the base in Figure 2.1 is all women in the survey.

2. We were able to use several occupational classifications to analyse women's jobs in the 1988 survey through use of a computer programme designed by Dr Ken Prandy of Cambridge University, for which we are very grateful.

3. For more information about SOC see the *Employment Gazette*, April 1988 or *Population Trends*, Spring 1989.

4. See *Equal Opportunities in the Civil Service: Progress Report 1984-1987*, Cabinet Office, 1988 and *Career Breaks and Childcare Provisions in the Civil Service: A Review of Progress*, 1989, Cabinet Office, May 1989 for details of the measures taken by the civil service to increase the representation of women.

3 Maternity rights legislation in perspective

In Chapters 1 and 2 we created a framework for our subsequent analyses of the operation of maternity rights legislation. We built the framework by briefly reviewing changes in women's job opportunities over the 1980s and 1990s, by outlining our survey procedures and fieldwork results, and by showing how our ensuing samples of women and employers compared with other women and other employers in the labour market. We reported in some detail on women's economic activity during pregnancy. In addition, we took particular care to stress that our survey of employers was designed to over-represent employers of women of childbearing age; that is to say, employers who might be expected to be prone to any difficulties associated with the employment of women who may become pregnant.

The present chapter aims to put the legislation itself into some perspective by examining, first, the place maternity rights legislation has assumed amid the many issues which confront managers in the running of their establishments and the extent to which such legislation has given rise to problems for them. Secondly, it examines changes in women's employment conditions as a result of pregnancy, the extent to which women took time off work for antenatal care – one of their rights under the legislation – and the range of problems associated with being pregnant at work.

By undertaking these analyses as a preface to the chapters in which we present our main findings, we show that maternity rights legislation

was *not* a central concern for employers; complying with its provisions may occasionally have caused operational inconvenience, but seldom gave rise to major difficulties. We show also that, for the overwhelming majority of women, being pregnant at work gave rise to very few problems. The majority remained in the jobs they had before pregnancy until they stopped working. They generally took time away from their jobs for antenatal care. They had few difficulties over the time when they left work. In slightly differing ways, then, both women and their employers tended to accept pregnancy at work and its implications as part of the routine.

Employers' problems with maternity rights legislation

A recurrent problem in policy-oriented research is that the topic under investigation threatens to assume an exaggerated importance, not only from the perspective of the researcher, but also in the minds of the people being studied. In an attempt to avoid this problem and thus avoid the possible danger of overstating the salience for employers of maternity rights legislation, we first asked managers about the main general problem they currently faced in running their establishment. Respondents who did not mention staff or personnel issues in reply were subsequently asked whether they currently faced any particular staff problems. In this way, we hoped to identify the place maternity rights legislation occupied among the different concerns of employers at the beginning of the 1990s. Tables 3.1 and 3.2 summarise the issues confronting employers, and provide comparative information from 1980.

It is clear that difficulties in recruitment were by far the largest single problem in the minds of employers, over the decade and in both the public and private sectors. Over one third of employers spontaneously mentioned issues which focused on recruitment in some way. But if recruitment was a primary concern, it was not employers' only problem. In the public sector, for example, one in five respondents reported being troubled by under-funding and a general lack of resources. This was echoed in the private sector by 11 per cent of employers who reported lack of demand or funding problems – a slight decline from 1980 when 12 per cent had reported difficulties over lack of demand. Inflation, a major difficulty in 1980, had dropped out of private sector employers' concerns in 1989, as had labour disputes and problems flowing from high currency exchange rates.

Table 3.1 General problems faced in running establishment

Column percentages

	All	Public sector	Private sector	1980
Staff/personnel problems				
Recruiting skilled/ specialist staff	13	14	12	18
Recruiting generally	12	10	14	10
Staff turnover	10	13	8	6
Pay problems	5	8	2	6
Absenteeism	2	1	3	5
Other staff problems	4	5	2	6
General business problems				
Lack of resources/funding	9	20	3	+
Lack of demand	5	–	8	12
Demand fluctuations	3	1	5	4
Competition	3	2	4	4
Inflation	–	–	–	6
Exchange rate/strong pound	–	–	–	4
Interest rates	1	–	1	2
Labour disputes	*	1	–	1
Intro. of new technology	1	1	1	+
Other general business problems	4	1	5	+
Government policy problems				
Employment/labour legislation	1	1	*	1
Maternity rights legislation	*	1	–	*
Education policy changes	2	7	–	+
Privatisation/competitive tendering	2	4	–	+
Red tape generally	1	1	*	*
Other legislation-related problems	1	1	1	+
Other problems	7	7	7	7
No problems	25	16	20	20
Can't say	1	1	1	1
Base: All				
Weighted	502	193	309	715
Unweighted	502	188	314	302

* Less than 0.5 per cent.

+ response not recorded in 1980.

Table 3.2 Staff or personnel problems faced by respondents who did not mention staff issues in response to question on general problems

Column percentages

	All	Public sector	Private sector	1980
Recruiting specialist/skilled or good staff	11	12	10	12
Recruiting generally	5	4	5	5
Staff turnover	3	3	4	4
Turnover owing to pregnancy	1	2	1	1
Pay problems	3	5	1	4
Worker commitment	1	2	1	+
Absenteeism	1	1	1	2
Female absenteeism	–	–	–	*
Employment legislation	1	1	1	1
Maternity rights	–	–	–	*
Trade union problems	*	1	–	3
Other problems	3	4	3	9
No staff problems	25	13	33	26
Base: All				
Weighted	502	193	309	715
Unweighted	502	188	314	302

Note: The base for percentages is all workplaces although the question was asked only of respondents who did not mention staff issues in response to the initial question on general problems.

* less than 0.5 per cent.

+ response not recorded in 1980.

Recruitment problems are relevant to our study and are considered more fully in Chapter 6. Of immediate interest is the place occupied by maternity rights legislation among the whole range of problems experienced by our employers. Table 3.1 shows that it was clearly a minority concern: only 1 per cent of employers in the public sector and none in the private sector spontaneously mentioned maternity rights legislation when asked about the main general problems currently facing them. This does not mean that employers had had no problems with maternity rights legislation. Rather, the inference must be, as in 1980, that, among all of the matters with which managers are

Table 3.3 Extent and nature of employers' problems with maternity rights over the last few years

Column percentages

	All	Public sector	Private sector	1980
Some problems	13	19	9	18
No problems	85	78	89	82
Can't say	2	3	2	1
All answers	100	100	100	100
Nature of problems				
Keeping job open/				
finding replacements	4	4	3	9
Uncertainty about return	1	2	1	2
Failure to return	–	–	–	2
Nuisance taking back				
poor worker	*	1	–	1
Disputes/legal cases		–	*	1
Having responsibility				
for SMP payments	5	7	4	n/a
General maternity				
pay problems	1	2	1	1
Other answers	3	5	3	3
Base: All				
Weighted	502	193	309	712
Unweighted	502	188	314	302

* less than 0.5 per cent.

n/a this response was not applicable in 1980.

concerned in running their establishments, maternity rights legislation only rarely surfaces.

Moreover, a comparison of responses to direct questions in 1989 and 1980 about problems arising from the legislation shows that in the present survey many fewer employers reported that they had had any such problems over the previous few years (Table 3.3). Setting aside public sector employers, because they were not included in the 1980 systematic survey, only one half of the proportion of employers reported problems with maternity rights. Whereas about one in five private sector employers had had some problem related to maternity

rights in 1980 – when the legislation was only a few years old – only about one in ten reported having had problems in 1989. This might mean that because employers have become more familiar with maternity rights legislation, they now find its implementation more straightforward. But as much of the legislation itself has changed over these years, it is difficult to separate the impact of greater familiarity from the impact of changed legislation. It is likely that both of these have had a beneficial effect on the operation of maternity rights in the private sector.

Public sector employers, however, reported a substantially higher level of problems arising from maternity rights legislation in recent years. As already explained, public sector employers were not included in the systematic survey in 1980, although loosely structured discussions were held with people in 28 public sector organisations, generally at central or head office level. At that time, there did not appear to be any great difference between public and private sector employers in their experiences of maternity rights. This had clearly changed in 1989. It should be noted, however, that in 1989 we spoke directly to managers at the workplace level. By this method alone we were likely to have come across more problems arising from the legislation. Moreover, as we report in later chapters, public sector employers tend more than private sector ones to employ women who satisfy statutory requirements for maternity rights and who are more likely to take up their right to reinstatement. This too carries the possibility of increasing the incidence of problems.

The nature of problems experienced by employers in both the public and private sector also suggests that there may have been a differential impact between sectors of changes in legislation, particularly to do with Statutory Maternity Pay (Table 3.3). Seven per cent of public sector employers reported problems associated with the introduction of employer responsibility for the payment of Statutory Maternity Pay, compared with only 4 per cent of private sector employers. Most public sector employers already had maternity pay schemes in place in 1980, thus it is possible that they experienced more difficulties in changing their own schemes to comply with the system of statutory pay than did employers in the private sector.

Additional differences between sectors were found in regard to the right of women to return to work following childbirth. Public sector managers were more likely to report having had problems keeping jobs

open or finding temporary replacements for women on maternity absence, perhaps a reflection of their concerns mentioned earlier to do with under-funding and general lack of financial resources. Among private sector employers, the proportion reporting problems in this area fell sharply over the decade, from 9 per cent in 1980 to only 3 per cent in 1989.

Table 3.4 Proportions of workplaces reporting some problem over maternity rights

Row percentages

Workplace size	Some problem experienced	Base (a)	(b)
Public sector			
Under 25 employees	9	48	34
25-99 employees	18	54	49
100-499 employees	(9)	38	40
500 employees or more	25	53	65
All public sector	**19**	**193**	**188**
Private sector			
Part of group workplaces			
Under 25 employees	7	54	41
25-99 employees	4	40	46
100-499 employees	10	51	62
500 or more employees	(5)	38	40
All part of group workplaces	**9**	**183**	**189**
Private sector			
Independent workplaces			
Under 25 employees	8	63	48
25-99 employees	(5)	32	37
100-499 employees	(2)	21	26
500 or more employees	(1)	10	11
All independent workplaces	**10**	**126**	**124**
All workplaces	**13**	**502**	**502**

(a) Weighted.
(b) Unweighted.
() denotes actual number.

We explore further variations among employers in their experiences of maternity rights problems by taking into account the

size of the workplace and the enterprise of which it is a part (Table 3.4). In both the public and private sector, the proportion of employers who reported problems tended to increase with the size of the workplace. Since the introduction of maternity rights legislation, concern has often been expressed that it is the smaller employers who are likely to suffer the greatest hardships resulting from statutory obligations. We are able to contribute to the debate over that concern by analysing variations in the experience of maternity rights, first in relation to *workplace* size and secondly in relation to whether the workplace is an independent enterprise or part of a larger organisation.

Clearly, small firms or smaller employers, in the context of such an analysis, are independent workplaces employing relatively few people. As Table 3.4 shows, in practice small firms employing fewer than 25 people experienced problems to a similarly modest degree as both counterparts which were parts of a group of organisations and larger private sector workplaces. Moreover, in the smallest firms, independent establishments which employed fewer than 10 people, only 6 per cent reported any problems over maternity rights. In interpreting the pattern of findings in relation to workplace and firm size, it should be borne in mind that the small workplaces in our sample will have experienced a woman stopping work to have a baby much more recently than small firms generally. As noted in the Introduction, our sample design ensured that all our small firms had had a woman employee stop work to have a baby within the previous year to eighteen months whereas we estimate that, on average, a small firm with ten employees will have that experience about once every eight or nine years.

We began this section with an attempt to put in perspective the extent to which employers reported having had any problems with maternity rights. We pointed out, first, that our sample selection procedures predisposed us to surveying employers who could be assumed to be prone to problems in this area. Secondly, we noted that only 1 per cent of employers in the public sector, and none in the private sector, spontaneously mentioned maternity rights legislation among their current operational difficulties. We also pointed to recruitment as a significantly more problematic concern for employers than maternity rights. To complete the account of employers' problems with maternity rights, we asked all employers if they had had any disputes with an employee over any issue concerned with

maternity rights and if they had, whether the dispute had gone to either an Industrial Tribunal or a Social Security Appeal Tribunal. Overall, 7 per cent of employers reported having had a pregnancy-related dispute with an employee. Three per cent reported disputes related to the right to reinstatement. Two per cent reported disputes related to Statutory Maternity Pay. One per cent reported disputes about time off for antenatal care.

Table 3.5 summarises the incidence of disputes by type of employer and size of workplace. The analysis shows, first, that in the private sector the incidence of disputes was modest, secondly, that disputes were concentrated in the largest workplaces but, thirdly, once again, that they were more common in the public sector.

Table 3.5 Proportion of employers who reported any dispute with an employee in the previous two years over maternity rights

Column percentages

Size of workplace	Public sector	Private sector Part of group	Independent	All private sector
1-24	9	5	2	3
25- 99	6	–	–	–
100-499	(5)	3	(2)	5
500+	18	(6)	(1)	15
All	11	6	3	5
Base: All				
Weighted	193	183	126	309
Unweighted	188	189	124	314

Note: For numerical bases see Table 3.4 .

() denotes actual number.

Among private sector employers as a whole, 5 per cent reported having had a dispute with an employee over a maternity rights-related issue in the previous two years. This figure seems to suggest that there has been an increase in the level of disputes in private sector workplaces since the 1980 PSI survey when only 2 per cent of employers had had similar disputes. However, the questions asked by

the two surveys were sufficiently dissimilar to encourage caution in judging change. Specifically, the earlier survey referred to any disputes within the previous twelve months, while our present inquiries related to the previous two years. And although it is unlikely that cutting the 1989 result by half would yield a more accurate estimate of the extent of disputes, it is also possible that the calculation of 5 per cent slightly overstates the extent of employers' difficulties in any one year. In any event, it was only a small minority of employers in the private sector who had had such disputes.

Moreover, less than 1 per cent of employers (three cases in all) reported any dispute with an employee that had gone as far as a tribunal. Of these, none came from independent enterprises; one came from a private sector establishment that was part of a larger organisation and two from public sector employers. The level of tribunal cases in 1980 had been similar, with three employers out of a possible 302 having reported disputes that went to tribunal.

From our findings, then, it seems clear that, as was the case in the 1980 PSI survey of employers, problems with maternity rights exist for only a minority of employers, even when the employers under the spotlight are ones which might be expected to be most likely to experience any such difficulties. Moreover, where problems were found to exist, it was largely among employers in the public sector and especially in larger workplaces. These lines of questioning did not exhaust our enquiries among employers with respect to the operation of maternity rights legislation, however, and we return later on to problems associated with the legislation in our chapters on maternity pay and statutory reinstatement.

Job loss as a result of pregnancy

As explained earlier, one of the provisions of maternity rights legislation is protection against unfair dismissal because of pregnancy. Nevertheless, dismissal on grounds of pregnancy is known to continue. In 1987/88, for example, there were 97 applications to an Industrial Tribunal for unfair dismissal on grounds of pregnancy and refusals of the right to return after pregnancy (Central Offices of the Industrial Tribunals); in addition, the Equal Opportunities Commission received 102 enquiries about pregnancy dismissal during 1987, including 45 requests for legal support, and assisted in 31 cases of pregnancy-related dismissal. It is possible, of course, that these

figures provide only a partial picture and that many women do not take any action upon being dismissed, either because they are unaware of their rights or, if aware, do not know how to proceed, or because they prefer to look forward to the birth of their baby rather than backwards to an unpleasant incident.

We sought in our research to establish how far women generally continue to lose their jobs owing to pregnancy. Our conclusions are based on the answers of mothers to three questions; first, whether they stopped working or lost their jobs earlier than they expected and, secondly, if they had, why their employment had come to an end; and thirdly, whether they had made any complaint to an industrial tribunal about unfair dismissal. Analysis of answers to these questions in combination and patterns of variation in answers enabled us, in summary, to put together the following picture.

First, only seven women (less than 0.5 per cent) reported that they had brought a complaint of unfair dismissal owing to pregnancy to an industrial tribunal. Secondly, 1 per cent said that they had left their jobs before they intended because they were dismissed. The bulk of these had less than six months of service, and the large majority had less than the two years of service needed to qualify for protection from unfair dismissal owing to pregnancy. But, thirdly, substantially more women (7 per cent) stopped working before they had intended principally because of their working conditions or their own state of health. Moreover, the characteristics of such women were patterned in striking ways, as we now go on to demonstrate.

As Table 3.6 shows, there were marked differences between women of different occupational levels, with different lengths of service and with different numbers of children in the extent to which they stopped work before they had intended.

Women in higher-level non-manual jobs and women in clerical or secretarial jobs were substantially less likely than women in semi-skilled manual or sales jobs to have left their employment earlier than intended. There was, in fact, almost a direct relationship between lack of qualifications and skills and the likelihood of a mother's employment coming to a premature end through pregnancy.

Similarly, the time mothers had spent in their jobs before becoming pregnant was directly related to their chances of leaving that job earlier than they wished. Almost one-third of women with less than six months' continuous service in the job held during pregnancy left

Table 3.6 Proportion of women who lost their job/stopped working earlier than wanted because of their pregnancy, according to mother's characteristics

Row Percentages

		Base
By occupation		
Managers and administrators	3	170
Professional occupations	2	238
Associate professional occupations	2	335
Clerical and secretarial	4	798
Craft and skilled manual	6	107
Personal and protective service	15	266
Sales occupations	12	241
Plant and machine operatives	14	159
Other occupations	14	180
By length of service		
Under 6 months	29	139
6 months - less than 1 year	15	286
1 year - less than 2 years	6	424
2 years - less than 5 years	5	773
5 or more years	2	869
By birth order		
First baby	6	1,728
Second baby	6	528
Third or subsequent baby	13	254
All who lost their job/ stopped work earlier than wanted	7	2,514

Base: All women employees during pregnancy

work prematurely because of pregnancy, compared with 2 per cent of women with five or more years' continuous service. The close association between premature leaving and length of service necessarily meant that women who did not qualify for maternity rights were more likely to stop work early than women who did qualify. For instance, 13 per cent of mothers who failed to satisfy length of service requirements for maternity rights left work earlier than intended

because of pregnancy, while the same was true for only 3 per cent of women with service records of two or more years. But, generally, it appears unlikely that maternity rights had any direct influence upon the pattern. First, the association between length of service and premature leaving is continuous rather than revealing step changes at key threshold qualification service periods. Secondly, the principal step change takes place after women have completed one year of service, whereas the critical period for maternity rights is two years. Overall, it is likely that the association is that, for women of childbearing age, length of service tends to reflect levels of personal investment in a job on a whole range of dimensions, psychological and social as well as instrumental. Qualifying for statutory maternity rights is likely to represent only one part of such investment.

It was also the case that women who were pregnant with their third or subsequent child were almost twice as likely as other women to have left work earlier than intended. This is in part related to their shorter service records, compared especially to women having their first child, but it also reflects the greater likelihood that they were ill during pregnancy.

Table 3.7 summarises the main reasons given by women about why their employment came to an end, and continues to distinguish among the mothers by occupation and length of service in the job they held while pregnant and by birth order.[1] Once again, occupational level was one of the main sources of variation among mothers, with women in less skilled jobs more likely to have been dismissed or eased out of their jobs, more likely to have had working conditions that they felt were not suited to pregnancy (and less likely to be in jobs where alternative work was available), and more likely to have been ill during pregnancy. These differences are particularly marked among women in personal and protective service occupations, who were eight times as likely to have left their jobs because of their working conditions than were women in white-collar or skilled manual work; and among women plant and machine operatives who endured the highest level of illness during pregnancy.

The relationship between length of continuous service and dismissal because of pregnancy is brought out again in Table 3.7 which shows that women with less than six months service were particularly vulnerable to dismissal. They were six times more likely than those with longer service to have been dismissed or eased out of their jobs

Table 3.7 Reasons why job lost or work stopped earlier than wanted, according to mother's characteristics

Row percentages

	Dismissed	Working conditions	Illness	Base
By occupation				
Managers/administrators	1	1	1	170
Professionals	–	*	2	238
Associate professionals	1	1	1	335
Clerical and secretarial	1	1	2	798
Craft and skilled manual	1	2	2	107
Personal and protective service occupations	2	8	5	266
Sales occupations	2	5	6	241
Plant/machine operatives	3	4	9	159
Other occupations	2	7	6	180
By length of service				
Under 6 months	6	14	13	139
6 months - under 1 year	1	6	7	286
1 year - under 2 years	1	2	2	424
2 years - under 5 years	1	2	3	773
5 or more years	*	*	1	869
By birth order				
First baby	1	2	3	1,728
Second baby	1	3	3	528
Third or subsequent baby	1	6	7	254
All	1	3	3	2,514

Base: all women employees during pregnancy

* less than 0.5 per cent.

because of pregnancy. But what is slightly surprising about the pattern is that the step change comes at six months rather than at the two years when women qualify for protection from unfair dismissal under maternity rights. Women must have at least two years' (or five years' if employed for between eight and sixteen hours weekly) continuous service in order to qualify for protection from unfair dismissal on grounds of pregnancy. It may be that the pattern owes more to the

length of probationary periods within the domestic arrangements of employers than to maternity rights.

So far we have examined differences among women whose employment came to an early end according to their personal characteristics. If we examine the characteristics of their employers, we find further variation. Table 3.8 provides information about the proportions of women who stopped working earlier than intended because of their pregnancy according to sector, workplace size and industry.

Table 3.8 **Proportion of women who lost their job/stopped working earlier than wanted because of their pregnancy, according to workplace characteristics**

Row percentages

		Base
By sector		
Public sector	4	819
Private sector	8	1,351
Other	8	208
No information	14	88
By size of workplace		
Less than 10 employees	8	455
10 - 25 employees	9	410
100 or more employees	6	946
By industry		
Manufacturing	9	437
Distribution	10	234
Hotels & catering	15	144
Finance and banking	3	333
Other services	6	1,178
All who lost their job/ stopped work earlier than wanted	7	2,514

Base: All women employees during pregnancy

We have just shown that it was women in semi-skilled and unskilled manual or sales jobs, with short length of service records, who were the most likely to lose or leave their jobs prematurely. Thus, it should come as no surprise that women who left work prematurely

tended to have been employed in the private sector, especially in distribution, hotels and catering and manufacturing, and to have worked in smaller workplaces. Women in the hotel and catering industry were particularly likely to have left work early because of working conditions that were not suited to pregnancy. Table. 3.9 summarises the reasons given by women for the premature ending of their employment.

Table 3.9 Reasons why job lost or work stopped earlier than wanted, according to workplace characteristics

Row percentages

	Dismissed	Working conditions	Illness	Base
By sector				
Public sector	1	1	2	819
Private sector	2	3	4	1,351
Other	–	4	4	208
No information	–	4	8	88
By size of workplace				
Less than 10 employee	2	4	3	455
10 - 25 employees	1	4	4	410
100 or more employees	1	2	4	946
By industry				
Manufacturing	2	3	5	437
Distribution	2	3	6	234
Hotels & catering	1	10	4	144
Finance and banking	1	1	1	333
Other services	1	2	3	1,178
All	1	3	3	2,514

Base: All women employees during pregnancy

Overall, then, 7 per cent of women employees who remained in their jobs after becoming pregnant lost those jobs earlier than they had intended: 1 per cent because they were dismissed or otherwise eased out of their jobs; 3 per cent because of working conditions thought not to be suitable while pregnant; and 3 per cent because of

pregnancy-related illness. We cannot judge the extent to which these results represent any change over the past decade in women's employment conditions during pregnancy as the comparable set of questions were not asked in 1979. What we can say with some certainty, however, is that which mothers came to lose their jobs prematurely, for whatever reason, did not depend upon chance. Rather, women in less skilled jobs or with short service records, and women in the private sector, especially in distribution, hotels and catering, were much more likely than other women to be dismissed, to have worked in inappropriate conditions, to have been ill. And as a result, such women were more likely than others to find themselves without jobs before they had wished.

The need for alternative work
When women become pregnant it may not be practicable for them to continue to do some of the jobs that they generally fill without difficulty. Maternity rights legislation makes no provision for the arrangement of alternative work, but because we were generally interested in women's working conditions during pregnancy, we asked respondents if their jobs had changed in any way as a result of their pregnancies. If we exclude from our analyses women who had lost their jobs earlier than intended, then 85 per cent of women in work during pregnancy experienced no change at all in their jobs. The most common change among those experiencing change was a move to cleaner or lighter work, especially among women who had been employed in manual or sales jobs, accounting in most instances for over three-quarters of job changes among such women, and among those who had worked in manufacturing or wholesale and retail distribution. In all, 10 per cent moved to lighter or cleaner work. In addition, 3 per cent worked shorter hours – often for reduced wages – and 1 per cent gave up working on Visual Display Units (VDUs).

Arranging alternative work: employers' problems
Among the women who had left their jobs prematurely because of working conditions that they felt were not suitable for pregnant women, there were a small number who spontaneously indicated that alternative work was not available. We did not ask mothers if they had requested alternative work, seeking instead information about job changes as a result of pregnancy. Our enquiries among employers

confronted the issue of alternative work directly, however, and revealed that one-third had arranged alternative work for a pregnant employee, either recently or at some time in the past. Table 3.10 summarises the proportion of employers in the public and private sector who had ever arranged alternative work, distinguishing by size of workplace and, in the private sector, by whether workplaces were independent organisations or part of a larger organisation.

Table 3.10 Proportion of employers who had ever arranged alternative work for a pregnant employee

Percentages

Size of workplace	Public sector	Private sector Part of group	Independent	All private sector
1-24	29	10	15	12
25-99	22	20	16	19
100-499	(19)	34	(4)	30
500+	65	(18)	(6)	52
All	41	26	19	24
Base: All				
Weighted	193	183	126	309
Unweighted	188	189	124	314

Note: For numerical bases see Table 3.4 .

() denotes actual number.

Employers in the public sector were substantially more likely to have arranged alternative work for a pregnant employee either recently or in the past, whatever the size of the workplace concerned. Forty-one per cent had done so compared with 24 per cent of private sector employers. Size of workplace was an independent consideration, however, and employers in larger establishments were more likely to have arranged alternative work than those in smaller establishments, regardless of sector or, within the private sector, whether the workplace was an independent enterprise.

A much smaller proportion of employers (8 per cent) reported having been caused problems in arranging alternative work. Again, it

was employers in the public sector who were more likely to have experienced some problems concerned with pregnancy. Overall, 13 per cent of public sector employers had had some problem related to arranging alternative work for a pregnant employee, compared with only 4 per cent of private sector employers. Size of workplace again had an independent effect, with employers in larger workplaces more likely to have had some problem. As these employers were also more likely to have been called upon to arrange alternative work, it is not particularly surprising that they should have experienced more difficulties.

Of further interest were differences within the private sector. Employers in private sector workplaces that were part of a larger organisation were more likely than independent private sector enterprises to have been asked to arrange alternative work but less likely to have experienced any problem in doing so. In all, more than twice as many independent establishments (6 per cent) than workplaces that were part of a group (3 per cent) reported problems, with the largest independent establishment considerably more likely to do so (20 per cent). The differences may well be accounted for by increased opportunities for employers within a group of establishments to draw upon the organisation as a whole for replacement personnel for the original job.

In total, however, only 38 employers reported having experienced any difficulties in arranging alternative work either recently or in the past. Partly for this reason, analyses based on other possible sources of variation among employers, such as industrial sector, tended to reveal little of interest. The contrast between the public and the private sectors overshadowed all other sources of variation. Similarly, looking at the nature of the problems faced by employers across our usual sources of variation among employers also revealed few differences of interest. Accordingly, we provide only a single snap-shot view of the types of problems encountered by employers in arranging alternative work.

The most common problem was that no alternative work was available. Six per cent of employers reported that they were unable readily to provide alternative work. Public sector workplaces and independent private sector enterprises were the most likely to encounter difficulties in this way. Problems also arose in relation to other staff members because of increased workloads and work

rescheduling (1 per cent) and in relation to finding replacement personnel for the original job (1 per cent).

We also asked employers which level of job, if any, caused them particular problems when it came to arranging alternative work. No employer mentioned jobs in middle or senior management or at a senior professional level. The most problematic jobs as far as employers were concerned were supervisory or junior technical/professional jobs (3 per cent), followed by clerical and sales-related jobs (1 per cent each). Secretarial jobs were mentioned as causing particular problems by only two employers.

In summary, then, although a third of employers had been called upon, either recently or in the past, to arrange alternative work for a pregnant employee, only a small proportion reported that this had caused them any difficulty. Public sector employers were both more likely to have been asked to arrange alternative work and to have experienced some problem in doing so. The existence of problems was also associated with workplace size, with larger workplaces – especially among independent enterprises – more likely than smaller ones to have had some problem. Among workplaces that did experience difficulties, the problem lay in the lack of suitable alternative work, in particular for women employed in supervisory or junior technical and professional work.

Time off work for antenatal care

Since implementation of the Employment Act 1980, employed pregnant women have had the right 'not to be unreasonably refused time off work to receive antenatal care' and to be paid for their time away from work for this reason. The 1980 PSI survey of employers showed a high demand among employees for the provision of this right (the issue was not investigated in the survey of women): 40 per cent reported that they had had requests from women for time off work for visits to antenatal clinics. Just over half (55 per cent) of the employers surveyed in 1980 said that women employees were permitted time off work for this reason, although in only 10 per cent of workplaces was their entitlement embodied in a formal agreement or contractual arrangement. In about one fifth of workplaces women were not able to take time away from work. Women who had been employed as semi-skilled workers in manufacturing were particularly likely to have been denied time off.

Table 3.11 summarises the impact upon women of the statutory right to time off work for antenatal care. Well over 80 per cent of women who had been in work on a full-time basis took time away from work; 9 per cent of full-time workers had arranged their appointments for times outside normal working hours, while 6 per cent were no longer working when the time came to attend antenatal clinics. Women who had been in work on a part-time basis were much less likely to have taken up their entitlement to time off, however. Fewer than one in three part-time workers took time off work for antenatal care, generally because their appointments were made for times outside normal working hours.

Table 3.11 Extent to which women took time off work for antenatal care according to industrial sector and whether employed full-time or part-time

			Percentages
	Total	Employed full-time	Employed part-time
Took time off work	**68**	**84**	**30**
Employed in:			
Manufacturing	76	86	34
Distribution	66	84	22
Hotels & catering	42	56	25
Banking & finance	82	92	28
Other services	63	82	28
Other industries	80	89	41
Did not take time off work	**32**	**16**	**71**
Because:			
Appointments made outside working hours	22	9	57
Had stopped working	6	6	8
Other reasons	3	2	5
Not stated	1	*	1
Base: Women employees during pregnancy	2,514	1,703	711

As regards variation by industrial sector, Table 3.11 shows that, for full-time workers at least, women who had been employed in the manufacturing sectors seemed to have overcome the difficulties associated with taking time off work for antenatal care that were revealed by the 1980 PSI survey of employers; part-time workers in manufacturing, however, remained substantially less likely than most other women to have arranged time away from work. But it was women who had been employed full-time in the hotel and catering trades who were the least likely to have taken time off work for antenatal care. Barely half of these women took time off compared with over 80 per cent of all other women who had worked full-time.

Table 3.12 summarises the extent to which women were paid for the time they took off work for antenatal care, again distinguishing between women by occupational sector and whether they had worked full-time or part-time. It is apparent that few full-time workers failed to receive their normal wages for the time that they were away from work, although 9 per cent of women in manufacturing and 7 per cent of those in distribution were not paid for this time. There was no difference in levels of payment or non-payment among full-time workers in the two component parts of distribution identified previously. Many fewer part-time workers had been paid for their time off work, however. In most instances the base numbers in Table 3.12 are too small for percentage distributions to be used – reflecting the small number of women employed part-time who had taken time off work for antenatal care. The actual numbers shown nonetheless indicate that women who had been employed in distribution and in manufacturing remained less likely to have been paid for their time away from work. Indeed, it was only in other services (and our residual category 'other industries') that the number of part-time workers being paid for time off for antenatal care approached the level reached among women employed full-time. This is likely, of course, to reflect the substantial number of public sector employees included in these industrial sectors.

It is possible that some of the women whose appointments were made for outside normal working hours were denied their statutory right to time off work, either because they were unaware that such a right existed or because their employers insisted that appointments were arranged in the women's own time. But it is possible also that many women were content with the timing of their appointments. Our

Table 3.12 **Extent to which women were paid for the time taken off work for antenatal care according to whether employed full-time or part-time**

Percentages

	Paid Normal wages	Holiday pay	Not paid	Other/ not stated	Base
Manufacturing					
Full-time	88	1	9	2	301
Part-time	(19)	–	(8)	(2)	29
Distribution					
Full-time	89	1	7	1	182
Part-time	(16)	(1)	(9)	(5)	32
Finance and Banking					
Full-time	94	2	3	*	259
Part-time	(11)	–	(2)	(1)	14
Other services					
Full-time	95	2	3	*	628
Part-time	80	1	13	8	112
Other industries					
Full-time	95	3	2	–	128
Part-time	(10)	–	(3)	(1)	14
All women					
Full-time	93	1	4	*	1498
Part-time	74T1	18	25	201	

Base: Women who took time off for antenatal care

() denotes actual number.

survey design unfortunately does not allow us to investigate this issue. Thus we are unable to determine the full extent to which women wanted, but were denied, the opportunity to take time off work for antenatal care, although some measure of this is given below. We were able, however, to examine the extent to which women who did take time off work for antenatal care experienced difficulties in obtaining this time off.

Tables 3.13 and 3.14 summarise several sources of variation among women who, in taking time off work for antenatal care, encountered some difficulty obtaining this time off. Overall, 4 per cent

**Table 3.13 Proportion of women reporting problems in obtaining time off
work for antenatal care, by occupation and length of service**

Row percentages

			Base
By occupation			
Managers and administrators	3		147
Professional occupations	1	2	168
Associate professional occupations	6		216
Clerical and secretarial	3		649
Craft and skilled manual	7		84
Personal and protective service	10		114
Sales occupations	5	6	137
Plant and machine operatives	4		108
Other occupations	6		68
By length of service in job			
Under 6 months	–		50
6 months - under 1 year	6		153
1 year - under 2 years	9		257
2 years - under 5 years	5		521
5 or more years	3		709
All reporting problems	4		1,705

Base: All women employees taking time off work for antenatal care

of women employees taking time away from work for antenatal care
fell into this category. As with many of our analyses which focus on
problems arising from maternity rights legislation, the proportion
encountering difficulties represented only a small proportion of the
women in the survey, and in this case included 75 women.

Occupational level was one of the chief sources of variation among
women who encountered problems taking time off work for antenatal
care. If we view women as comprising two broad groups – manual
workers and non-manual workers - then it becomes plain that manually
employed women were generally more likely than women in
non-manual jobs to have had problems getting time off, although plant
and machine operatives seem to be an exception. Within each of these
two broad groups, women employed in personal or protective service

Table 3.14 Proportion of women who reported problems in obtaining time off work for antenatal care, by industry and workplace size

Row percentages

		Base
By industry		
Manufacturing	4	330
Distribution	6	154
Hotels & catering	8	60
Finance and banking	3	273
Other services	4	741
By size of workplace		
5 or fewer employees	6	151
6-9 employees	8	120
10-24 employees	3	253
100-499 employees	2	373
500 or more employees	6	329
All reporting problems	4	1,705

Base: All women employees taking time off work for antenatal care

occupations (manual) and as associate professionals (non-manual) were particularly likely to have had problems. In each case this reflected the preponderance of health service workers among these two occupational categories.

Women employed by the health authorities were more likely to have experienced difficulties in obtaining time off for antenatal care than women employed elsewhere in the public sector or in the private sector. Nine per cent reported problems compared with 5 per cent for the public sector overall, and 5 per cent of women in the private sector. This may seem incongruous, given the common purpose of antenatal care and the health service. The sense of incongruity is likely to increase when it is noted that the most common problem encountered by women was hostility from co-workers and employers towards their absences for antenatal care. Hostility, which ranged from unco-operative attitudes to pressure being brought for appointments to be cancelled, was reported by just over 40 per cent of the women who had had some problem getting time off. The next most common

problem, being required to take one's appointments outside working hours, was reported by only 10 per cent.

Women who had been in their jobs for less than two years also tended to have more problems arranging time off work than did other women. In total, 7 per cent of the women with continuous service of less than two years reported problems, compared with only 3 per cent of the women with longer service records. It should be remembered that *all* pregnant women have the right not to be unreasonably refused time off work for antenatal care, not just those women who satisfy the statutory requirements for maternity pay or the right to return to work. That it was the women who just missed qualifying for reinstatement who were the most likely to have had problems in arranging time off work (women with continuous service of more than one but less than two years) suggests that there may be some confusion over entitlement to time off for antenatal care. But it is also striking that women who failed to qualify for any other maternity right or benefit – those with less than six months continuous employment with the same employer – were also the least likely to have had any problems arranging time off work.

Analyses of the characteristics of women's employers revealed variation by industrial sector and by size of workplace (Table 3.14). Women who had been employed in distribution, hotels and catering during pregnancy were almost twice as likely as other women to have encountered some problem getting time off for antenatal care. As we have also shown that women employed in this sector were substantially less likely than other women to have taken time away from work for antenatal care, it is perhaps not surprising that among those women who did take time off, an above average proportion encountered problems.

The final source of variation identified among women who had experienced some difficulty taking time off work for antenatal care was size of workplace. Women in the smallest workplaces (less than 10 employees) and in the largest (over 500 employees) had more problems than other women, whether they were employed in the public or the private sector. It is hardly surprising that women in the smallest workplaces had difficulties, but the difficulties experienced by women in large workplaces are more surprising. The most common problem cited by women employed in the largest establishments was hostility to time being taken off, but this was the case in most

workplaces and does not explain the level of problems encountered among women in the largest establishments.

Overall, then, arrangements for time off work for antenatal care appear to be working relatively well. Over 80 per cent of women in full-time employment during pregnancy took advantage of their statutory entitlement. Most part-time workers and a small proportion of women in work full-time arranged their appointments so that they fell into their non-working hours, however; and a small proportion, especially manual workers and women employed in the health service, experienced some difficulty in arranging their time off. The most common problem encountered among women who did take time off was hostility from either co-workers or employers, but when expressed as a proportion of all women taking time off for antenatal care, women who experienced such hostility accounted for only 2 per cent. Finally, it is likely that some women were denied their right to time off but only 8 women explicitly reported this to be the case and they represented less than 1 per cent of all women taking time off work for antenatal care.

Difficulties over the time at which women stopped working
The time at which women stop work for childbirth has implications not only for maternity rights but also for women's mental and physical health and well-being as they prepare for motherhood. We discuss the relationship between the time women stopped work and qualification for maternity pay or the right to return to work in the following two chapters. Here our emphasis is upon women's reasons for stopping work when they did, and whether they had had any problems with their employers over the time when they stopped. As in 1979, two main reasons dominated the timing of women's withdrawal from active employment: qualification for Statutory Maternity Pay or reinstatement; and their own or their baby's health or physical condition.

Table 3.15 summarises the reasons women gave for stopping work according to the week when they stopped. The impact of statutory regulations on women's behaviour is striking. Qualification for maternity pay or the right to reinstatement dominated the reasons given for stopping work by women who stopped at the two critical weeks in maternity rights legislation. Forty-nine per cent of women who stopped work six weeks before the birth – the latest time women

may work and not forfeit any Statutory Maternity Pay (SMP) – said that they had stopped working when they did in order to comply with statutory regulations. Fifty-six per cent of women who stopped work eleven weeks before the birth – the earliest week women may begin their SMP payments and the earliest they may stop work and maintain their right to return – said that they had stopped work for these reasons.

Table 3.15 Reasons for stopping work according to time of stopping

Column percentages

	Total	0-5	6	7-10	11	12	13-15	16+
				Number of weeks before the birth				
To qualify for maternity rights	28	13	49	27	56	22	23	4
Normal time to go	6	5	6	6	11	11	9	2
Financial reasons	1	3	4	4	–	*	–	–
Illness	15	8	4	12	6	15	24	36
Tired/strain	22	22	18	31	12	22	17	19
Job ended	6	6	1	3	*	5	9	16
Did not want to work longer	8	14	7	8	4	10	7	9
Baby came early	1	6	1	*	–	–	–	–
Kept working	1	4	–	–	–	–	–	–
Other reasons	6	9	4	4	1	4	5	11
Not stated	8	8	4	9	9	10	7	5
Base: Employees during pregnancy	2,514	373	293	629	401	237	123	458

We discuss later the analytical difficulties associated with the timing of women's decisions to stop work in relation to the *actual* week of birth, the information we sought from mothers, and to the *expected* week of birth, the critical week as regards qualification for benefits and rights under employment legislation. Here we would wish only to note the rather striking contrasts in women's reasons for the timing of their withdrawal from active employment.

We also asked women if they had experienced any difficulties with their employers about the time when they wanted to stop working. Overall, 4 per cent of the mothers reported that they had had some problem, commonly as a result of being required to work longer than they wished in order to comply with the statutory requirements for maternity pay or reinstatement. This reason was given by only 1 per cent of women employees, although it was the only response that was offered by as many as 1 per cent. Other reported difficulties included wanting to work longer but not being allowed to do so by her employer (8 women); unhelpful or hostile attitudes on her employer's part (11 women); proof of fitness to continue working being required by her employer (5 women); and mistakes made by the employer in calculating her leaving date (7 women). It should noted that many other difficulties were reported by the mothers: almost as many different problems, in fact, as women who experienced them.

Amidst this considerable variation in the sorts of problems that arose over the time at which women stopped working, there was very little variation in the characteristics of those who had experienced problems. Women who had been employed as managers and administrators were the most likely to have had some difficulty (6 per cent), but overall there was no distinct pattern as between manually or non-manually employed women. Variations in terms of birth order, length of service, industrial sector, size of workplace, public or private sector, or occupation within the public sector revealed differences of a similar order. There were differences of only one or two percentage points between particular groups of women and no particular pattern in the variations.

Self-employed women
The position of self-employed women who remain in work during pregnancy differs markedly from that of women employees. If self-employed women wish to take time off work for antenatal care, they do so at their own expense; if their working conditions are not suited to pregnancy, their only alternative is likely to be to stop working. Self-employed women are entitled to Maternity Allowance if they fulfil the statutory requirements, but they have no statutory right to return to work and must create their own employment opportunities after having a baby.

Nonetheless, it is of some interest to examine whether the self-employed mothers in our sample had experienced any problems similar to the ones discussed above. In all, 125 of the women surveyed were self-employed before the birth of their recent baby; all ran small establishments, generally in the service sector. Just over half of self-employed women took time off work for antenatal care, compared with two-thirds of women employees. Ten per cent had already stopped working before they felt it necessary to attend antenatal clinics, and the remainder made their appointments for non-working hours.

Six of the self-employed women (5 per cent) left work earlier than originally intended: two because of their working conditions, four because of illness. Forty-three per cent had received Maternity Allowance upon leaving work; 12 per cent, however, had encountered some problem associated with maternity pay. Of these, half reported that they were ineligible because they had made insufficient National Insurance contributions and half reported that they had experienced delays in payment from the DSS. There were too few self-employed women in any of these categories of difficulty to undertake further analyses by occupation, industrial sector or birth order.

Notes

1. In addition to the reasons shown in Table 3.7, 16 women reported that they left work earlier than intended because their job contracts had come to an end.

4 Maternity pay

Maternity rights legislation entitles women in employment who meet specific qualifying conditions to receive up to eighteen weeks maternity pay after stopping work for childbirth. According to her qualifications for this right, a woman will be paid either by her employer (Statutory Maternity Pay) or by the Department of Social Security (Maternity Allowance). Employers may also choose to make maternity payments in addition to the statutory minimum, or they may make payments to women who do not fulfil the statutory requirements. Our findings suggest that 80 per cent of women in work during pregnancy received some type of maternity pay upon leaving work for childbirth, generally as a result of fulfilling the requirements for Statutory Maternity Pay (SMP).

Our analyses in relation to maternity pay had two major objectives. The first was to establish the extent to which women of differing occupational levels and with different types of employers received maternity payments. It appeared from the 1979 PSI survey that a substantial minority of women in the small firm sector were failing to receive their entitlement to maternity pay. Accordingly, we wished to determine whether this remained the situation in 1988. Our second major objective was to examine employers' experiences of Statutory Maternity Pay and the extent to which they provided additional payments under contractual agreements. Maternity pay was initially introduced in the 1960s in the public sector in response to severe staff shortages in the public services, particularly in education and health.

It subsequently became available through the provisions of employment protection legislation to all employed women who meet specific qualifying conditions. Two questions that arise in relation to employers' experiences of maternity pay are: how far there has been an increase in maternity payments in addition to the statutory minimum; and to what extent the provision of additional maternity pay is related to perceived staff shortages and the retention of women employees after childbirth. We address the first of these questions in this chapter. The second is addressed in Chapter 6.

Types of maternity pay
Our surveys investigated three types of maternity pay: Statutory Maternity Pay (SMP), Maternity Allowance (MA) and maternity pay received under a contract of employment or Contractual Maternity Pay (CMP).

Statutory Maternity Pay
Statutory Maternity Pay (SMP) is paid to eligible women employees and was introduced in April 1987 for all women whose babies were due on or after 21 June 1987. Women must have worked for the same employer continuously for six months into the 15th week before the baby is due in order to qualify for the basic-rate SMP payment; or for two years and at least sixteen hours weekly (or five years if employed for between eight and sixteen hours), also continuing into the 15th week before the baby is due, in order to qualify for the higher rate of payment. Overall weekly earnings in either case must be sufficient to attract National Insurance contributions. In 1987-8, the basic rate of SMP was £32.85 a week, while the higher-rate payment was based upon 90 per cent of the woman's usual weekly earnings.

Sixty-nine per cent of our sample of women employees reported that they had received basic-rate SMP, while 42 per cent reported that they had received higher-rate SMP.

Maternity Allowance
Maternity Allowance is paid by the DSS to self-employed women in work during pregnancy and to women employees with at least six months employment during the twelve months prior to the fourteenth week before the baby is due. Full-rate National Insurance contributions must have been paid in order for a woman to qualify for

Maternity Allowance. In 1987-8, the rate for Maternity Allowance was £30.05 a week. As with SMP, women may receive up to eighteen weeks' Maternity Allowance.

Fourteen per cent of women in work during pregnancy received Maternity Allowance.

Contractual maternity pay
Contractual Maternity Pay (CMP) is paid to women employees on the basis of qualifying conditions established by their employers. Our analyses suggest that the large majority of employers used CMP to 'top up' statutory maternity payments. The large majority also attached return-to-work conditions to the receipt of CMP. Failure to return would be likely to lead to the non-payment or repayment of contractual maternity pay.

We estimate from our survey of women that 14 per cent of women received contractual maternity pay.

Problems associated with maternity pay
We preface our detailed analyses of maternity pay with a general overview of some of the problems associated with such payments. Our comments in this section are based upon open-ended questions to both managers and women in work during pregnancy. As such they do not exhaust our analyses in relation to difficulties associated with maternity pay; further problems are explored as they arise in relation to specific issues relating to maternity pay.

Employers' problems with Statutory Maternity Pay
From the perspective of an employer, SMP works much like Statutory Sick Pay. SMP is paid to an employee in the way that an employee would receive her wages; it is reclaimed by employers through deductions from their National Insurance contributions; compensation for the National Insurance contributions paid on SMP are reclaimed from the Inland Revenue. SMP must be paid to all eligible employees whether or not they intend to return to the employer following childbirth.

When informed that a woman intends to leave work in order to have a baby, an employer must determine whether the employment and earnings rules are satisfied, notice must be received of the employee's last day of work and evidence of pregnancy must be

Table 4.1 **Proportion of employers reporting some problem over the introduction of Statutory Maternity Pay (SMP)**

Row percentages

Workplace size	Some problem experienced	Base (a)	(b)
Public sector			
Under 25 employees	15	48	34
25-99 employees	14	54	49
100-499 employees	(7)	38	40
500 employees or more	23	53	65
All public sector	18	193	188
Private sector part of group workplaces			
Under 25 employees	5	54	41
25-99 employees	17	40	46
100-499 employees	8	51	62
500 or more employees	(10)	38	40
All part of group workplaces	13	183	189
Private sector			
Independent workplaces			
Under 25 employees	10	63	48
25-99 employees	(3)	32	37
100-499 employees	(2)	21	26
500 or more employees	(3)	10	11
All independent workplaces	10	126	124
All private sector	12	309	314
Industrial sector			
Other services	17	197	187
Manufacturing	16	76	83
Distribution	9	120	119
Finance & banking	20	60	60
Other	7	49	52
All workplaces	14	502	502

(a) Weighted (b) Unweighted

() denotes actual number

obtained. Once these steps have been completed, an employer must work out the first day of payment, how much to pay, when and how to make the payment, and how to claim back the SMP (and National Insurance) paid out.

These are detailed administrative steps in comparison with the DHSS-paid arrangements for maternity allowance that existed prior to April 1987. Nevertheless, only a minority of employers (14 per cent) reported having had difficulties related to the introduction of SMP. Table 4.1 summarises the extent to which problems arose, and shows that larger workplaces were more likely to have had any problems over the introduction of SMP, regardless of sector, and that public sector managers were generally more likley than those in the private sector to have reported having had difficulties.

The nature of problems experienced over the introduction of SMP is important. Overall, 8 per cent of managers reported an increase in paperwork (not surprisingly), 1 per cent reported that they had found it necessary to alter computer software programmes to take account of the regulations governing SMP, and 4 per cent reported that learning the new regulations had been difficult, but that all was working well now.

Table 4.1 refers to problems with the *introduction* of SMP. We also asked managers for their *current* views of SMP. These are indicated in Table 4.2, which distinguishes between respondents by industrial sector.

Forty-five per cent of managers said that they thought that SMP was either a good system or at least satisfactory. If we take the view that believing SMP to be adequate or feeling that it encourages women to return to work after having a baby also implies a degree of managerial approval, then over half, and in manufacturing and distribution almost two-thirds, of managers reported that they were satisfied with the present system, whatever their initial teething problems might have been. Indeed, a low proportion reported that they found the arrangements for SMP to be too complicated or bureaucratic (12 per cent), while only a tiny minority (1 per cent) said that they wished to return to the system in force prior to 1987. From the perspective of employers at least, SMP appears to be a generally satisfactory system.

Table 4.2 Employers' current views about Statutory Maternity Pay

Column percentages

	All	Other services	Manufac-turing	Distri-bution	Finance/ Banking	Other inds.
A good thing	18	19	22	19	15	12
Satisfactory	27	25	35	34	25	20
Adequate	2	4	1	1	–	4
Better than old scheme	4	5	2	2	3	8
Encourages women to return to work‡	11	13	8	9	8	12
Too complicated/ bureaucratic	12	11	6	12	14	19
The DSS should pay SMP	1	2	2	1	–	–
Payment level is too low	3	4	4	2	–	3
No views	8	8	10	6	8	5
Other answers	9	9	10	14	27	12
Base:						
Weighted	502	197	76	120	60	49
Unweighted	502	187	83	119	60	53

‡ Eligible women are entitled to SMP whether or not they return to work. It is possible that some employers were referring to contractual maternity pay schemes when giving this response.

Women's difficulties with maternity pay

It was important to ask employers if they had had any problems with SMP as they are responsible for disbursing the payment to women. It was equally important to ask if the women themselves had experienced any difficulties connected with maternity pay, including SMP, as they are the intended beneficiaries of the arrangements. In 1979, less than half of women employees in work during pregnancy received maternity pay from their employers. At that time, 3 per cent of women reported that they had had difficulties associated with maternity pay, most commonly a failure to receive any pay because of too little information from employers received too late to qualify.

In 1988, 80 per cent of women in employment during pregnancy received some form of maternity pay, generally SMP (65 per cent of women in work) or Maternity Allowance (14 per cent), with a tiny proportion only receiving payment due under their contract of employment (11 women). In total, 8 per cent of women reported that they had had some problem over maternity pay. The extent to which these difficulties arose varied, however, according to whether maternity pay was in fact received and by type of pay. Only 3 per cent of women who had received SMP reported having had any difficulties, and these ranged from lack of information to delays in payment and questions over their entitlement. No particular pattern emerged from an analysis of the personal or workplace characteristics of these 52 women. Similarly, only 3 per cent of women reported having had a problem with their employers over maternity pay due under a contract of employment. We examine the nature of these problems when we address the issue of contractual maternity pay later in the chapter.

The majority of women who reported that they had had some problem associated with maternity pay were, then, either women who had received no pay at all or women who had received Maternity Allowance from the DSS. Table 4.3 summarises the extent to which these women had difficulties, and the nature of their problems.

Fourteen per cent of the women in work during pregnancy received Maternity Allowance, with almost one in five reporting some difficulty associated with this payment. Examination of the occupations held by the women who reported difficulties with Maternity Allowance revealed that they were quite evenly distributed throughout the occupational hierarchy, with women in clerical and secretarial work and women in unskilled manual jobs slightly more likely than others to have had some problem.

Twenty per cent of the women in work during pregnancy received no maternity pay at all, however, and of these, 16 per cent reported being dissatisfied with this outcome. Table 4.3 shows that the majority (13 per cent) reported that they had been told that they were ineligible for either SMP or Maternity Allowance (4 per cent ultimately received either sick pay or unemployment benefit). These women tended to be employed as personal or protective service workers or in unskilled manual jobs. They tended to work in the private sector, in smaller workplaces and to be having their first baby. Our own calculations indicate that just over half of these women did not in fact fulfil the

Table 4.3 Extent and nature of mothers' reports about problems with maternity pay

Column percentages

| | Received: | |
	MA	No pay
Had no problem	81	78
Had some problem	18	16
No information	1	6
All answers	100	100
Nature of problem		
Deemed ineligible because:		
of length of service	1	4
insufficient/no NIC paid	2	6
stopped working early	1	1
reason unspecified	2	2
Payment delayed:		
by employer	3	–
by the DSS	6	*
because self-employed	*	–
Employer bankruptcy	1	–
Employer refusal to pay	1	*
Other problems	4	2
What happened about problem		
Payment received:		
maternity payment	8	–
sick pay	1	3
unemployment benefit	1	1
Payment in dispute	3	4
No information given	8	7
Base number+	382	519

+ The base for each column is all women in work during pregnancy who reported having received (a) a Maternity Allowance or (b) no maternity pay

* less than 0.5 per cent

MA Maternity Allowance

statutory requirements for SMP, but we were unable to calculate eligibility for Maternity Allowance.[1]

The problems which confronted the women who received Maternity Allowance were largely of a different order, and generally concerned delays in payment. Just over half of the women who registered a complaint about Maternity Allowance referred to delays, either by the DSS (6 per cent) or by their employers (3 per cent). An additional 0.5 per cent felt that their self-employed status had resulted in delayed payments from the DSS.

Our analyses here do not exhaust the full range of women's problems with maternity pay. We turn now, however, to more detailed examinations of the issues surrounding maternity pay and explore any further difficulties as they arise in relation to specific aspects of maternity pay such as the method and timing of payments.

The extent to which women received maternity pay

We now turn to our detailed analyses of the extent to which women reported having received maternity pay upon stopping work to have a baby. Our analyses in relation to women's *reported* receipt of Statutory Maternity Pay are followed subsequently by comparisons between our *calculations of eligibility* for such payment and women's reports of payment. We would wish to emphasise that there may be some error in our calculations of eligibility. In the manipulation of large data sets, such as the present one, there is generally room for some error and a discrepancy between eligibility for, and receipt of, SMP might be expected for that reason alone. In addition, our measure of entitlement for maternity pay may have been particularly prone to some error, especially in reference to the expected time of birth (from which eligibility for maternity pay and the right to statutory reinstatement is calculated) and the actual time of birth. In designing our questionnaire, we felt it best to ask women about stopping work in relation to the actual date of the birth of their baby. Our questionnaire was sent to women some eight or nine months after the birth, and we believed that they would be more likely to remember how many weeks before the *actual* birth they had stopped working than to remember when they left work relative to the week in which they *expected* to give birth. Accordingly, we expected a certain degree of imprecision in any analyses which depended upon the expected week of confinement. After all, babies usually pick their own time of

birth, and about half of the women in our survey reported that their babies had arrived more than one week earlier or later than expected. Moreover, as we saw in Chapter 3, some women in work during pregnancy found it necessary to stop working earlier than intended because of illness. And although these situations are covered by the regulations governing Statutory Maternity Pay and thus women who would be otherwise eligible for maternity pay should remain eligible, they were *not* catered for in our calculations. Alternatively, it is possible that women who were otherwise eligible for SMP will have chosen not to remain in work until the required 15th week before the expected week of birth. If such women subsequently gave birth early, our calculations might suggest that they were entitled to SMP when in fact they were not. Information from our survey allows us, however, to take account of this possibility.

Table 4.4 summarises the extent and type of maternity payments received by women according to occupational level. Two preliminary comments are necessary. First, because self-employed women are entitled to Maternity Allowance, Table 4.4 encompasses all women in work during pregnancy rather than just women employees. Secondly, the proportions receiving the different types of maternity pay shown in Table 4.4 sum to more than the proportion receiving some pay because the majority of women who had been paid CMP also had received a state maternity payment: 82 per cent received SMP and 3 per cent received a Maternity Allowance.

Our analyses show that women who had been employed in non-manual occupations were noticeably more likely to have received some type of maternity pay than women in sales or manual jobs, although women who had worked as plant and machine operatives were an exception to this general trend. Differences in the *type* of pay received were marked, however. Contractual maternity pay, for example, formed a substantially greater part of the pay received by women in non-manual jobs. Women in non-manual jobs who were the least likely to have received CMP – clerks and secretaries – were nonetheless more than twice as likely to have done so than women who had been employed in sales or manual jobs during pregnancy. Women in jobs lower down the occupational hierarchy had more frequently gained their maternity pay directly from the DSS in the form of a Maternity Allowance. About one in five received maternity pay in this way.

Table 4.4 Extent and type of maternity pay received by women according
to occupational level

Row percentage

	Received some pay	Type of pay* SMP	MA	CMP	Received no pay	Base
Managers/ administrators	87	74	13	16	13	190
Professional occupations	78	67	11	35	22	255
Associate professional occupations	89	77	11	26	11	351
Clerical/secretarial	89	75	13	12	11	813
Craft and skilled manual	85	68	18	4	15	114
Personal and protective sevice occupations	67	46	21	5	33	290
Sales	67	51	16	4	33	250
Plant and machine operatives	83	63	19	4	17	163
Other occupations	56	38	17	5	44	182
Not stated	(23)	(16)	(4)	(3)	(4)	27
All women	80	65	14	14	20	
Base: Women in work during pregnancy	2,116	1,723	382	360	519	2,635

Notes: SMP designates statutory Maternity Pay; MA, Maternity Allowance; CMP,
Contractual Maternity Pay.
 The base for the table is all women in work during pregnancy, including
self-employed women.
* The proportions receiving SMP, MA or CMP sum to more than the proportions
receiving some pay because the majority of women who received pay under a
contractual agreement (CMP) also received SMP or Maternity Allowance.

But perhaps the most salient contrast was between women who
received some pay and those who did not. One third of sales workers
and personal and protective service workers received no pay at all on
leaving work, compared with about one in ten professional, clerical
and secretarial workers. Women in unskilled jobs (other occupations)

Table 4.5 Number of hours worked according to occupational level

Row Percentages

	Under 8 hours	8 to under 16	16 to under 21	21 to under 31	31 and over	Base
Managers/ administrators	1	5	4	2	86	190
Professionals	6	10	4	9	66	255
Associate professional	1	5	8	11	73	351
Clerical/secretarial	2	6	7	5	79	813
Craft & related	2	7	6	8	75	114
Personal/protective service	5	14	11	16	52	290
Sales	2	17	14	9	57	250
Operatives	1	4	7	10	75	163
Other occupations	5	26	12	12	43	182
All women	3	9	8	9	70	2,635

Base: Women in work during pregnancy

were the least likely to receive maternity pay. Only just over half received any pay from whatever source. A rather surprising finding was the relatively high proportion of professionally employed women who had received no pay compared with other women of similar occupational level. Just over one in five had had no maternity pay. Only two-thirds had had Statutory Maternity Pay. The importance of contractual maternity pay is illustrated by the experiences of women professionals, over a third of whom had benefited from their employers' maternity pay schemes.

Tables 4.5 and 4.6 show the number of hours worked and the length of time women had been continuously employed with the same employer in their last job during pregnancy according to occupational level. As noted, women must have been continuously employed for six months in order to receive basic-rate SMP. And although there is no specific number of hours that must be worked in order to qualify for basic-rate SMP or Maternity Allowance, women's earnings must be high enough to attract National Insurance contributions. The fewer

Table 4.6 Continous service in last job according to occupational level

Row Percentage

	Under 6 months	6 months to under one year	One year to under two years	Two or more years	Base
Managers/ adminstrators	4	7	18	70	190
Professionals	4	5	13	78	255
Associate professionals	2	8	16	73	351
Clerical/secretarial	4	11	14	69	813
Craft & related	6	12	23	57	114
Personal & protective service	9	16	18	56	290
Sales	6	18	24	50	250
Operatives	9	12	17	62	163
Other occupations	10	14	20	55	182
All women	5	11	17	65	2,635

Base: Women in work during pregnancy

hours women work, especially in lower-paid sales and semi-skilled or unskilled manual jobs, the less likely it is that they will earn over the National Insurance contributions threshold. Together, Tables 4.5 and 4.6 account for much of the differential in women's experiences of maternity pay. Women who were least likely to have received any maternity pay at all or to have received Maternity Allowance – sales workers, personal and protective service workers and unskilled manual workers – were also the most likely to have worked very short hours and to have had short records of continuous service. For example, almost one third of women who had been employed as unskilled workers (other occupations) worked less than sixteen hours weekly, as did about one in 5 sales workers and personal and protective service workers. In contrast, only 5 per cent of plant and machine operatives and fewer than one in ten clerical or secretarial workers had weekly hours of less than sixteen. The comparatively low proportion of professional workers who received maternity pay may also be

accounted for partially by the figures presented in Table 4.5. Sixteen per cent of professionals worked less than sixteen weekly hours compared with 6 per cent of managers and 6 per cent of associate professionals.

The relationship between hours of work and continuous service and the receipt of maternity pay may be further illustrated by examining variations among women according to the number of children they had before the birth of their recent baby. The large majority of first-time mothers had been in work full-time prior to their recent baby's birth, while the majority of women having their second, third or fourth babies had worked on a part-time basis and were likely to have had substantially more disrupted work histories. This is reflected in the reduced proportion of women with more than one child who had received any pay at all upon stopping work for childbirth. Only about two-thirds of second-time mothers (64 per cent) and less than half of those having their third or subsequent child (43 per cent) received maternity pay from any source, compared with 89 per cent of first-time mothers. The main shortfall for women with more than one child came in the receipt of Statutory Maternity Pay, for which qualification requirements are more stringent. Little variation was found according to birth order in the extent to which women received Maternity Allowance.

Table 4.7 summarises the extent and type of maternity pay received by women according to type of employer. Particularly notable within the private sector were women who had been employed in formerly nationalised industries. Only a small number of these women were covered by our survey, but the evidence presented in Table 4.7 strongly suggests that they had retained the benefits enjoyed by women employees in the public sector. Nearly all of the women who had worked in former nationalised industries received maternity pay. Over one in four had had contractual maternity pay.

Otherwise, Table 4.7 presents variations by type of employer that might have been expected from the differences among women according to their occupational level. Women in the public sector were substantially more likely than other women to have had maternity pay under a contractual agreement. Women in private small firms were much less likely than women either in the public sector or in larger private sector workplaces to have received any pay at all, and the least likely to have had any contractual maternity pay.

Table 4.7 Extent and type of maternity pay received by women according to type of employer

Row percentages

	Received some pay	Type of pay* SMP	MA	CMP	Received no pay	Base
Public sector						
Civil service	85	83	2	44	15	124
Local/Education authority	69	66	3	35	31	353
Health authority	80	77	3	25	20	342
Nationalised industry	83	79	4	13	17	48
Private sector						
Larger/medium businesses	85	72	13	6	15	887
Small firms	75	58	17	3	25	428
Former nationalised industry	92	86	6	28	8	36
Other	70	52	18	5	30	208
Self-employed	43	-	43	-	57	121
Not stated	86	70	14	13	14	88
All women	80	65	14	14	20	2,635
Base: All women in work during pregnancy	2,116	1,723	382	360	519	2,635

* See notes to Table 4.4

Table 4.7 also identifies women who had been in work on a self-employed basis. Women who work for themselves are entitled to Maternity Allowance provided that they have been working and paid National Insurance contributions for at least 26 weeks out of the 52 weeks which ended in the 15th week before their baby was due. Fewer than half of the self-employed women covered by our survey had received Maternity Allowance after stopping work for childbirth. This finding may well reflect the intermittent and part-time nature of much self-employment among women.

Not shown in any of the tables so far, but worth noting are the experiences of ethnic minority women. There did not appear to be any substantial differences between ethnic minority women and women as a whole in the receipt of maternity pay. Against an average level of payment of Statutory Maternity Pay of 65 per cent, 62 per cent of women from ethnic minorities had received SMP. Thirteen per cent had had a Maternity Allowance and 11 per cent had had contractual maternity pay. In total, 21 per cent of ethnic minority women received no pay at all.

In Table 4.8 we look at the extent and type of payment received by women according to the industrial sector in which they had worked during pregnancy. Women who had been employed in distribution, hotels and catering were much less likely than other women to have received any pay at all, to have received SMP or to have received contractual maternity pay. This is largely accounted for by the experiences of women who had worked in the hotel and catering trade, among whom 36 per cent received no pay whatsoever, while fewer than half (45 per cent) had been in receipt of Statutory Maternity Pay. Women who had been employed in retail and wholesale distribution and repairs (the other component of SIC 6) were also less likely than other women to have received SMP (63 per cent) and more likely to have received no pay (26 per cent), but were nonetheless in a more favoured position than women in hotel and catering.

Table 4.8 Extent and type of maternity pay according to industrial sector

Row percentages

	Received some pay	Type of pay* SMP	MA	CMP	Received no pay	Base
Manufacturing	85	67	17	4	15	448
Distribution	70	54	15	5	30	404
Finance & banking	88	76	11	8	12	344
Other services	79	64	14	22	21	1,242
Other industries	88	72	15	9	12	185
All women	80	65	14	14	20	2,635
Base: Women in work during pregnancy	2,116	1,723	382	360	519	2,635

* See Note to Table 4.4

100

Occupation, type of employer and industrial sector were the main sources of variation among women in relation to the receipt of maternity pay. The picture created by the information presented so far can be summarised as follows: women in non-manual jobs were generally more likely than other women to have received some form of maternity pay. In addition, their sources of pay were more likely to have been the state Statutory Maternity Pay scheme, supplemented by contractual maternity pay. The majority of women holding these particular occupations tend to be employed in the public sector. Accordingly, women in the public sector were shown to have been substantially more likely to have been in receipt of SMP and CMP than women in the private sector. Women in sales and in manual jobs, on the other hand, gained a greater part of their maternity pay through the Maternity Allowance scheme, largely because their hours of work and continuous service records meant that they failed to meet the statutory qualifications for Statutory Maternity Pay. Few women employed in sales or manual jobs received contractual maternity pay. As a result, women in the private sector were more likely to have received no pay at all and this was particularly marked among women who had been employed during pregnancy in the hotels and catering trades.

Eligibility for Statutory Maternity Pay
So far we have examined variations among women in the receipt of maternity pay from whatever source. These analyses have been based upon women's reported receipt of maternity pay. The question which now arises is the extent to which women who fulfilled the necessary qualifications for Statutory Maternity Pay did in fact receive this pay. Sixty-nine per cent of women employees received SMP.[*] In order to have gained this benefit, women had to satisfy a number of conditions in addition to the continuous service requirement previously outlined.

[*] Tables 4.4, 4.7 and 4.8 showed that 65 per cent of women in work during pregnancy, including both employees and the self-employed, received SMP. The base for analysis in this section (and that concerning higher-rate SMP) has been altered to encompass only women employees during pregnancy. This accounts for the change in the proportion receiving SMP to 69 per cent.

The other conditions include: their last job must have been with an employer eligible to pay National Insurance contributions in Britain, they must have paid Class 1 National Insurance contributions, they must have been in work during the 'qualifying week' (the 15th week of before the expected week of confinement) and they must have stopped working.[2] Table 4.9 summarises the extent to which our calculations of women's eligibility for basic-rate SMP matched their reported receipt of the payments. The table is based upon all employees during pregnancy and categorises women according to the industrial sector in which they were employed.

Table 4.9 **Relationship between fulfilment of qualifying conditions and receipt of payment for basic-rate SMP, according to industrial sector**

Column percentages

	Total	Manu-facturing	Distri-bution	Hotels & catering	Finance & banking	Other services	Other inds
Appeared to fulfilled criteria							
Payment received	61	59	58	37	73	58	68
No payment	10	11	9	10	6	10	10
Did not appear to fulfil criteria							
Payment received	8	8	6	8	5	8	6
No payment	23	22	28	44	16	24	16
All answers	100	100	100	100	100	100	100
Base: All employees during pregnancy	2,514	437	234	144	333	1,178	178

Two important points arise from Table 4.9. First, one in ten women employees did not receive basic-rate SMP *despite appearing to have the qualifications for the payment.* Secondly, 8 per cent of women reported that they had received SMP when we calculated they were not eligible to do so. We would stress again that there is scope for error in our calculations of eligibility, based on imprecision in women's reports, on the contrast between the expected and actual date

of birth and on the possibility that some number stopped working earlier because of illness but nonetheless remained eligible. Accordingly, we would expect to find a discrepancy between the proportion receiving SMP and the proportion who, by our calculations, were entitled to receive it. And, indeed, about 1 per cent of women employees stopped work before the required 15th week before the expected week of birth and yet retained the *appearance* of qualification because their babies were born substantially earlier than expected. Our calculations, based on the actual date of birth, suggested that such women remained eligible for SMP when, in fact, this was not a true description of their circumstances. However, our analyses do suggest that a small, but not inconsiderable, minority of women appear not to have received the payments to which they were entitled.

Table 4.10 focuses upon women who met all of the qualifying conditions for basic-rate SMP and examines variations in receipt of the payment according to occupational level. Overall, 14 per cent of

Table 4.10 Extent to which women who appeared to meet the qualifying conditions for basic-rate SMP received the payment, according to occupation

			Row percentages
	Payment received	No payment	Base
Managers/ administrators	91	9	138
Professionals	86	14	182
Associate professionals	88	12	276
Clerical/secretarial	89	11	618
Craft & related	84	16	76
Personal and protective services	79	21	121
Sales	82	18	135
Machine & plant operatives	82	18	106
Other occupations	73	27	75
All women(a)	86	14	1,741

(a) All employees who fulfilled qualifying conditions for basic-rate SMP

women with the necessary qualifications reported that they had not had the payment, rising to 27 per cent in the case of unskilled manual workers (other occupations) and 21 per cent of personal and protective service workers. Managers and administrators were the least likely (9 per cent) not to have received basic-rate SMP when they were entitled to do so.

Table 4.11 continues our examination of the experiences of women who appeared to fulfil the conditions for basic-rate SMP. Here women are categorised according to our three main types of employer, and the size of their workplace is taken into account.

Table 4.11 Extent to which women who appeared to meet the qualifying conditions for basic-rate SMP received the payment, according to type of employer and workplace size*

Row percentages

	Received payment	No payment	Base
Public sector	**87**	**13**	**638**
1-24 employees	84	16	146
25-99 employees	88	12	160
100+ employees	88	12	323
Private sector part of group workplaces	**88**	**12**	**658**
1-24 employees	87	13	182
25-99 employees	87	13	167
100+ employees	90	10	307
Private sector independent firms	**82**	**18**	**271**
1-24 employees	81	19	125
25-99 employees	83	17	76
100+ employees	84	16	69
All women(a)	86	14	1,567

* excludes women who did not give type of employer and women employed by 'other' types of employer.

() denotes actual number.

(a) all employees who fulfilled the qualifying conditions for basic-rate SMP.

The table shows that, in comparison with other women, women who had worked in independent firms in the private sector during pregnancy were less likely, as a group, to have received the payments to which they appeared entitled. This was particularly the case for women in smaller workplaces within this sector. Nineteen per cent of women in independent firms with fewer than twenty-five employees who had the relevant qualifications did not receive SMP, compared with 13 per cent of their counterparts in similar size workplaces in the private corporate sector and 16 per cent of women in small public sector workplaces.

We would again stress that room exists for a margin of error in the figures provided in Tables 4.10 and 4.11, arising not only from our own calculations but also from the mothers' reports of their experiences as regards the qualifying conditions for SMP. On the other hand, the fact that there is a clear pattern in the proportion of women who did not receive maternity pay when they appeared to qualify for such pay suggests that the proportion is not simply a consequence of errors in reporting or data management. If the proportion was simply a consequence of errors it would, in principle, be similar among all categories. But the fact, for instance, that more employees of independent firms appeared to fail to receive their entitlement suggests that the pattern is reflecting real inadequacies in the operation of maternity pay and real differences. We would not suggest that our figures demonstrate the exact number of women who fail to receive maternity pay when they are qualified. We would suggest that the number is of some significance and concentrated among the employees of independent private sector firms.

We turn now to the second group of interest highlighted in Table 4.9, women who reported that they had received basic-rate SMP when they appeared not to have the necessary qualifications. Tables 4.12 and 4.13 repeat the analysis we have just seen but are based upon all women employees who did not meet the qualifying conditions for SMP. Table 4.12, which categorises women according to their occupational level during pregnancy, shows no particular pattern by occupation, except that sales workers and women in our residual unskilled category (other occupations) were the least likely to have reported receiving SMP without having the necessary qualifications. Overall, about one quarter of women employees who did not satisfy the requirements for SMP appeared to have received the payment,

rising to 44 per cent of women employed as associate professionals and falling to 12 per cent of sales and unskilled workers.

Table 4.12 Extent to which women who did not appear to fulfil the qualifying conditions for basic-rate SMP received the payment, according to occupation

Row percentages

	Payment received	No payment	Base
Managers/administrators	(11)	(21)	32
Professionals	23	77	56
Associate professionals	44	56	59
Clerical/secretarial	27	73	180
Craft & related	(12)	(19)	31
Personal and protective services	24	76	145
Sales	12	88	106
Plant & machine operatives	25	75	53
Other occupations	12	88	105
All women(a)	24	76	773

(a) all employees who did not meet qualifying conditions for basic rate SMP.

() denotes actual number.

Table 4.13 presents our analysis in relation to type of employer and size of workplace. Women who had been employed in the public sector during pregnancy appeared substantially more likely to have received SMP in the absence of the relevant qualifications than women elsewhere in the labour market. This may reflect a degree of confusion between SMP payments and payments received from employers through contractual or collective agreements. We show below that women in the public sector were markedly more likely than other women to have been in receipt of contractual maternity pay. Accordingly, there is greater scope for women in this sector to have inaccurately reported that they received SMP.

The size of the differences between women in the independent firms sector and the private corporate sector also reflects their differing

Table 4.13 Extent to which women who did not appear to fulfil the qualifying conditions for basic-rate SMP received the payment, according to type of employer and workplace size*

Row percentages

	Received payment	No payment	Base
Public sector	**34**	**66**	**229**
1-24 employees	23	77	78
25-99 employees	27	73	74
100+ employees	51	49	70
Private sector part of group workplaces	**24**	**76**	**260**
1-24 employees	17	83	102
25-99 employees	19	81	52
100+ employees	34	66	105
Private sector independent firms	**17**	**83**	**154**
1-24 employees	11	89	101
25-99 employees	(9)	(18)	27
100+ employees	(6)	(18)	24
All women(a)	**24**	**76**	**773**

* excludes women who did not give type of employer and women employed by 'other' types of employer.

() denotes actual number.

(a) all employees who did not fulfil the qualifying conditions for basic rate SMP.

chances of receiving contractual maternity pay, as we show later in this chapter. Thus, it seems likely that some of these women also reported receiving SMP when in fact they did not do so. But despite the likelihood of inaccuracies in some women's reports about receiving SMP payments to which they were not entitled, it nonetheless appears to be the case that a small number of employers made SMP payments to women who failed to meet all the qualifying conditions attached to these payments. About one third of these women reported, however, that they had been ill before the birth of their baby and had stopped working for this reason. With the relevant medical certificates, such women would retain eligibility for SMP

despite appearing, on our analyses, to have not fulfilled the requirement to remain in work until fifteen weeks before the expected due date. We did not ask about the issue in our survey of mothers, and therefore are unable to judge how many women might have remained eligible for SMP in this way.

There is a range of other possible explanations which might also account for the chances of women receiving SMP when they did not appear to have the necessary qualifications. Employers may not have been fully informed about the qualifications; they may have chosen, on a discretionary basis, to make payments to women who just missed qualifying and not reclaimed the payments or they may simply have been making fraudulent payments. We cannot make any assessment of these possibilities from our present data but, clearly, our overall analysis of statutory maternity pay indicates that its operation raises a number of questions that require further study.

The number of SMP payment weeks

If qualified, women in work during pregnancy are entitled to receive a maximum of eighteen weeks Statutory Maternity Pay, provided that at least six, and no more than eleven, weeks of payment are taken before the week in which the birth is expected. If women work beyond the six-week mark (except in cases where their baby comes early), they forfeit one week of SMP for every week worked. In total, 6 per cent of women who had received SMP received less than the maximum number of weeks payment, most commonly because they remained in work beyond the stipulated six-week departure. Table 4.14 analyses the time at which women stopped work in relation to the number of weeks' SMP payments they received, and shows that a substantial proportion of women who received less than eighteen weeks' SMP worked beyond the six-week period.

There was little variation in the characteristics of women who received less than 18 weeks pay. No clear pattern emerged in terms of occupational level, type of employer or workplace size. Managers and administrators and personal and protective service workers were equally unlikely to have received eighteen weeks payments (9 per cent), as were women in craft and related jobs and women in associate professional occupations (4 per cent). Six per cent of women having their first baby did not receive the full eighteen weeks payment, nor did 7 per cent of women having their third or subsequent baby. Five

per cent of women in the public sector and 6 per cent of women in the private sector received fewer than eighteen weeks payment, as did 7 per cent of women who worked in workplaces with fewer than 10 employees and 6 per cent of women in workplaces with more than 100 employees.

Table 4.14 Number of weeks SMP received according to time work stopped

Column percentages

Number of weeks before birth work stopped	Number of payment weeks		
	Less than 18 weeks	18 weeks	More than* 18 weeks
0-5 weeks	49	8	(7)
6 weeks	10	14	(1)
7-10 weeks	20	28	(12)
11 weeks	5	26	(5)
12 weeks	7	10	(6)
13-15 weeks	6	5	(2)
16 weeks or more	4	8	(4)
All answers	100	100	(37)
Base number (a)	103	1,150	37

(a) All women who received SMP only.

() Denotes actual number.

* According to number of weeks' payment reported by women. It should be noted that the maximum entirlement for SMP is 18 weeks.

The extent to which women received higher-rate SMP

We now turn to an examination of the extent to which women received SMP at the higher rate of 90 per cent of salary, which is paid for a maximum period of six weeks. In order to qualify for this benefit, women must have been continuously employed with the same employer for at least two years (or five years if their working hours were between eight and sixteen hours weekly). Our analyses of higher-rate SMP were based upon women employees during pregnancy, and show that 42 per cent received payment at the higher rate.[4]

Table 4.15 summarises the proportion of women who received higher-rate SMP according to the type of employer for whom they had worked during pregnancy, and additionally shows the median number of payment weeks and the average weekly pay received.

Table 4.15 Proportion of employees who received higher-rate SMP according to type of employer

	Received higher rate %	Median no. of weeks	Average weekly pay	Base
Public sector				
Civil service	68	6	108.77	124
Education/Local authority	52	5	111.45	353
Health authority	51	5	93.49	342
Nationalised industry	44	6	102.13	48
Private sector				
Large/Medium business	40	6	95.35	887
Small firm	28	6	84.83	428
Former nationalised industry	(25)	6	99.91	36
Other	27	5	83.26	203
Not stated	43	6	99.42	88
All women	42	6	94.70	2,514

Base: Employees during pregnancy

() denotes actual number

The results shown in Table 4.15 are comparable with many other analyses presented in our report. Women who had been employed in the public sector were not only more likely to have received SMP after leaving work, but they were also likely to have received higher-rate payments. Indeed, the pattern of variation as between women in private sector small firms or larger private sector businesses and women in the public sector is generally what might be expected from our earlier analyses concerning Statutory Maternity Pay. The proportion of women in the public sector who received higher-level

payments (53 per cent) exceeded that in the corporate private sector (40 per cent). But women in private sector small firms were substantially less likely than most other women to have received these payments (28 per cent). Moreover, the average weekly pay of women in the private sector tended overall not to match that of women in the public sector. Women who had worked in small firms, for example, received almost £10 per week below the average payment level. Women health workers also received less pay than many other women, particularly in comparison with their other public sector colleagues.

Some caution is required, however, in regard to the average earnings shown in Table 4.15. Almost half (49 per cent) of the women who had received higher-rate SMP did not respond to our request for details about the amount of their weekly payments. In a great many cases, women simply repeated that they had received 90 per cent of their salary; in other cases, they said that they had received the 'standard' amount. As one purpose in asking how much higher-rate SMP was received was to check whether in fact women had had an amount equivalent to 90 per cent of their normal wages, we saw little point in attributing answers to our non-respondents based upon information we had been given elsewhere about their earnings before becoming pregnant.

It is also necessary to comment upon the number of weeks payment shown in Table 4.15. The figure given is the median. One quarter of women who received higher-rate SMP did not provide details about the number of weeks they had received payment. Of those who answered the question, just over three-quarters had had six weeks of payment, 4 per cent had had fewer than six weeks and one in five had had seven or more weeks payment. It seems likely that eight or nine months after the event, many women no longer had clear recollections about the exact number of weeks payment they had received. It is clear, however, that the majority had received the statutory number of payments.

Table 4.16 summarises the proportions receiving higher-rate SMP according to occupational level. The contrasts in payment by occupation reflect those we saw in Table 4.4 in relation to basic-rate SMP. Women in professional (61 per cent) and associate professional (56 per cent) occupations were the most likely to have received higher-rate SMP, and women in personal and protective service jobs (23 per cent) and unskilled manual work (19 per cent) the least likely

to have done so. These variations reflect differences in job tenure noted in Table 4.6.

Table 4.16 Proportion of employees who received higher-rate SMP according to occupational level

	Received higher rate %	Median no. of weeks	Average weekly pay	Base
Managers/Adminstrators	50	6	122.63	170
Professional occupations	61	5	123.43	238
Associate professional occupations	56	5	118.50	335
Clerical and secretarial	47	6	95.26	798
Craft and skilled manual	35	5	79.76	107
Personal and protective service occupations	23	5	71.65	266
Sales	29	6	83.39	241
Plant and machine operatives	31	6	67.35	159
Other occupations	19	5	67.00	180
All women	42	6	94.70	2,514

Base: Employees during pregnancy

In view of the substantial number of women who did not provide information about the amount of their weekly payments, we would stress again that caution is necessary in interpreting payment differences by occupation. It was the case, however, that non-response was spread quite evenly across all of the occupational groups shown, as may be inferred from the generally hierarchical nature of the payments received. Moreover, with the exception of sales workers, the relationship between occupational group and average weekly SMP payment compares favourably with an analysis of average hourly earnings by occupation (not shown). Sales workers appear to have received higher SMP payments than would be expected from their average hourly earnings, which tended to be lower than those of women who had been employed in skilled manual or personal and protective service jobs. The number of women in these three

occupational groups who received higher-rate SMP was small, however, and is likely to distort any comparison with the earnings of the occupational groups as a whole.

Table 4.17 provides information about the receipt of higher-rate SMP according to industrial sector. One feature of note shown in the table is the comparatively poor position of women who had worked in the hotel and catering trades. Not only did a substantially lower proportion of these women receive higher-level SMP, but their average weekly payments fell well below the amount received by other women. Women who had been employed in finance and banking, on the other hand, were markedly better paid on average than other women and took home over £10 per week more than their nearest comparators, women in other services who, of course, generally comprised public sector employees.

Table 4.17 Proportion of women employees who received higher-rate SMP according to industrial sector

	Received higher rate %	Median no. of weeks	Average weekly pay	Base
Manufacturing	39	6	79.41	437
Distribution	32	6	82.71	234
Hotels & catering	19	6	74.38	144
Finance & banking	51	6	114.67	333
Other services	44	5	103.35	1,178
Other industries	50	5	93.40	178
All women	42	6	94.70	2,514

Base: Employees during pregnancy

On the basis of our analyses so far we are able to summarise the variations in the receipt of higher-rate SMP in the following way. In general, women in higher-level non-manual jobs were more likely than those who had worked during pregnancy in sales or manual jobs to have received higher-rate SMP and to have enjoyed higher average weekly payments. Women in small private sector firms and women in the hotel and catering trades were poorly favoured in the receipt of

higher-rate SMP in comparison with other women. When women who had been employed in hotels and catering received higher-rate SMP, their average weekly payments were low in comparison with all other women, but especially in comparison with women who had worked in finance and banking. Women from the financial sector benefited from the highest average payment levels.

The overall pattern of variations among women with respect to the receipt of higher-rate SMP compares favourably with, first, the pattern of variations among women who received any SMP, and secondly, with that found among women in the 1979 PSI survey who had received maternity pay from their employers. In the 1979 PSI survey, the chief differences associated with the receipt of maternity pay were women's occupational levels and the type of employer for whom they had worked. Women in higher-level non-manual jobs, and women who had worked in the public sector, were substantially more likely than other women to have received maternity pay. Like our own survey, in 1979 women in unskilled manual jobs and women who had worked in private sector small firms were the least likely to have benefited from this part of maternity rights legislation.

Eligibility for higher-rate SMP

We are able to calculate potential eligibility for higher-rate SMP in much the same way that we previously calculated eligibility for SMP at the basic rate. We have reported that 42 per cent of women employees reported that they had had payments at the higher rate. Calculations based on hours of work and length of continuous service, the payment of National Insurance contributions, whether the employer was liable to pay National Insurance Contributions, if the woman had been in employment fifteen weeks before the expected week of birth and whether she had stopped working show, however, that 14 per cent of women employees appeared to fulfil these qualifying conditions but did not in fact receive higher-rate SMP.

As we outlined in relation to basic-rate SMP, we would not expect an exact match between the proportion who appeared to fulfil the statutory requirements for higher-rate SMP and the proportion who reported that they had received the payment. Our information is based upon self-completed questionnaires. These necessarily provided scope for error when women were filling in their length of service, their hours and their time of stopping work. Error on a substantial scale in relation

to any one of these three questions would have invalidated our calculations in respect of eligibility for payment. Table 4.18 summarises the extent to which our calculations of eligibility for higher-rate SMP were in accordance with women's reports about receiving the payment. The table includes all employees during pregnancy and distinguishes among women on the basis of industrial sector.

Table 4.18 Relationship between fulfilment of qualifying conditions and receipt of payment for higher-rate SMP, according to industrial sector

Column percentages

	Total	Manu-facturing	Distri-bution	Hotels & catering	Finance & banking	Other services	Other inds
Appeared to fulfil criteria							
Payment received	37	35	29	17	47	37	44
No payment	14	16	11	10	16	13	14
Did not appear to fulfil criteria							
Payment received	5	4	3	2	4	7	6
No payment	44	45	56	71	34	43	36
All answers	100	100	100	100	100	100	100

Base: Employees during pregnancy

Overall, 37 per cent of women both fulfilled the qualifying conditions for higher-rate SMP and received the payment. Forty-four per cent neither had the relevant qualifications nor received the payment. Five per cent reported having had SMP at the higher rate although they did not appear to have met the qualifying conditions. And, as we have noted, 14 per cent of women employees did not receive higher-rate SMP although they appeared to be entitled to do so.

Tables 4.19 and 4.20 explore variations among women who appeared, by our calculations, to have had the relevant qualifications for higher-rate SMP and distinguish between those who did and did not receive the payment. The most marked shortfall between

eligibility and receipt in relation to occupation was found among women who had worked in personal and protective service occupations, as plant and machine operatives or in unskilled manual jobs (other occupations). Over 40 per cent of women in these occupational groups who appeared to meet the qualifying conditions for higher-rate SMP reported that they had not received the payment.

Table 4.19 Extent to which women who appeared to fulfil the qualifying conditions for higher-rate SMP received the payment, according to occupation

Row percentages

	Payment received	No payment	Base
Managers/administrators	76	24	100
Professionals	87	13	141
Associate professionals	79	21	205
Clerical/secretarial	75	25	467
Craft and related	63	37	48
Personal and protective services	56	44	82
Sales	74	26	80
Plant & machine operatives	53	47	75
Other occupations	52	48	54
All women(a)	73	27	1,261

(a) Women who fulfilled the criteria for higher-rate SMP.

There was also a marked shortfall between eligibility and receipt among women who had worked in private sector independent firms. Thirty-seven per cent of women in independent firms who appeared to have satisfied all of the requirements for higher-rate SMP did not receive the payments to which they were entitled. Women in the smallest and the largest workplaces within the independent sector were particularly unlikely to have received their entitlements in comparison with women in similar size workplaces in the private corporate sector or in the public sector.

Table 4.20 **Extent to which women who appeared to fulfil the qualifying conditions for higher-rate SMP received the payment, according to type of employer and workplace size***

Row percentages

	Payment received	No payment	Base
Public sector	**78**	**22**	**508**
1-24 employees	73	27	102
25-99 employees	85	15	132
100+ employees	77	23	269
Private sector part of group			
workplaces	**72**	**28**	**460**
1-24 employees	72	28	109
25-99 employees	63	37	119
100+ employees	77	23	231
Privates sector independent			
firms	**63**	**37**	**180**
1-24 employees	58	42	78
25-99 employees	78	22	46
100+ employees	57	43	56
All women(a)	73	27	1,261

* excluding women who did not give type of employer and women employed by 'other' types of employer.

(a) Women who fulfilled the qualifying conditions for higher-rate SMP.

() denotes actual number.

We would stress once again that scope exists for error in our calculations of the proportions of women who met the qualifying conditions for higher-rate SMP. However, it would appear that, as was the case in 1979, a shortfall existed in 1988 between eligibility for, and receipt of, maternity payments which depended upon women meeting precise hours and service requirements. And again as it was in 1979, women who worked in the independent sector were the most likely not to have received their entitlements.

Table 4.21 Extent to which women who did not appear to fulfil the qualifying conditions for higher-rate SMP received the payment, according to occupation

Row percentages

	Payment received	No payment	Base
Managers/administrators	13	87	70
Professionals	23	77	97
Associate professionals	20	80	130
Clerical/secretarial	8	92	331
Craft and related	12	88	59
Personal and protective services	9	91	184
Sales	7	93	161
Plant & machine operatives	11	89	84
Other occupations	6	94	126
All women (a)	12	88	1,253

(a) Women who did not fulfil the criteria for higher-rate SMP.

Table 4.18 also showed that 5 per cent of women employees reported that they had received higher-rate SMP when they appeared not to have had the necessary qualifications for the payment. If allowance is made for the possibility of error in relation to our calculations of eligibility for higher-rate SMP, arising from the women's reports, then it seems unlikely that proportion represents a source of cause for concern. Accordingly, we include Tables 4.21 and 4.22, which explore variations among women who did not appear to qualify for higher-rate payments, for information only.

Employers' reports about the extent to which women who stopped work received SMP and higher-rate SMP

The large majority of workplaces covered by our survey of employers reported that SMP had been paid to women leaving work for childbirth during the previous two years. Eighty-five per cent of managers in the public sector and 77 per cent in the private sector said that women had received SMP. In those establishments where it was reported that no women had received SMP, managers most commonly cited failure to

Table 4.22 Extent to which women who did not appear to fulfil the qualifying conditions for higher-rate SMP received the payment, according to type of employer and workplace size*

Row percentages

	Payment received	No payment	Base
Public sector	**18**	**82**	**359**
1-24 employees	12	88	122
25-99 employees	19	81	102
100+ employees	24	76	124
Private sector part of group workplaces	**8**	**92**	**458**
1-24 employees	4	96	175
25-99 employees	6	94	100
100+ employees	13	87	181
Private sector independent firms	**9**	**91**	**245**
1-24 employees	8	92	148
25-99 employees	12	88	57
100+ employees	5	95	37
All women(a)	**11**	**89**	**1,253**

* See note to Table 4.20.

(a) Women who did not fulfil the qualifying conditions for higher-rate SMP.

() denotes actual number.

meet statutory length of service conditions (24 per cent) and insufficient weekly hours (20 per cent) as the reasons why women were considered ineligible. However, almost half of these respondents did not provide reasons for the non-payment of SMP. Table 4.23 summarises the proportion of women who received Statutory Maternity Pay at the basic and higher rates according to our employers' accounts of the number leaving work and of the number receiving SMP.

The 88 per cent who received SMP according to employers' reports is noticeably greater than the figure of 69 per cent that emerged from our survey of women. The contrast between women's and employers' reports is not as marked as was the case in the earlier PSI

Table 4.23 Proportion of women reported by employers as having received SMP and higher-rate SMP

	Mean* (per cent) of women who got SMP	Mean+ (per cent) of women who got higher-rate SMP
Public sector		
Under 25 employees	91	96
25-99 employees	96	97
100-499 employees	89	90
500 employees or more	89	90
Private sector part of group workplaces		
Under 25 employees	86	97
25-99 employees	81	83
100-499 employees	89	77
500 or more employees	88	76
Private sector independent workplaces		
Under 25 employees	80	83
25-99 employees	91	82
100-499 employees	93	75
500 or more employees	90	75
All workplaces	88	86
Weighted	425	365
Unweighted	433	375

* All establishments where women were reported as having stopped work to have a baby in the previous two years.

+ All establishments where women were reported as having received SMP.

surveys, however, when 75 per cent of women leaving work were said by employers to have received maternity pay in comparison with 45 per cent of women who reported having had some pay. At that time, Daniel (1981a:73) suggested that the most plausible explanation for

the discrepancy in reports was that employers were likely to have missed women who had left work at the early stages of pregnancy from their accounts of the number of women stopping work for childbirth. That explanation was supported by the fact that over half of the respondents to the survey of employers in 1980 gave the same number as having stopped work for childbirth and as having received maternity pay.

It appears likely that the same explanation holds for the divergence of accounts in the current surveys. Indeed, only one in five employers reported having had in their employ *both* women who received SMP *and* women who did not receive SMP upon leaving work for childbirth. In other words, four-fifths of our managers reported that all of the women who had stopped work because of pregnancy in the previous two years had received Statutory Maternity Pay. As we know from our survey of women, this was unlikely to have been the case. Rather, it seems likely that employers tended to 'remember' – or count as stopping work owing to pregnancy – only those women to whom they paid flat-rate or higher-rate SMP.

Flexibility and maternity pay
When Statutory Maternity Pay was introduced in April 1987, an element of flexibility over the timing of maternity payments was also brought in. Women who receive either SMP or a Maternity Allowance now may choose to be paid over a flexible period, provided that at least six, and no more than eleven, of their eighteen weeks' payment are taken before the week in which their baby is expected. We asked women if they had been aware of this flexibility, if they personally had chosen how to divide their payment weeks and if they were happy with the way in which these weeks had been divided. We also asked employers if they knew about the options open to their women employees regarding the timing of their SMP payments, and questioned them further about who in practice took this decision in their workplace. Table 4.24 summarises our results from the survey of mothers.

SMP and flexibility
Our initial question to women about the timing of their maternity payments was intended to gauge the level of their awareness about arrangements for flexibility. But in order to ask women whether they

Table 4.24 Flexibility arrangements for SMP and Maternity Allowance according to survey of women

Percentages

	Total	Received SMP	Received MA
Aware of flexible option	75	78	63
not aware	19	16	31
no answer	6	6	6
Personally chose division of payment weeks	46	50	29
Average No. of weeks pay:			
Before the EWC*	8.5	8.4	8.9
After the EWC	9.5	9.7	8.6
Unhappy with division of payment weeks	5	4	10
Would have preferred:			
More payments before the birth	+	+	1
More payments after the birth	2	1	2
A lump sum payment	1	1	1
Not a lump sum	1	+	1
Other answers	1	1	5
Base: All women who received either SMP or Maternity Allowance	2,105	1,723	382

* Expected week of confinement.
+ less than 0.5 per cent.

knew about the choice open to them, we had first to tell them that it existed. This meant that our question was rather long and cumbersome, and 6 per cent of women did not answer the question. Among women who had been employed in semi-skilled and unskilled manual work non-response rose to 10 per cent.

In total, 16 per cent of women who received SMP reported that they had been unaware of the new flexibility (Table 4.24). Occupation

was the primary source of variation as regards women's knowledge, with the main divide falling between women in non-manual occupations and women in sales and manual jobs. Little variation existed within these two broad categories. Among women in sales and manual work, for example, the proportion who did not know about the possibility of dividing their payment weeks ranged from one in four to just over one in five. The range among non-manually employed women was from 10 per cent of professionals to 16 per cent of associate professional and technical workers.

Differences by type of employer existed but were not marked. Eighteen per cent of women who had been employed in the public sector and 17 per cent of women in the private sector reported that they had been unaware of the arrangements for flexibility. Within the public sector, health authority employees were the most likely (18 per cent) and civil servants the least likely (10 per cent) to report that they did not know (but 15 per cent of women who had been employed in the civil service failed to answer the question). Outside the public sector, women who had worked in finance and banking reported the highest level of awareness (13 per cent had not known) and women employed in manufacturing reported the lowest level (20 per cent had not known).

Overall, then, 78 per cent of women who received SMP reported that they had known about the option to choose the division of their payment weeks. Their relatively high level of awareness about arrangements for flexibility was reflected in the accounts we received from employers regarding this issue. Awareness was highest among public sector managers, among whom only 1 per cent reported that they did not know about the flexibility open to women. Size of workplace had no impact on the responses of managers in the public sector, but proved to be an important source of variation among managers in the private sector.

Eleven per cent of private sector managers said that they had not known about the flexibility option, with managers in private sector workplaces that were part of a larger organisation slightly less likely not to know (10 per cent) than their counterparts in independent enterprises (13 per cent). When size of workplace was taken into account, however, marked differences emerged. Respondents from smaller workplaces (fewer than 25 employees) were substantially less likely to have known about arrangements for flexibility. This was

particularly the case where the workplace was part of a larger organisation (29 per cent had not known), but was true also of small independent workplaces (19 per cent had not known). In private sector workplaces with over 100 employees, the level of awareness among managers more closely resembled that of their public sector counterparts, with fewer than 5 per cent overall who reported that they had not known about the arrangements for the division of SMP payment weeks. Table 4.25 summarises the pattern of responses from managers.

Table 4.25 Employers' awareness of flexible arrangement for payment of SMP

Row percentages

	Aware of flexible option	Base Weighted	Unweighted
Public sector			
Under 25 employees	94	48	34
25-99	92	54	49
100-499 employees	100	38	40
500 employees or more	97	53	65
Private sector part of group workplaces			
Under 25 employees	71	53	41
25-99 employees	91	40	46
100-499 employees	95	51	62
500 employees or more	92	37	40
Private sector independent workplaces			
Under 25 employees	81	62	48
25-99 employees	86	32	37
100-499 employees	(17)	21	26
500 employees or more	(9)	10	11
All women(a)	89	502	502

() denotes actual number.

The comparative lack of awareness among managers in small workplaces that were part of a larger organisation was in all likelihood due to decisions concerning maternity pay being taken at head office. But for whatever reason, it is worth noting that it was only among the smallest workplaces that managerial lack of awareness approached the level found among women. Managers in the public sector in particular were more aware of women's options than the women themselves. This suggests that more efforts might be made by managers in bringing the matter to the attention of their women employees.

By way of continuing our exploration of the arrangements for flexibility, we asked women if they had personally chosen how to divide their SMP payment weeks and we asked employers who in practice took this decision. Table 4.24 shows that exactly half of the women who received SMP had themselves decided how to divide their payment weeks. Women in non-manual jobs were more likely to have done so, however, ranging from 60 per cent of managers and administrators to 50 per cent of clerical and secretarial workers. As we shall see below, the tendency for non-manually employed women to make their own choice generally reflects their employment in the public sector. In contrast, fewer than half of women employed in sales and manual jobs personally chose how to divide their payment weeks. Here the range was from 40 per cent of women employed in craft and related skilled manual jobs to 46 per cent of women employed in personal and protective service occupations.

The pattern of responses from our survey of employers about how the decision is taken to divide SMP payment weeks is summarised in Table 4.26. Analyses which took size of workplace into account produced no variation of any interest from the pattern shown in the table.

In all independent private sector workplaces – whatever the size of workplace – respondents were more likely to have said that the decision as to how SMP payment weeks should be divided was a joint decision, and least likely to have reported that they alone took the decision. In all public sector workplaces, again regardless of size, managers were the least likely to have reported that it was their decision alone, and most likely to have reported that the woman chose how to divide her payment weeks. And in all private sector workplaces that were part of larger organisations, managers' responses fell

somewhere between their counterparts elsewhere in the private sector and in the public sector.

Table 4.26 Employers' reports on how decision to divide SMP payment weeks is taken

Column percentages

Who decides	Total	Public sector	Private sector Part of group	Inde- pendent
The woman	29	35	32	17
The employer	25	21	28	29
Both woman and employer	36	38	30	41
Can't say/not stated	10	6	10	13
Base: All workplaces				
Weighted	502	193	183	126
Unweighted	502	188	189	124

However women and their employers came to a decision, Table 4.24 also shows that few women who received SMP were unhappy with the way in which their payment weeks had been divided. Only 4 per cent reported that they would have preferred alternative arrangements. These women tended to have been employed in higher-level professional and managerial jobs in the public sector and to have wanted more payments after the birth or a lump sum payment. Women in sales and manual work were less likely to have chosen how to divide their payment weeks, but generally were less likely to have been unhappy about the way in which they had been divided. This may well reflect differences in the physical demands or working conditions of jobs done by women in higher-level non-manual jobs compared with women in sales and manual work. The former may well feel physically able to work longer, and therefore would prefer not to stop work at the sixth week before their expected week of birth in order to collect their full SMP entitlement. We are, however, referring to a small group of women.

Maternity Allowance and flexibility

Within certain limits, women who receive a Maternity Allowance after stopping work for childbirth may also choose how many weeks' payment they will receive before and after the expected week of confinement. Some women are not given the option of flexibility about their payment weeks and are required to begin maternity payments at the beginning of the eleventh week prior to their expected week of confinement. This includes women who stop working before the eleventh week, women receiving unemployment benefit and women on sickness or invalidity benefit.

In comparison with women who received SMP, proportionately fewer women who received Maternity Allowance were aware of the arrangements for flexibility and proportionately fewer personally chose how to divide their payment weeks (Table 4.24).

Women who had received a Maternity Allowance were asked the same question about their awareness of arrangements for flexibility that was asked of women who had received SMP. There was again an overall 6 per cent non-response, which rose to 10 per cent in the case of women who had been employed in sales or as semi-skilled and unskilled manual workers. We assume this level of non-response to be the result of an over-long and cumbersome explanation of the flexible arrangements available to women. Women who received Maternity Allowance were no more likely, however, than women who had had SMP not to have answered questions on flexibility.

In the event, there was no consistent pattern of variation among women according to occupation or size of workplace. Overall, 31 per cent did not know about the flexibility option. Women who had been employed in the public sector were slightly more likely (36 per cent had not known) than their private sector counterparts in both small firms (31 per cent) and larger businesses (31 per cent) to have been unaware of the arrangements for flexible choice. However, responsibility for bringing this information to the attention of women who received Maternity Allowance falls not upon individual employers or managers, but on the Department of Social Security from whom payments are made directly to the women concerned. The Department provides women with the relevant information through its literature relating to maternity benefits.

The comparatively higher proportion of women receiving a Maternity Allowance who did not know about the arrangements for

flexible choice is associated with a lower proportion of women who personally chose how to divide their payment weeks. We saw above that half of the women who received SMP had decided how many weeks' payment they would have before and after the week in which they expected to give birth. In the case of women who received a Maternity Allowance, this fell to less than one third (29 per cent). As we note above, however, certain groups of women are not given the option of flexibility about their payment weeks. Women in these particular circumstances accounted for just over two-thirds of those who reported that they had not been able personally to choose the division of their Maternity Allowance payment weeks. Over half (57 per cent) had stopped work more than eleven weeks before the expected week of birth, 27 per cent because of illness. A further 11 per cent had been on unemployment benefit.

Some variation existed as regards the occupational distribution of Maternity Allowance recipients who stopped work before the eleventh week. Women who had been employed as managers or administrators during pregnancy were the least likely (40 per cent) to have stopped work and women who had been employed in sales the most likely (73 per cent). Women in sales or manual jobs tended more than others to have stopped work because of illness (and therefore were more often in receipt of Statutory Sick Pay); women in higher-level non-manual jobs tended to have stopped because they no longer wished to work. Secretaries and clerical workers were more likely than managers and professional workers to have stopped work because of illness, and more likely than sales and manual workers to have stopped because they wished to do so.

The majority of Maternity Allowance recipients who did not personally choose how to divide their payment weeks had not been given this opportunity, then, for reasons which fell within the regulations associated with Maternity Allowance. We can shed no light, however, on the reasons why the remaining one third of Maternity Allowance recipients who did not make this choice were not able to do so. These women accounted for one in five of all those who received a Maternity Allowance.

Method of maternity payment
Regulations governing Statutory Maternity Pay stipulate that it should be paid to women in the way that they would have received their

normal wages. Our results indicate that in the majority of cases this was done. Eighty-four per cent of women in total had had no change in payment method associated with the receipt of SMP (or contractual maternity pay), rising to 90 per cent of women who had been employed in the public sector during pregnancy and falling only to 79 per cent of women who had worked in small firms.[5]

Table 4.27 summarises variations according to type of employer in the methods used for the payment of maternity pay and indicates whether the means of payment had changed and if any problems had arisen from the system used. In the large majority of cases (92 per cent), no problems associated with the method of payment had occurred, whether or not that method had changed. Where problems had arisen, women whose payment method had changed were more likely to have had difficulties. Fourteen per cent of women who reported being paid in a way that differed from the payment of their wages said that this had caused some difficulties. In contrast, only 5 per cent of women whose payment methods remained the same had any difficulties. There was, however, no consistent relationship between the nature of the problems and whether the method of payment had changed. Table 4.28 summarises the nature of problems according to whether the system of payment was changed or unchanged.

Problems fell into two broad groups: problems over payments and problems of inconvenience. In the first group were late or slow payments (cited by 21 per cent); confusion over payment calculations (12 per cent); and payments made in arrears (6 per cent). In total, problems with payments were reported by 40 per cent of the women who experienced any problems. The second group of difficulties centred on the ways in which women were paid. Twenty-nine per cent found it inconvenient to collect their pay from their workplaces; 14 per cent did not like being paid by cheque; and 6 per cent found the change in frequency of payments inconvenient. These types of difficulties were reported by 48 per cent of women who had had problems.

Sales workers were prominent among women who reported problems. Fifteen per cent of sales workers who received SMP (20 women) had experienced some problem associated with the way in which it was paid. They were evenly divided between women who reported that their method of payment had altered and those who

Table 4.27 How maternity payments were made according to type of employer

Column percentages

		Public sector					Private sector		
	Total	Civil service	Local/ Education authority	Health authority	Nationalised industry	Medium/ large business	Small firm	Former nationalised industry	Other
Method of payment									
Direct to bank/building society	67	87	87	83	76	65	30	79	56
By post	12	5	9	8	13	13	19	12	13
In cash	12	-	1	2	5	13	38	-	18
Cheque picked up from workplace	4	1	1	3	5	5	8	-	6
Other	1	3	-	1	-	1	1	3	3
Not stated	4	4	2	4	-	4	5	6	4
	100	100	100	100	100	100	100	100	100
If method was same or different from wages									
Same	84	91	93	90	89	81	79	82	76
Different	12	5	5	6	11	15	16	12	21
Not stated	4	5	2	4	-	4	6	6	4
	100	100	100	100	100	100	100	100	100
If method caused problems									
Yes, problem caused	6	5	2	4	3	7	9	12	8
No problems	92	90	96	94	97	92	88	85	91
Not stated	2	3	2	2	-	1	3	3	1
	100	100	100	100	100	100	100	100	100
Base: Women who received SMP or contractual maternity pay	1791	111	247	278	38	654	253	33	112

* percentages may not sum to 100 due to rounding

Table 4.28 Nature of problems arising from method of maternity payment

Column percentages

| | Method of payment | |
	Changed	Unchanged
Problem caused by:		
Picking up payment at workplace	(5)	34
Payment by cheque	(12)	3
Late payments	(13)	13
Change in frequency of payments	(2)	5
Payment in arrears	–	9
Confusing calculations	(1)	15
Other answers	(4)	19
Base: All women who had problems	30	79

() denotes actual number.

reported that it had not altered. But whether the payment method was changed or unchanged was not associated with the nature of the problems. Sales workers experienced the three general problems over the payment of SMP in equal numbers.

Ten per cent of craft workers who had received SMP (eight women) also reported difficulties associated with the way they were paid. For craft workers, however, having to pick up their payments from their previous workplace was the main problem. This was cited by seven of the eight craft workers who had had difficulties. Clearly, what had been a convenient method of receiving wages while working had become an inconvenience once work had been stopped.

In contrast to craft and sales workers, fewer than 5 per cent of women employed in professional and associate professional jobs reported problems with their payments methods.

Notification and medical evidence of pregnancy
Statutory Maternity Pay regulations require employers to inform pregnant employees about the need to provide medical evidence of pregnancy and the need to give at least twenty-one days notice of their intention to stop work for childbirth. In order to maintain their

eligibility for SMP, employees in turn are required to give twenty-one days notice and to provide medical evidence of their pregnancy.

Two-thirds of the women covered by our survey reported that they had been given information about the required period of notice, but fewer than one in ten women said that they had in fact given twenty-one days notice. Instead, women told their employers of their intentions quite early on in pregnancy. Almost 70 per cent gave more than six weeks notice, while the average number of weeks' notice given (excluding women who gave no notice or did not answer the question) was thirteen weeks.

We also asked employers about the minimum period of notice they would accept from women who intended to stop working because of pregnancy. About one-third said they accepted three weeks notice. Fifteen per cent said that they required less than three weeks and 40 per cent required one month or more. It should be noted, however, that our question to employers was a general one, covering all women stopping work for childbirth. If our inquiries had been directly related to the payment of Statutory Maternity Pay, it is possible that more respondents might have cited the regulation three week period.

Accounts from our survey of women suggest that information about the need to provide medical evidence was received by 70 per cent of women. In their turn, 78 per cent of women gave their employers the relevant evidence, most commonly a Maternity Certificate (Form Mat B1). Ninety-six per cent of women who received information about the need to provide medical evidence had given their employers a Maternity Certificate, while 4 per cent provided a letter from their doctor or midwife. Nine women reported that they had been charged for the medical evidence they required. These charges ranged from £1 to £5, although the majority paid £2 or less.

In their turn, only 5 per cent of workplaces covered in our survey of employers reported that they did not require medical evidence of pregnancy. Private sector workplaces were more likely than public sector ones not to require medical evidence, particularly those in distribution, hotels and catering (11 per cent) and in manufacturing (9 per cent). Independent private sector workplaces also were less likely to require medical evidence (11 per cent). Across all workplaces, however, a Maternity Certificate was the most common form of evidence required. Almost three-quarters of managers accepted this

form of evidence, while 17 per cent said that they would accept a letter from a doctor or midwife.

Contractual maternity pay (CMP)

We now turn to an examination of the extent to which employers offered, and women received, maternity payments as a result of contractual or collective agreements. In our survey of women, we asked respondents if they had received '*Contractual maternity pay, which is paid to women by their employers as part of a woman's employment contract (and which may or may not be in addition to SMP or Maternity Allowance)*'. We intended that our questions about CMP should be answered both by women whose employers had formal contractual or collective maternity pay agreements and by women who had benefited from informal arrangements that depended upon managerial discretion. We are unable to judge to what extent our definition of CMP discouraged women who fell into the latter group from responding to our inquiries. To the extent that such women were discouraged, our results will underestimate the numbers who received less formal forms of maternity pay from their employers.

From our survey of women, we estimate that 14 per cent of women employees received contractual maternity pay (CMP) after stopping work to have a baby. This appears to be a slight increase in the numbers receiving CMP since the 1979 PSI survey when 10 per cent of women reported that they had received maternity pay in excess of the statutory minimum six weeks' payment. Contractual maternity pay was not addressed directly in the earlier survey of women, however, and it is possible that that survey also under-estimated the proportion who received such payments.[6]

Evidence from our survey of employers also suggests that there has been some increase in the proportion of employers who provide contractual pay benefits. In the 1980 PSI systematic survey of employers, which focused exclusively on the private sector, 2 per cent of establishments reported that they had contractual maternity pay arrangements that provided payments in addition to the statutory minimum. These establishments were all workplaces which were part of larger organisations and the majority employed 100 or more people. In the current survey of employers, 4 per cent of private sector workplaces reported that they had formal contractual maternity pay arrangements. Again these were almost wholly larger workplaces,

particularly workplaces employing 100 or more people that were part of larger businesses. However, one independent small workplace (fewer than 10 employees) within the private sector also reported having a contractual maternity pay scheme.

It would seem, then, that there has been a modest increase in the proportion of private sector employers who offer maternity payments in excess of the statutory minimum (as well as a modest increase in the number of women who receive CMP). It nevertheless remains the case, as was shown in the 1979 PSI survey, that the large majority of CMP schemes are to be found in the public sector. In our survey of employers, over half (55 per cent) of the public sector workplaces covered reported having arrangements for CMP. These workplaces accounted for 90 per cent of workplaces that reported having arrangements for CMP. As a result, women who had been employed in the public sector were substantially more likely to have received CMP than other women in our survey of mothers. Table 4.29 summarises the proportion of women who received contractual maternity pay in relation to all employees during pregnancy, and shows marked differences between women according to occupational level and type of employer.

The variations shown in Table 4.29 reflect the tendency for women who held higher-level non-manual jobs during pregnancy to have worked in the public sector. Over three-quarters of women who received CMP had worked in the public sector, 58 per cent as managers or administrators, professionals and associate professionals. Within the public sector, civil servants were the most likely to have received CMP (reflecting, again, civil service efforts to encourage the recruitment and retention of women employees), and health workers the least likely, reflecting the generally unfavourable position of health workers compared with their other public sector colleagues. Women who had been employed in sales and manual jobs were substantially less likely to have received CMP, as were women who had been employed in small firms.

We would also note that 86 per cent of women who received CMP had worked full-time during pregnancy and that 90 per cent had been in that job for more than two years. Thus it was the case that the great majority of women who received CMP also fulfilled the requirements for state maternity benefits. All but eleven of such women had received

either Statutory Maternity Pay or a Maternity Allowance in addition
to payments from their employers.

Table 4.29 **Proportion of women employees who received contractual
maternity pay according to occupational level and type of
employer**

Percentages

Occupational level	Received CMP	Base	Type of employer	Received CMP	Base
Manager/Administrator	18	170	**Public sector**		
Professional	38	238	Civil service	44	124
Associate prof. and technical	27	335	Local/education authority	35	353
Clerical and secretarial	12	798	Health authority	25	342
Craft and related	5	107	Nationalised industry	(6)	48
Personal and protective service	6	266	**Private sector**		
Sales	4	241	Large/medium business	7	887
Machine and plant operatives	4	159	Small firm	3	428
Other occupations	6	180	Former nationalised industry	(10)	36
Not stated	(3)	20	Other	5	208
			Not stated	13	88
All women	14	2,514	All women	14	2,514

Base: Employees during pregnancy

() denotes actual number.

Details of contractual maternity pay schemes
Women who received CMP were asked if they had received full pay
for the entire duration of their CMP period. Women who had received
less than full pay for all or part of this time were asked to provide
details of the amounts and duration of payments received. In the event,
it turned out that almost as many different combinations of payment
level and duration existed as women who had received these payments.
Thus we decided to code only the receipt and duration of periods of
full pay and leave detailed analyses of CMP schemes to our survey of
employers.

In that survey, 118 workplaces reported a contractual maternity pay scheme, and 106 of these were in the public sector. When we excluded variations in the number of unpaid weeks of maternity leave offered by these workplaces, we were able to identify forty-two different CMP schemes. Taking unpaid leave into account increased the number of different schemes to fifty, which represented almost one for every two workplaces.

There were, however, some common features among these many schemes. Just over half (29 schemes) offered some period of full pay which ranged from two to twenty-six weeks. One in five were based on some variation of the statutory eighteen week period. Such schemes may have been divided, for example, into thirteen weeks' full pay and five weeks half pay or six weeks full pay and twelve weeks half pay. Or they may have incorporated the statutory 90 per cent of salary, such as schemes which offered four weeks at 90 per cent of full pay and 14 weeks at half pay. The two most common schemes each embodied 90 per cent of full pay. One of these, offered by 42 employers (one in the private sector), provided women with four weeks full pay, two weeks at 90 per cent of full pay and twelve weeks half pay. About one-quarter of the workplaces who reported this scheme also offered unpaid leave extending from eleven to twenty-nine weeks. The second most common scheme, offered by 28 employers (two in the private sector), featured six weeks at 90 per cent of salary and twelve weeks at half pay. Seven of these employers additionally offered periods of unpaid leave extending from nine to twenty-two weeks.

In about two-thirds of the workplaces which reported CMP arrangements, women had to satisfy qualification requirements, which were generally based on length of service. Two-thirds of workplaces with length of service conditions required a minimum of one year, while about one in five required only six months. The remaining workplaces based their requirements upon the statutory two-year period. Two-thirds of workplaces also had minimum weekly hours requirements, but only one in ten excluded women on grounds of occupational level. In general, where payments were not made to all categories, manual workers were the most likely to be excluded. All workplaces reporting the exclusion of certain categories of worker were in the public sector.

We noted above that the variety of CMP schemes meant that we did not code all of the information about contractual maternity pay

provided by respondents to our survey of women. We are able, however, to report the following:

Just over one-quarter (26 per cent) of women who received CMP had full pay for the entire duration of their maternity pay period.

Thirty-five per cent had part full pay, for an average duration of seven weeks.

Thirty-three per cent had no periods of full pay.

The most common duration of CMP received by women (including those who did not received any full pay) was eighteen weeks.

Three per cent had received a lump sum payment.

Problems with contractual maternity pay
There appear to have been fewer managerial problems associated with contractual maternity pay than with SMP. For the large majority of employers (89 per cent), CMP was used to 'top-up' the state system of maternity payments, while 9 per cent reported that women received the full amount of both types of payment. Most workplaces (89 per cent) reported that conditions were attached to the receipt of CMP. Most commonly, women were required to return to work for a specified length of time following maternity leave. Eighty per cent of workplaces attached return-to-work conditions; two-thirds stipulated that women must return for a period of three months. Failure to return would be likely to lead to the non-payment or repayment of contractual maternity pay.

We asked employers if, in the previous two years, any women had returned to work and subsequently left their employ soon after fulfilling the contractual obligations associated with CMP. Just over half (52 per cent) reported that this had happened, and just under half of this number (48 per cent) reported that they had been caused some difficulties by the departure. Workplaces that experienced such difficulties accounted for one-quarter of all workplaces with arrangements for CMP. An equal number, however, reported no problems associated with the departure of women after they had fulfilled their contractual obligations.

The predominance of public sector workplaces among those with arrangements for CMP meant that the large majority of workplaces experiencing problems were in the public sector. Only three private sector workplaces reported having had women leave work soon after

fulfilling their contractual obligations; only one of these reported having been caused any problems by the departure. For this workplace, as for two-thirds of public sector workplaces, difficulties had arisen in relation to finding replacements for departing employees.

Three per cent of women who received CMP reported having had some problem with their employer about this payment. This was the same proportion as reported difficulties associated with Statutory Maternity Pay. Numerically, of course, we are referring to a substantially smaller group of women with problems than in our discussion of SMP, reflecting the proportionately smaller number of women in receipt of CMP. In all, eleven women reported problems related to CMP. Of these, one had worked in the hotel and catering trade, five had been employed by health authorities, two had worked for education authorities and three for local authorities. Unfortunately, the one private sector respondent, a hotel employee, gave no details about the nature of her problems with her employer.

Health workers, however, provided detailed accounts of misinformation and mismanagement. The five women involved had been employed across all levels of the health service and included a part-time domestic, a student nurse retraining after several years away from her profession, a full-time nurse, a pharmacist, and a health visitor with ten years' experience. The difficulties they reported entailed an alleged over-payment (the domestic); being told at six weeks' pregnancy that she qualified for CMP and at thirty weeks' pregnancy that she did not (the student nurse); being asked to sign a part-time contract before stopping work in order that only part-time maternity payments needed to be paid (the nurse); being told to return to work on a full-time basis or forfeit all CMP paid, when a part-time return had been arranged (the pharmacist); being told to work until the sixth week before the expected week of confinement, and then being told she had worked too long and would lose some pay (the health visitor). All of these problems had been, or were being, sorted out by the time of our survey. Moreover, the women who experienced these problems represented only a minority of health workers who received CMP (6 per cent). Nevertheless, in principle, one might expect that health authorities would be more considerate towards pregnant employees than other types of employers. But in practice, our evidence on problems over CMP and time off work for antenatal care suggests that this was not always the case.

Changes in maternity pay over time

We note at the beginning of the chapter that two major objectives in relation to our analyses of maternity pay were, first, to determine whether, as had appeared to be the case in 1979, women in small firms were less likely to have received their entitlements; and secondly, to establish whether there had been an increase in the extent to which employers provided maternity pay in addition to the statutory minimum. These seemed to be the most important issues arising from the 1979 PSI survey as regards maternity pay. We are unable to compare directly the extent to which changes may have occurred over the decade in the overall number of women who received maternity pay. This is in part because both the types of maternity pay available to women and the conditions for entitlement changed substantially over the decade. Figure 4.1 outlines the conditions women must currently fulfil to qualify for the differing types of maternity pay and provides comparable information about the regulations in effect in 1979.

In 1979, pregnant women in employment who met the statutory weekly hours and continuous service requirements were entitled to six weeks maternity pay from their employers at a level of 90 per cent of salary, less the amount of the flat-rate state Maternity Allowance. Such women would also be entitled to the flat-rate Maternity Allowance payment for a period of up to eighteen weeks. In order to gain the full eighteen weeks' state Maternity Allowance, women would have had to stop working by the start of the eleventh week before the expected week of birth. Women without the relevant qualifying hours and service but who had sufficient insured earnings were entitled to state Maternity Allowance for a period of eighteen weeks, again provided they stopped work by the start of the eleventh week.

The 1979 PSI survey of women did not explore the extent to which women received Maternity Allowance from the DSS, an omission which further hinders our ability to make direct comparisons over time. That survey found, however, that 45 per cent of women in work during pregnancy received maternity pay from their employers upon stopping work. Two per cent received less than six weeks' payment, 26 per cent received six weeks' payment, and 10 per cent received more than six weeks' payment. Seven per cent were unable to remember the number of weeks' maternity pay they had received. It seems likely that some number of these women (particularly those who

received less than or more than the statutory 6 weeks payment) will have received contractual maternity pay. As we suggested earlier, there appears to have been a slight increase in both the extent to which women received CMP and the proportions of private sector employers who provided such pay. In the current survey, 14 per cent of women received CMP.

Figure 4.1 Statutory requirements for maternity payments and type of payment received, 1979 and 1988

Payments in 1979	Statutory requirements	Payments in 1988
	6 months continuous insured employment with the same employer 15th week before EWC+ (1979 and 1988)	18 weeks basic-rate SMP
6 weeks maternity pay at 90% of salary less flat-rate Maternity Allowance; and 18 weeks flat-rate Maternity Allowance	2 years/16 hours pw or 5 years/8-16 hours pw continuous employment with the same employer up to 15th week (1988) or 11th week (1979) before EWC	6 weeks SMP at 90% of salary; and 12 weeks basic-rate SMP
18 weeks Maternity Allowance	6 months insured employment in previous 12 months (1979 and 1988*)	18 weeks Maternity Allowance

+ Expected week of confinement.
* The comparison here is not exact; see below.

The 1979 survey also found that 12 per cent of the women who appeared to fulfil the qualifications for maternity pay did not receive any payment. Women in the private sector, particularly those who had worked in small firms, were markedly less likely to have received maternity pay when they appeared to have satisfied the hours and service requirements. One quarter of the women with qualifying hours and service who had worked for small firms with fewer than

twenty-five employees said that they not received maternity pay, compared with 11 per cent of women in establishments of a similar size belonging to larger firms and only 4 per cent of women in public sector workplaces of similar size. On the basis of the findings of the current survey, we are able to report that there continues to be a shortfall between eligibility for, and receipt of, maternity pay, in relation in this case to both basic-rate and higher-rate SMP. Fourteen per cent of women who appeared to fulfil the qualifications for basic-rate SMP did not receive the payment. For higher-rate SMP, the proportion was 27 per cent. Moreover, a substantial number of women in small firms (21 per cent) who appeared to meet the conditions for Statutory Maternity Pay continued to fail to receive their entitlements. Thus, although the comparison over time may not be exact, it does appear to be the case that there continues to be a shortfall between eligibility for, and receipt of, SMP which appears particularly marked among women who had been employed in small firms.

Notes

1. In order to qualify for Maternity Allowance women must have worked for at least 26 of the previous 52 weeks and paid national insurance contributions. We were not able to construct our question about length of time in last job in a way which could capture the difference between six months of continuous employment ending in the 15th week prior to confinement (the requirement for flat-rate SMP) and six months of interrupted work. Thus we are unable to estimate eligibility for Maternity Allowance.

2. At the time of our research women in legal custody, in the armed forces or outside the European Community when the SMP payment period is due to begin do not qualify for SMP. We were unable to explore these possibilities within the confines of our questionnaire. Since August 1990, women in the armed forces have been able to claim SMP.

3. It is also possible that the error rate *might* vary between women with different types of job histories/stabilities. However, we were unable to measure these differences in our questionnaire.

4. When we designed the questionnaire for the survey of mothers, we judged it likely that women who received contractual maternity

pay might not be aware that some part of that payment comprised higher-rate SMP (provided, of course, that they met the statutory requirements). Accordingly, such women were not asked whether they had had the payment. However, in our subsequent analyses of the extent to which women received higher-rate SMP, we found that excluding women who had had contractual maternity pay resulted in over-complicated explanations of the base used, and generally unsatisfactory results. This was particularly the case in relation to women in the public sector who were the major recipients of contractual maternity pay (see Table 4.29). Therefore, for analytical reasons, we imputed receipt of higher-rate SMP to all women in receipt of contractual maternity pay who satisfied length of service requirements for the statutory payment. We felt that this approach was justified for two reasons. First, our subsequent analyses were more straightforward and easier to understand. Secondly, the primary recipients of contractual maternity pay were women in the public sector, and employers in this sector were particularly likely to be aware of the regulations pertaining to statutory maternity pay and hence likely to reclaim any payments made from the Inland Revenue. Thus it seemed unlikely that attributing payments to women in the public sector would markedly distort the extent to which such women had in fact received the payment through their employers. For women in the corporate private sector and in small firms, attribution of payment appeared less problematic because only 7 per cent and 3 per cent, respectively, of these women received contractual maternity pay.

5. Questions about maternity payment methods were directed at women who received contractual maternity pay or Statutory Maternity Pay. Because over 80 per cent of women receiving contractual maternity pay also received SMP, they are not distinguished in the analysis or the table included in the text. It seems improbable that many of the women who received both payments would have received them via differing methods. Maternity Allowance payments are made to women through a book of weekly orders cashable at a named post office. As women have no choice about the method of payment for Maternity Allowances, we did not investigate whether they had had any problems associated with its payment.

6. In 1979, because the statutory requirements for maternity pay at the higher rate of 90 per cent of salary were the same as the requirements for the right to reinstatement, only women who fulfilled the statutory criteria for reinstatement were asked questions about maternity pay. In this way, women would have been missed whose employers offered maternity pay to women whether or not they had the statutory qualifications. Calculations made in 1979 suggested that about 1 or 2 per cent of women employees fell into this category.

5 The right to reinstatement

The right to reinstatement gives an employed pregnant woman the right, under certain qualifying conditions, to return to work with her former employer at any time before the end of twenty-nine weeks after the birth of her baby. On returning, a woman has the right to be employed on terms and conditions in line with those which would have been applicable if she had not been absent.

There have been changes in the detailed provisions of the statutory right during the 1980s. In June 1976, legislation was passed entitling all women who met continuous service requirements to return to their previous jobs. In 1980, the right to return was qualified. In the case of firms employing five or fewer employees, if the employer can prove to an Industrial Tribunal that it is not reasonably practical to take an employee back, then failure to permit her to return is not treated as unfair dismissal. At the same time, provision was made so that where it is not reasonably practical for employers in larger firms to offer a woman her old job back, they may offer a suitable alternative job with terms and conditions not substantially less favourable than under the former job.

The earlier PSI study of maternity rights concluded that the initial political debate over the right to reinstatement had more to do with its symbolic properties than any practical impact that it had (Daniel, 1981b:82). So far as women employees were concerned, the right resulted in real modest benefits, but it was not associated with any measurable propensity to continue in paid work following childbirth.

So far as employers were concerned, there was no evidence that the right had generated major administrative difficulties for managers, nor that it had made them less willing to employ women of childbearing age. Fewer than one in fifteen employers surveyed by Daniel reported any difficulty associated with the right to reinstatement. Any difficulties found were much more likely to be reported by larger establishments than smaller, and least likely to be reported by independent enterprises employing fewer than 50 people.

Since the 1979 PSI survey it has become more common for women to return to work relatively soon after having a child and to take up their entitlement to reinstatement. In 1979, 41 per cent of women who stopped work for childbirth gave formal notice of return; by the 1988 survey this had increased to 72 per cent. But despite considerable growth in the number of women signalling an intention to return, the proportion of private sector employers who reported having experienced any difficulty associated with the right to reinstatement fell from 14 per cent in 1979 to 5 per cent in 1989. Among public sector employers, the proportion who had had some similar difficulty was 8 per cent. Moreover, in 1988 over 90 per cent of women reported that they had had no difficulties with their employers over the right.

Thus, all the indications are that greater awareness of the legislation, combined with labour market and social changes, has made women more likely to use their right to reinstatement but that, at the same time, greater familiarity with the legislation among employers has meant that it now poses even fewer problems for them.

Levels of qualification for the statutory right to reinstatement
Under British legislation, the right to reinstatement is dependent in part upon continous employment requirements. Women must be employed continuously with the same employer for a minimum of two years and work for at least sixteen hours weekly, or if employed for between eight and sixteen hours, their continuous employment must extend over five years. The extent to which women in work during pregnancy complied with this requirement is detailed in Table 5.1, which also provides comparative information about the situation in 1979.[1]

There has been an noticeable increase in the proportion of women who fulfilled the statutory hours and length of service requirements: from 54 per cent of women employees in 1979 to 60 per cent in 1988.

**Table 5.1 Proportion of women qualifying for the right to return to work
by virtue of hours and service: 1979 and 1988 compared**

Percentages

	Total	I+II	IIIN	IIIM	IV	V†
			Occupational level			
Two years and 16 or more hours/ or five years and 8 or more hours						
1988	60	68	61	61	48	40
1979	54	64	58	66	34	18
Two years and 16 or more hours						
1988	59	67	60	59	46	38
1979	54	64	58	66	34	15
Five years and 8 to under 16 hours						
1988	1	1	1	2	2	2
1979	*	–	*	–	*	3
Base: all employers during pregnancy						
1988	2,514	799	1,015	150	437	93
1979	1,100	246	552	41	212	33

† 1970 OPCS/Registrar General social classes.
* less than 0.5 per cent.

But as in 1979, it remains the case that significant numbers of women employees in work while pregnant do not qualify for the right to return to work after having a baby.

The continuous service requirement has been criticised by those concerned to promote equal opportunities on the grounds that it reduces women's flexibility in the labour market – and hence may reduce their career opportunities – by making it possible that women of childbearing age may have to choose between maintaining their statutory entitlement and advancing their careers through changes of employer. In 1979, the proportion of women entitled to the right to reinstatement would have increased from 54 per cent to 73 per cent, were the present continuous length of service criterion to be replaced with one requiring two years' continous *employment* but not necessarily with the same employer.

It is clear that one change in the qualifying conditions for the right to reinstatement would have a substantial impact upon the proportion of women who qualify. As the qualifying conditions vary so widely in member countries of the European Community and because the issue of harmonisation has become so salient as we approach the Single Market, we also explored the implications of other qualifying requirements. For this purpose, we asked women for information about the overall duration of their labour force participation since first entering the labour market. The results of this analysis are presented in Table 5.2 in relation to the length of time women were employed with their last employer. It is possible that the figures may slightly overstate durations in the labour force, but nevertheless Table 5.2 provides an interesting contrast with Table 5.1.

Table 5.2 **Length of time in the labour force according to length of time with last employer**

Column percentages

| | | Length of time with last employer | | | |
	Total	Under 6 mths	6 mths- under 1 yr	1 year- under 2 yrs	2 or more years
Length of time in labour market					
Under 1 year	1	2	–	–	–
1- under 2 years	2	7	5	7	–
2- under 5 years	15	31	23	25	10
5- under 10 years	39	29	42	39	40
10 years or more	38	22	26	26	44
Not stated	5	9	5	3	5
Base: employees during pregnancy	2,514	139	286	424	1,642

In order to qualify for the right to reinstatement (and other maternity benefits) in most European Community member states, women must be employed and have insured earnings for between six and ten months; in Italy, women need only to be employed and insured

at the beginning of their pregnancy.[2] If Britain were to adopt the requirements of, say, France, Germany or Belgium, the proportion of qualifying women would rise from 60 per cent to 95 per cent (allowing for the 5 per cent in Table 5.2 about whom we have no information). If, alternatively, Britain maintained *two years* as the basic qualifying period, but altered its applicability to cover women's overall time in the labour force, then 92 per cent would qualify for reinstatement.

Variations in the proportion of qualifiers

Table 5.1 also provides comparative information about the extent to which women at different occupational levels met the statutory hours and length of service requirements for reinstatement. The 1970 OPCS/Registrar General's six-point social class schema is used in the table in order to provide a comparison with the 1979 PSI survey. In both surveys, there was a clear tendency for women to be more likely to qualify the higher their occupational level. In consequence, women in higher-level non-manual employment were substantially more likely to have met the statutory requirements than women in semi-skilled and unskilled manual work. A little surprisingly, perhaps, proportionately *fewer* skilled manual workers and proportionately *more* unskilled workers qualified in 1988 than in 1979. In each of these cases, however, the size of the base number in 1979 warrants caution about inferences of marked change.

Table 5.3 re-groups women employees according to the Standard Occupational Classification (SOC). The hierarchical pattern noted in Table 5.1 is maintained here, with a few fluctuations, most notably among plant and machine operatives. Women in sales occupations were the least likely to meet the statutory requirements for reinstatement.

There were also other marked variations in the proportions of women who qualified for reinstatement. Differences according to type of employer are discussed later in the chapter. Here it is worth noting differences in relation to industrial sector. In particular, women employed in distribution, hotels and catering were especially unlikely to qualify for reinstatement (47 per cent) – a situation little changed from 1979 when only 44 per cent of women in distribution had qualified.[3] In manufacturing, however, women's chances of qualifying had improved over the decade: in 1988, 62 per cent of women in manufacturing had qualified compared with less than half

Table 5.3 **Extent to which women qualified for the right to return to work after childbirth according to occupational level**

Row percentages

	Formally* qualified	Not qualified	Base
Managers/administrators	67	33	170
Professionals	67	33	238
Associate professionals	70	30	335
Clerical/secretarial	65	35	798
Craft and related manual	52	48	107
Personal and protective services	48	52	266
Sales	44	56	241
Plant and machine operatives	60	40	159
Other occupations	47	53	180
All	60	40	2,514
Base: All employees during pregnancy	1,509	1,005	

* had worked either 2 years and 16 or more hours or five years and 8 or more hours for same employer.

in 1979. Women who had worked in the financial sector were consistently above average in their tendency to qualify: 72 per cent in 1979; 69 per cent in 1988, while women in other services matched the sample average of 60 per cent.

Age was a further source of variation. As in 1979, older women were more likely to have qualified than younger but, unlike 1979, women over thirty were not substantially less likely to qualify than women between twenty-five and twenty-nine years of age. In 1979, the enhanced likelihood for older mothers to qualify collapsed among women over thirty. Indeed, only a bare majority (51 per cent) of women aged thirty to thirty-four years and less than half (48 per cent) of those aged thirty-five and older had met the statutory requirements compared with almost two-thirds of twenty-five to twenty-nine year old women. In contrast, in 1988 only one percentage point separated

the proportions who had qualified among twenty-five to twenty-nine year old women from their over-thirty counterparts (65 per cent and 64 per cent). Explanations for this change over the decade are likely to include the drift upwards in age at first birth, and an increased tendency for women with more than one child to remain in employment continuously over their childbearing years.

We noted in Chapter 2 that there had been a relative increase in the labour force participation of women whose recent baby was their second or third child. We noted further that this included increases in both full-time and part-time employment. One possible outcome of an upward trend in participation rates among mothers with young children would be an increase in their levels of qualification for reinstatement. And it is indeed the case that proportionately more women with two or more children qualified for reinstatement in 1988 than in 1979, as is summarised in Table 5.4.

Table 5.4 **Proportion of women who qualified for the right to return by virtue of their hours and service according to birth order of recent baby**

		Column percentages		
	Total	First baby	Second baby	Third or subsequent
Two years and 16 or more hours/ or five years and 8 or more hours				
1988	**60**	**68**	**43**	**38**
1979	54	63	33	27
Two years and 16 or more hours	59	68	41	33
Five years and 8 to under 16 hours	1	*	2	5
Base: Employees during pregnancy	2,514	1,728	528	254

* less than 0.5 per cent.

The increase in entitlement to reinstatement among mothers of two, three or more children signals the cumulative effect of an increased propensity for women to return to the same employer

following childbirth, either because of maternity rights legislation or for some other reason. Sixty-eight per cent of women with two or more children at the time of our survey had had the right to return to their old job before the birth of their first baby. Thirty-five per cent of these women had in fact returned to their old job following their first baby's birth. At the time of our survey, some of these women may well have been returning to the same employer following a maternity absence for the second, or even third, time.

Part-time employment and qualification for reinstatement
Often, women prefer to return to part-time work after having a baby. But when they do so, it often leads them to lose their right to reinstatement either because they have to change employers to find a suitable part-time job or because they delay their return beyond the twenty-nine week point or because their hours of work fall below the minimum threshold.

Under current legislation, if women have been employed full-time, they do not have the right to return to work on a part-time basis following childbirth.[4] Informally, though, many appear to have the opportunity to do so. In our survey of employers, there was widespread agreement that women could return part-time if they wished: 84 per cent of public sector workplaces reported that women could come back part-time, together with 76 per cent of workplaces in the private sector that were part of larger organisations and 72 per cent of independent private sector enterprises. A return to work with the same employer which comprises a change from full-time to part-time status may not, however, guarantee continuity of employment in terms of future entitlement to maternity rights or benefits.[5]

Table 5.5 provides an indication of the extent to which part-time and full-time workers differed in relation to their formal qualification for reinstatement rights. Women who had been in work on a part-time basis – that is, women who had worked 30 hours or less a week – made up 28 per cent of all women employees in our survey, but only 14 per cent of all women who formally qualified for reinstatement.

The second column in Table 5.5 is based upon women's *reports* about whether they had the right to return to work and thus includes women who did not have the necessary hours and service. Eighteen per cent of women who worked fewer than eight hours a week reported that they had the right to return to work. According to our calculations,

Table 5.5 **Relationship between hours of work and qualification for the right to return (a) by virtue of hours and service; and (b) according to mothers' own reports**

Percentages

Hours of work	Formally* qualified	Reported qualified	Base
Under 8	–	18	69
8- under 16	12	37	232
16- under 21	43	45	194
21- under 31	52	53	214
31- under 36	79	82	271
36-40	73	76	1,324
Over 40	63	71	163
All	60	66	2,514

Base: Employees during pregnancy

* fulfilled statutory hours and service requirements.

such women would have gained the right either through contractual or collective agreements with their employers or through it being granted at their employers' discretion. Similarly, our analysis suggests that 25 per cent of women who worked for more than eight, but less than sixteen, hours a week had the right to return despite not fulfilling the statutory requirements. In other categories of working hours, the contrasts in the proportions who fulfilled the conditions for the right and who reported the right were more modest. This does not mean, of course, that women with longer working hours had the right to return only through fulfilling the statutory requirements.

Reported levels of qualification for the right to reinstatement
Table 5.5 also gives the first evidence of the extent to which employers had voluntary arrangements or collective agreements that went beyond the minimum maternity provisions. Overall, 66 per cent of women employees reported that they had had the right to return to work following childbirth; just over 2 per cent reported that they failed to meet the statutory requirements but were given reinstatement rights

through a contract of employment. We explore the extent to which
employers provided enhanced maternity benefits in relation to
reinstatement presently. First, however, the relationship between
women's reported qualification and formal qualification for
reinstatement is examined. Table 5.6 gives details of this relationship
and in addition provides comparative data from the 1979 PSI survey.

Table 5.6 **Reported relationship to right to reinstatement according to
whether women satisfied service and hours requirements for
qualification**

Column percentages

| | | Whether had formal qualifications for right | | |
	Total	Had qualifi- cations	Did not have qualifi- cations	Had quali- fications- left 11 weeks or less before EWC†
Reported relationship to right				
Qualified for right/ had contractual right				
1988	**66**	**87**	**33**	**92**
1979	65	88	36	92
Did not qualify				
1988	**20**	**5**	**42**	**3**
1979	21	5	42	2
Did not know whether qualified				
1988	**9**	**5**	**15**	**3**
1979	9	5	14	*
Did not know about the right				
1988	**5**	**3**	**9**	**2**
1979	4	1	7	1
No information				
1988	**1**	**1**	*****	*****
1979	1	1	2	*
Base: employees during pregnancy				
1988	**2,514**	**1,509**	**1,005**	**1,126**
1979	1,100	594	475	387

* less than 0.5 per cent.

† Expected week of confinement.

The symmetry between the two surveys is immediately apparent. There was virtually no change over the decade in the patterning of the relationship between reported rights and statutory rights, nor in the reported levels of qualification. That is, there was a strong correlation between reported qualification for reinstatement and statutory qualification. Only a third of women without qualifying hours and service said they had the right to return, compared with 88 per cent of women with the required hours and service. Moreover, although there was again a substantial minority who said that they had known nothing of the right to return or had not known if they personally had qualified for this right, these women tended to be concentrated among those who lacked the necessary qualifications. Indeed, the evidence from the 1988 survey suggests that there has been little change overall in the extent of women's knowledge about their right to return to work following childbirth.

What did change in 1988, however, was the proportion of women who had fulfilled the statutory requirements for reinstatement. In consequence, the contrast between the proportion with the necessary hours and service (60 per cent) and those who reported that they had had the right to return (66 per cent) was slightly less marked than had been the case in 1979 when only 54 per cent of women had had the statutory requirements. This may well imply a slowing down in the extent to which employers have developed maternity provisions which extend those set out in the legislation, and we offer below some evidence which suggests this does in fact seem to be the case.

We should note, however, that, as was the case in 1979, we were unable fully to disentangle how far women who did not meet the statutory requirements for reinstatement gained the right through contractual arrangements or how far they had been granted an opportunity to return at their employer's discretion. We know that 2 per cent of our sample of women employees reported that, despite not having an adequate service record, they had the right to return because of their contract of employment. But we do not know how far the remaining 4 per cent had only an opportunity, but not a contractual entitlement, to return and how far some of them may have misunderstood our distinction 'contract of employment' and excluded collective agreements which extended reinstatement rights beyond the statutory categories. It is likely that the 4 per cent includes some of both. What is certainly true is that, since the initial PSI study,

proportionately more women had fulfilled the *statutory* requirements for reinstatement, thus rendering proportionately fewer women dependent upon discretionary opportunities.

Variations in relation to reported levels of qualification

Table 5.7 provides a further comparison of women's reported right and statutory right to reinstatement, delineating in this instance variations by type of employer. In addition, the table indicates the extent of increase by type of employer since 1979 in the proportion of women who satisfied the statutory requirements.

Table 5.7 **Proportion of women who reported having right to return compared with proportion who qualified for statutory reinstatement by virtue of hours and service, according to type of employer**

Percentages

Type of employer	Reported right to return	Statutory right to return	
		1988	1979
Civil service	89	85	76
Local/education authority	72	61	*
Health authority	80	71	*
Nationalised industry	67	71	60
All public sector	**77**	**69**	**
Large/medium businesses	66	61	53
Small firms	52	46	42
Former nationalised industry	89	89	***
All private sector	62	57	**
Total	66	60	54
Base: employees during pregnancy	2,514	2,514	1,100

* health or education authority = 62 per cent in 1979.
 local authority = 72 per cent in 1979.

*** not distinguished separately.

** not available.

The most obvious source of variation apparent in Table 5.7 is between the public and private sectors. In terms both of being formally qualified and of having a reported right to return, women in the public sector fared notably better than their private sector counterparts. In particular, women who had been employed in smaller enterprises during pregnancy particularly were much less likely to have had the necessary hours and service or to have had either a contractual right to return or an informal arrangement with their employer. In very small firms – those with ten or fewer employees, only 38 per cent of women had the necessary hours and service which would entitle them to return to work; only 42 per cent reported having had such a right.

Table 5.8 summarises women's reported levels of qualification for reinstatement according to job level, type of employer in workplaces with fewer than 25 employees and industrial sector – three of our primary sources of variation. The strong association between having formal qualifications and reporting the right to return means that the general pattern of variation by occupational level shown in Table 5.8 tends to follow our earlier description of the distribution of qualifying hours and service. Thus, as in 1979, women in higher occupational levels more commonly reported having had the right to return than women in sales or manual work. In addition, women who had been employed as plant or machine operatives continued to be more likely to qualify than other manual workers.

Perhaps the most striking feature in relation to occupational level was the consistently high proportion of skilled (manual or non-manual) and higher-level women without qualifying hours and service who reported that they had had the right to return (Base C). Over one third, and rising to half in the case of associate professionals, of such women without the relevant qualifications nonetheless had the right or opportunity to return to work. This again is much the same pattern as existed in 1979, when it was argued that these were the women who were doing exactly those kinds of jobs that critics of reinstatement had contended would pose the most onerous burdens on employers during maternity absence. However, it appeared then, as it does now, that the need of employers for such employees – or the latter's strength at the bargaining table – far outweighs any considerations of administrative inconvenience. Women in personal and protective service jobs and women in sales jobs were the least favoured as regards access to the right in the absence of qualifications,

Table 5.8 Proportion of women reporting that they had the right to return to work, on three separate bases

Percentages

	Base A*	Base B+	Base C†
(a) Occupational level			
Managers/administrators	76	95	38
Professionals	72	91	33
Associate professionals	80	92	51
Clerical/secretarial	71	91	34
Craft and skilled manual	64	88	39
Personal and protective services	49	74	26
Sales	48	79	24
Plant and machine operatives	60	81	27
Other occupations	52	70	35
(b) Employer type among workplaces with fewer than 25 people			
Public sector	68	88	42
Local/educational authority	64	90	43
Health authority	74	89	45
Other public sector	(16)	(14)	(2)
Private sector	53	79	30
Larger business	60	89	29
Very small firm	48	70	30
(c) Industry			
Manufacturing	65	86	29
Distribution	55	82	28
Hotels and catering	51	69	38
Banking and finance	74	93	31
Other services	67	89	36
Other industries	69	86	33

*Base A: Employees during pregnancy.
+Base B: Employees with qualifying hours and service.
†Base C: Employees without qualifying hours and service.
() denotes actual number.

reflecting also their generally inferior position relative to other women.

We have already shown differences in women's statutory and reported right in relation to type of employer. Table 5.8 provides additional information in this regard, but confines the analysis to workplaces with fewer than 25 employees. The relative positions of the small firm, larger businesses and the public sector remained constant; and again the main difference of interest was to be found between the public and private sectors. In particular, women in the public sector were more likely to have had the right to return, either formally through qualification or as a result of contractual agreements.

The final part of Table 5.8 summarises women's comparative access to the right to return in relation to industrial sector. Of interest are differences with the Standard Industrial Classification 6 'distribution, hotels and catering', where few differences exist as regards the proportion of all employees in the two component parts who reported having had the right (Base A), but rather marked differences exist in how this right was gained. Women employed in hotels and catering were considerably less likely than their counterparts in wholesale and retail distribution to have satisfied the hours and service requirement, largely through part-time working hours, but had more often gained the right through contractual or informal agreement. Women in wholesale and retail distribution, together with women in manufacturing, were the least likely to have had the right in the absence of statutory qualifications. We should stress that, as was the case in 1979, differences in relation to type of employer persisted when occupational level was taken into account.

Ethnic minority women and qualification for reinstatement
The experience of women from ethnic minority groups in relation to qualification for reinstatement differed only marginally from that of other women. Where differences did exist, they tended to suggest that ethnic minority women were more favoured as regards contractual or informal access to the right. Seventy per cent of ethnic minority women reported that they had had the right to return; 53 per cent because they fulfilled the statutory requirements for the right. This compares with 66 per cent of all employees who reported the right; and 60 per cent who had the relevant qualifications. Fourteen per cent

of ethnic minority women did not know, or could not remember, if they had qualified.

Time of stopping work before birth

So far our anlayses have focused upon variations among women in relation to their reported qualification for reinstatement and their qualification for the right based upon length of service and hours of work. Hours and length of service requirements are the prior conditions women need to meet in order to qualify for the statutory right to return. But if a woman who meets these minimal conditions wishes to ensure that she has the right to return, she must also fulfil a number of further conditions. These include, first, remaining in the employ of her employer until immediately before the beginning of the eleventh week before the expected week of confinement; and, secondly, informing her employer in writing at least 21 days before she begins her maternity absence that she will be absent from work to have a baby, that she intends to return to work afterwards and the expected week of her confinement. In addition, if requested to do so by her employer, a woman must produce a certificate of the expected week of confinement signed by a doctor or midwife and, after maternity absence has begun, provide written confirmation of her intention to return. Finally, a woman must inform her employer of the date she proposes to return, in writing, at least 21 days before that date.

It was not possible in an already complex postal survey to ask the many questions that would have been necessary to establish whether any women who fulfilled one part or several parts of these conditions had lost their right to return by a failure to fulful all of the conditions. Nor was it possible to establish whether all women who reported the right and had the necesary hours and service also fulfilled the remaining requirements. Accordingly, we have focused so far upon the proportion of women who met the minimal hours and service requirements, as the most appropriate indicator of the maximum proportion of employees in work during pregnancy who were in a position to make use of the statutory right to reinstatement if they chose to fulfil all the other requirements.

The design of our questionnaire did make it possible for us to refine our analyses of the right to work slightly further by taking into account one of the other conditions, the time at which women stopped work. We asked women how long before the birth they had stopped working

and why they had stopped at that stage. We needed this information in order to calculate the extent of formal qualification for both maternity pay and maternity absence, and to discover whether women timed their decision to stop working in a way which would maintain their statutory rights. Table 5.9 shows the times at which women stopped working in relation to whether they fulfilled the hours and length of service requirements for reinstatement.

Table 5.9 Time at which women stopped work for childbirth according to qualification for statutory reinstatement

Column percentages

	Total	Formally* qualified	Not qualified
11 weeks or less	67	75	57
of which			
0-5 weeks	15	14	16
6 weeks	12	14	8
7-10 weeks	25	26	23
11 weeks	16	21	9
12 weeks	9	9	9
13-15 weeks	5	4	6
16 or more weeks	18	12	28
Base: Employees during			
pregnancy	2,514	1,509	1,005

* Worked for at least two years and 16 or more hours or five years and 8 to 16 hours for the same employer.

The first point to note in the table is the clear link between the qualifying hours and service for the right to return and the time of stopping work. Where women had the relevant hours and service, they were markedly more likely to remain in work until the eleventh week before their baby's birth or later. Three-quarters of qualifying women stopped work during this period compared with just over half of women without the necessary qualifications. Furthermore, twice as many women who qualified left at the eleventh week point. In contrast, for women without statutory qualifications for reinstatement, the eleventh week appeared to have little to distinguish it form other points

at which women might leave work. One in five of non-qualifying women (and one in four qualifiers) in fact left work between the seventh and eleventh week before their baby's birth. These are the times that represent the latest and earliest times for the payment of Statutory Maternity Pay. It would seem plausible to suggest, then, that women's decisions regarding the time when they stopped work were influenced by a desire to maintain their statutory entitlements. Table 5.10 which summarises women's reasons for stopping work according to whether they reported having had the right to return, lends further support to this suggestion.

Table 5.10 Reasons for stopping work according to reported qualification for reinstatement

Column percentage

	Total	Qualified	Did not qualify	Did not know if qualified
To qualify for maternity rights	34	42	17	15
Illness	15	13	19	18
Tired/wanted to rest	22	21	24	26
Personal preference	8	7	12	11
Redundancy/job ended	6	2	12	9
Financial	1	1	1	1
Other reasons	7	6	8	12
Not stated	8	7	6	8
Base: Employees during pregnancy	2,514	1,652	493	220

It is important to note, however, that our data is imprecise in regard to the time of stopping work and its relationship to qualification for reinstatement. The statutory requirements for reinstatement refer to the *expected* week of birth. As we noted earlier, it made more sense for us to ask about the time when women stopped work in relation to the actual birth. But if the baby had been late, women may have left work before the beginning of the eleventh week before confinement and still have met the qualifying time before the expected birth. If they

had been ill, women may have stopped work before the beginning of the eleventh week and, by producing medical certification, remained fully eligible for reinstatement.

This brings us to the second point of interest arising from table 5.9, the extent to which taking into account the time of stopping work modified the proportion of women who met the qualifying conditions for reinstatement. However, given that there are many other qualifying conditions for reinstatement, as outlined above, and given the possibility of imprecision in calculations based upon the time of leaving work, the information provided in this regard in table 5.9 must necessarily be taken as approximate. Calculations based on the table suggest that 45 per cent of women employees both had the qualifying hours and service and remained in work until the eleventh week or later before the birth of their baby, and hence maintained their right to reinstatement after the birth. Calculations based upon a leaving time of twelve weeks or later before the birth suggest that 50 per cent of women employees maintained their statutory rights in this way.[6]

Both of these estimates are well below the 60 per cent of women employees noted earlier who fulfilled the statutory hours and service requirements for reinstatement. Accordingly, they each appear to suggest that substantial numbers of women timed their departures from work in ways that disqualified them from returning under the statutory provisions, had they wanted to do so. We cannot stress too often, however, that these estimates are approximate and do not take into account the possibility of error in women's reports about the time when they stopped working nor the impact of imprecision between actual and expected dates of birth nor the likelihood that some number of women will have left work early because of illness or have had delayed births. Indeed, among women with statutory hours and service who had left work twelve weeks or more before the birth (one-quarter of all women with the relevant hours and service) only about 100 women reported that they did *not* have the right to return to work after the birth. These women are likely to have disqualified themselves from the right to return by leaving early. In total, they represented about four per cent of employees during pregnancy; a proportion that is similar to the estimated five per cent of employees in work during pregnancy in 1979 who had lost their right to return as a result of the timing of their departure from work.

Reinstatement period

Under current legislation, women are entitled to return to work at any time up to twenty-nine weeks after the birth of their baby. These twenty-nine weeks constitute what is referred to here as the reinstatement period or time limit. In 1979, the length of reinstatement periods was explored for two principal reasons; first, to establish how the length of non-statutory reinstatement periods compared with the statutory twenty-nine week period; and secondly, to determine how far employers had increased the length of reinstatement periods through collective or contractual agreements.

In the event, the 1979 survey was able to cast only limited light on these matters. In the first instance, nearly half of the relevant women had forgotten – or reported that they had never known – the duration of their reinstatement rights; in addition, the statutory twenty-nine week period was cited by fewer than one-fifth of women who had had the appropriate qualifications, and many women cited periods considerably below their statutory allowance.

Despite these difficulties, the following patterns emerged from the 1979 survey. First, women who did not have the necessary hours and service to qualify for reinstatement tended to report reinstatement time limits which were more evenly spread across the range of periods. Secondly, the most common period cited by women who did satisfy the legislative requirements was the statutory twenty-nine week period or close to it, while the most common time limit cited by non-qualifiers was only about half of the statutory period. Thirdly, compared with women who had had the appropriate qualifications, women who had reported a right or opportunity to return through contractual or informal agreements tended to have substantially reduced reinstatement periods. Fourthly, there was little sign that employers had moved towards agreements to extend women's reinstatement periods.

We also investigated variations in reinstatement periods in 1988 for similar reasons. The chief difference of substance that emerged related to the fourth point. There were, of course, some changes in detail within the patterns identified. In particular, there was a decrease in the proportion of women, both qualifiers and non-qualifiers, who could not remember or never knew for how long after the birth they were entitled to reinstatement. Further, there was an increase in the proportion of qualifiers who cited the statutory twenty-nine week

period, from one in five to one in four. And finally, there was an increase in the proportion of non-qualifiers who reported relatively short reinstatement time limits. These changes are summarised in Table 5.11, which also provides comparative data from the 1979 PSI survey.

Table 5.11 Reinstatement period recorded by women according to whether they fulfilled statutory requirements for right to return to work

Column percentages

	Total 1988	1979	Formally qualified 1988	1979	Not qualified 1988	1979
1-9 weeks	8	7	6	4	13	11
10-20 weeks	10	8	8	6	17	13
21-25 weeks	6	8	6	8	5	8
26-28 weeks	12	12	13	15	6	8
29 weeks	22	14	25	19	7	4
30+ weeks	9	3	10	4	4	2
Can't remember/ never knew	34	46	31	44	48	53
Base: All women who said they qualified for right to return to work	1,652	712	1,318	434	334	251

It is likely, of course, that much of the seeming lack of awareness about the reinstatement period – among both qualifiers and non-qualifiers alike – arises from the inclusion in Table 5.11 of women who did not return to work after their baby's birth. It is quite plausible that these women would have had no good reason for knowing or remembering the exact duration of a right they had not taken up. In 1979, analyses based on whether or not women returned to work following childbirth showed clearly that where women had returned to their former employer, proportionately fewer had not known or could not remember the duration of their reinstatement period and proportionately more cited the statutory twenty-nine week period.

We also were interested in the relationship between women's knowledge of the reinstatement period and their return to work. Table 5.12 analyses women's reports about the duration of their right to return in relation to the time at which they returned to work after the birth. The table includes only women with a right to reinstatement who had returned to work by the time of our survey, but distinguishes between women with the relevant hours and service and women with only a reported right to return. In the second part of the table, the numbers of weeks of maternity absence or reinstatement have been collapsed to take account of the small number of women covered.

Reinstatement period recorded by women who returned to work according to duration of maternity absence after the birthA number of observations may be made on the basis of the figures provided in Table 5.12. First, as in 1979, women who returned to work were generally more knowledgeable about the statutory reinstatement period. This is as would be expected, and it comes as no surprise that women who returned would be more likely than those that did not to inquire into the limits of their statutory rights. But it is also the case that both groups of qualifying women displayed more knowledge about the reinstatement period, albeit in varying degrees. Secondly, the nearer women came to making full use of the statutory reinstatement period, the closer their accounts of their available reinstatement time came to the statutory leave period. This applies again to both groups of women, although the small cell sizes in the second part of the table require caution.

Table 5.12 also confirms the tendency noted earlier for women with a reported right to return to take periods of maternity absence of much shorter duration compared with women who had formally qualified for the right. Fifty-one per cent of women with the relevant hours and service had returned to work within 20 weeks of their baby's birth, compared with 65 per cent of women without formal qualifications. By 25 weeks after the birth, 61 per cent of formally qualified women were back in work; by 28 weeks, 73 per cent had returned. Among women who reported the right, however, 82 per cent had returned to work within 28 weeks of their baby's birth.

We address the issue of women's return to work more fully in the next chapter. Here we would simply wish to stress that although many women choose to return to work well within the statutory time limit, differences in the speed of return between these two groups of women

would appear to suggest that having a *statutory* right, as opposed to a contractual or discretionary one, does allow or encourage women to take longer periods of maternity leave.

Table 5.12 Reinstatement period recorded by women who returned to work according to duration of maternity absence after the birth

Column percentages

(a) Women with qualifying hours and service

Reinstatement period	Total	Number of weeks maternity absence after the birth				
		1-20	21-25	26-28	29	30+
1-20 weeks	12	19	6	1	–	10
21-25 weeks	4	5	7	5	–	2
26-28 weeks	14	20	25	35	–	9
29 weeks	33	23	37	28	90	27
30+ weeks	14	13	13	16	4	26
Never knew/can't recall	22	28	10	16	5	24
Base:	661	335	67	80	72	97

(b) Women without hours and service who reported having had the right to return

Reinstatement period	Total	Number of weeks maternity absence after the birth			
		1-20	21-28	29	30+
1-20 weeks	28	32	23	–	25
21-28 weeks	14	10	27	–	14
29 weeks	11	5	19	(4)	7
30+ weeks	5	1	12	–	11
Never knew/can't recall	43	51	19	–	28
Base:	151	98	26	4	28

() denotes actual number.

Enhanced reinstatement benefits
One further point raised in Table 5.11 warrants particular comment. The proportion of women who reported reinstatement periods longer than the statutory twenty-nine weeks had more than doubled since 1979; from 4 per cent of qualifying women to 10 per cent. It appears therefore from Table 5.11 that more employers now provide extended reinstatement periods.

Table 5.13 is derived from our survey of employers and examines the various ways in which employers offered enhanced maternity rights in relation to reinstatement. The table demonstrates that such enhancement is much more likely to be associated with employers in the public sector. Indeed, there is hardly any change since 1980 in the proportion of private sector employers who provided enhanced benefits to their women employees.

Table 5.13 **Extent to which employers offered enhanced maternity benefits in relation to women's right to return to work**

				Percentages
	Total	Public sector	Private sector	1980
Reduced service requirement	18	42	2	2
Reduced hours requirement	9	21	1	1
Increased leave after childbirth	13	29	2	2
Base: All workplaces				
weighted	502	193	309	715
unweighted	502	189	313	302

The small number of private sector employers who offered enhanced reinstatement benefits – only 22 workplaces in all – makes detailed analysis of variations among them inappropriate. We can note, however, that only two of these 22 workplaces were independent enterprises: the first, a workplace with fewer than ten employees where women were entitled to increased leave after childbirth; and the other, a slightly larger workplace (25-99 employees) where, in addition to extended leave after the birth, women needed to satisfy a reduced hours of work criterion in relation to that specified in the legislation.

No large independent enterprises offered women enhanced maternity benefits in relation to reinstatement (or, indeed, extra maternity pay, as we saw in Chapter 4).

It may be thought surprising that there has apparently been no movement towards enhanced reinstatement benefits by private sector employers since the 1979 PSI survey, in view of the growing importance of women as a source of labour supply. One explanation for the lack of change may be that there has been no demand for change. Certainly, our current survey offers no evidence that extended or enhanced maternity benefits have figured largely on trade union agendas in relation to collective bargaining. Moreover, extended maternity leave, although important, emerged as an issue of less concern to working women than the provision of childcare facilities (see Chapter 7).

Demands for extensions to the right to reinstatement
In the course of our survey of employers, we asked respondents if, in the previous two years, there had been any negotiations with trade unions over anything specifically to do with the employment of women. Overall, 18 per cent of workplaces with trade unions had had such negotiations: 20 per cent of those in the public sector and 14 per cent in the private sector. Amid the variety of issues cited by employers, such as workplace nurseries, career breaks and equal opportunities, requests for extended maternity rights benefits were cited by only five workplaces, three in the public sector and two in the private sector. We discuss the other issues raised in trade union negotiations in Chapter 7. Here, we simply wish to stress that, as was the situation in 1979 when about 1 per cent of employers reported negotiations concerned with extensions to the reinstatement period, the issue appears to remain a low priority, at least in relation to trade union negotiations.

There was, however, much more interest among women in changes to the right to reinstatement, although issues related to childcare commanded considerably more attention. When asked what changes they wished to see that might make it easier for women to return to work after having a baby, 8 per cent of women in work during pregnancy responded that they would like their jobs held open for longer and about 10 per cent wanted a longer maternity leave period (whether paid or unpaid). A tiny minority (2 per cent) said that they

would like more time to decide whether or not to return to work. In comparison, 50 per cent of women in work during pregnancy cited an increase in childcare facilities as a much desired improvement to their working and family lives.

Employers' attitudes to women who do not qualify for reinstatement

We noted at the beginning of this chapter that more mothers reported a right to return to their jobs than fulfilled the statutory requirements for reinstatement. Although the difference between the two was not as great as was the case in 1979, it nonetheless appeared that many employers had extended the right or opportunity to work beyond the requirements set down in the legislation. We have just seen, however, that outside of the public sector, the extension of maternity rights in relation to reinstatement had only rarely occurred by formal arrangement. Table 5.14 gives the results of our inquiries about

Table 5.14 Employers' views on non-qualifying women returning to work after having had a baby

Column percentages

	Total	Public sector	Part of group	Indep.	All private	1980
			Private sector			
Could come back	28	37	19	26	23	13
Would depend on circumstances	57	41	62	64	65	82
Would be asked to re-apply	7	6	12	3	5	*
Could not come back	2	3	2	2	2	3
Other answers	3	7	2	1	2	*
Not stated	5	6	4	5	4	*
Base: All workplaces						
weighted	502	193	183	126	309	715
unweighted	502	189	188	124	313	302

* does not apply/not available.

Columns may sum to more than 100 because of rounding.

employers' *informal* practices, based upon a question which sought their reaction to a woman who did not qualify for statutory reinstatement but who wished just the same to return to work after having her baby.

The familiar differences between employers in the public and private sectors arise yet again in relation to employers' discretionary practices. Well over a third of public sector employers gave an unequivocally positive reaction: 'Of course... Happy to have her...'; compared with just over one in five in the private sector. In the private sector, the majority of employers qualified their response with a reference to prior job performance, vacancies at the time and similar circumstances. About one in fifteen employers in both sectors reported that the woman would be asked to re-apply, often with the expectation that she would be given favourable consideration.

In practice, of course, the three types of response reported by employers are likely to amount to the same thing: employers by and large would welcome women returning to their jobs after childbirth, provided they retained discretion in relation to any one woman at any one point in time. There was certainly no evidence to suggest that employers had become reluctant to welcome women back.

Levels of notification of return

The most important finding that we have to report in relation to levels of notification of return is that since 1979 the proportion of women who gave such notice has nearly doubled. In 1979, 26 per cent of employees during pregnancy notified their employers of their intention to return to work after childbirth; in 1988 the proportion was 47 per cent. In 1979, 41 per cent of women who had the right to reinstatement gave notice that they would be returning; in 1988 the proportion was 72 per cent.

The 1979 PSI survey report argued that any woman who had the right to reinstatement would, if acting in her own rational self-interest, notify her employer of her intention to return to work whether or not she actually intended to return. A woman would have everything to gain and nothing to lose from doing so. Consequently, it was rather surprising that, at that time, less than half of the women who reported that they had had the right to return gave notice that they would be returning after the birth. It appeared that the majority of women did not act in their own best interests.

It is not our intention to suggest that over the decade women in the labour market have become more inclined to act according to rational self-interest, although this may in fact be the case. We show presently that the marked increase in women giving notice of return is strongly associated with a dramatic rise in the proportion of qualifying women who returned to work following maternity leave. To anticipate our findings a little: in 1979 there was little or no difference in the rate of return as between women with and without the right to return; our current findings, however, suggest a marked difference in women's behaviour. Women who qualified were substantially more likely to have returned, not only to work but to work with their pre-birth employers. In view of that increase, a corresponding rise in the proportions giving formal notice of return should not be unexpected.

Sources of variation in notification of return

In this section, we examine the sources of variation in the proportion of women who gave their employers notice of return. Following the 1979 PSI survey, we carried out our analyses in relation to three separate bases. The first, all employees during pregnancy, allows us to measure the frequency with which different types of employers are prone to notifications of return from different types of women. This provides a quantitative estimate of any potential disruption or administrative burden on employers. Such an analysis does not show, however, the extent to which women with the opportunity to give notice of return took up that opportunity. Accordingly, our second set of analyses are based upon women who said that they had had the right to return to work. Thirdly, we approach the issue from the employers' perspective and examine their reports about the extent to which women who stopped work for childbirth gave formal notice of return. And finally, we return to our first two bases and provide analyses which incorporate the Standard Occupational Classification (SOC) thus providing a baseline against which future change in the propensity of women to give formal notice of return may be measured.

Table 5.15 summarises the main sources of variation based on all employees during pregnancy, and provides comparative data from the 1979 PSI survey. Women's job levels are classified according to the 1970 OPCS/Registrar General social class schema in order to facilitate a cross-decade comparison. The chief points of interest arise in relation to job level and type of employer. And once again, the patterns of

Table 5.15 **Proportion of all women employees during pregnancy who gave employers formal notice of return to work: 1988 and 1979 compared**

Percentages

	Gave notice	
	1988	1979
By job level		
I or II	61	39
IIIN	47	22
IIIM	36	22
IV	33	24
V	28	18
By type of employer		
Public sector		
Civil service	78	38
Local/education authority	61	*
Health authority	60	*
Nationalised industry	56	34
Private sector		
Larger business	46	24
Small firm	27	16
Former nationalised industry	75	**
By hours of work		
Under 8 hours	13	17
8 to under 16 hours	25	20
16 to under 21 hours	32	21
21 to under 31 hours	37	25
31 to under 36 hours	64	27
36 or more hours	53	28
By type of employer and workplace and size		
Public sector		
Under 10 employees	41	36
10-24 employees	59	40
Private sector		
Larger business		
Under 10 employees	37	24
10-24 employees	44	29
Very small firms		
Under 10 employees	23	10
10-24 employees	30	15
Total	47	26
Base: All employees during pregnancy	2,514	1,100

* Local authority = 33 per cent; health or education authority = 37 per cent.
** Not distinguished separately.

variation apparent in the earlier survey are reflected in the later one. Women at all job levels were more likely to have given notice in 1988 than in 1979. But women whose jobs fell into social classes I or II remained substantially more likely to have done so than other women, although there was a marked increase in the rate of notification among women employed in routine non-manual jobs (IIIN). Women in the public sector also continued to be markedly more likely than their private sector counterparts to have given notice. Women in the civil service show a particularly notable increase over the decade, suggesting that attempts made in the civil service over the 1980s to retain their women employees may be taking effect.

An analysis in relation to hours of work and whether women were full-time or part-time workers in the 1979 PSI survey indicated only small differences in the respective proportions who had given notice. In contrast, our current findings show a marked surge in notifications among full-timers. But perhaps the most important change since the 1979 PSI survey has been the absolute increase in notifications among women employed in very small firms. In 1979 women employed in very small firms (less than ten people) and in slightly larger private sector businesses (10-24 people) were much less likely to have given notice of return than women working in larger businesses or in public sector workplaces of similar size. In the 1988 survey, the *relative* rate of notifications between type of employer when size is taken into account was largely unchanged. But within these relative differences by size and sector, the increase in notifications among women employed in the smallest private sector workplaces is substantial.

Table 5.16 summarises the proportion of women who gave notice based on *those who qualified*. Again the table shows a dramatic rise in the level of notifications, whatever characteristic of women's position in the labour market is taken into account. Of particular interest is the virtual disappearance of differences between women according to their hours of work. Women working part-time had been nearly as likely as those working full-time to give notice of return when they had had the opportunity to do so.

Moreover, in comparison with Table 5.15 the contrasts between different types of women are rather muted, although the same basic patterns of notification remain. Thus, although women who had been employed in higher-level jobs and women in the public sector continued to be much more likely to have given notice of return, the

Table 5.16 Proportion of all women reporting the right to reinstatement who gave employers formal notice of return to work: 1988 and 1979 compared

Percentages

	1988	1979
By job level		
I or II	81	52
IIIN	71	33
IIIM	60	36
IV	60	47
V	58	
By type of employer		
Public sector		
Civil service	87	45
Local/education authority	83	*
Health authority	75	*
Nationalised industry	84	43
Private sector		
Larger business	70	38
Small firm	51	34
Former nationalised industry	84	**
By hours of work		
Under 8 hours	(9)	***
8 to under 16 hours	66	53
16 to under 21 hours	73	52
21 to under 31 hours	69	46
31 to under 36 hours	79	34
36 or more hours	71	40
By type of employer and workplace size		
Public sector		
Under 10 employees	67	54
10-24 employees	82	50
Private sector		
Larger business		
Under 10 employees	67	46
10-24 employees	68	43
Very small firms		
Under 10 employees	50	24
10-24 employees	54	31
Total	72	41
Base: Employees reporting right to reinstatement	1,652	712

* Local authority = 38 per cent; health or education authority = 49 per cent.

** Not distinguished separately.

*** 1988 Base (13) too low for percentages; not included in 1979.

differences between them and women in manual jobs or women in the private sector were substantially less pronounced than had been the case in 1979. This particularly holds true for women in very small firms (less than 10 people), where half of the qualifying women had given notice compared with only one quarter a decade ago. It is also worthy of note that among ethnic minority women, 76 per cent of those who qualified for the right to return gave formal notice of their intention to return.

Our final examination of variations among women who gave formal notice of return is presented in Table 5.17 which re-classifies women on two separate bases according to the Standard Occupational Classification.

Table 5.17 Women who gave notice of return as a proportion of (a) all employees during pregnancy and (b) all women who reported the right to reinstatement

Percentages

	Gave notice	
	Employees during pregnancy	Had right to return to work
Job level		
Managers/administrators	58	77
Professionals	63	87
Associate professionals	63	78
Clerical/secretarial	51	72
Craft and skilled manual	36	55
Personal and protective services	36	71
Sales	30	63
Plant and machine operatives	35	59
Other occupations	31	59
Total	47	72
Base number:	2,514	1,652

The same basic patterns illustrated in Tables 5.15 and 5.16 reappear in Table 5.17: women higher up the occupational hierarchy were more likely to have given notice of return; differences among

women tend to become muted when only those women with the right to return are taken into the analysis.

The status of women who give notice of return

As we outlined at the outset of the chapter, a woman who qualifies for the statutory right to reinstatement has the right to return to work on terms and conditions 'not less favourable that those which would have been applicable to her if she had not been so absent'. Women on maternity absence remain formally in the employ of their employers only if this is provided for contractually. However, the statutory provisions for maternity absence mean that, if a woman returns to work, her absence does not break her continuity of employment.[7]

The 1979 PSI survey estimated that in only about two-thirds of private sector establishments, mainly those that were part of larger businesses, did employers treat women on maternity leave as if they were continuously employed.

We also were interested in this issue and investigated whether employers retained women's P45 tax forms during paid and unpaid maternity absences; if paid and unpaid leave counted towards pension or holiday entitlements; and if women's salaries continued to rise in accordance with set salary scales during paid and unpaid leave. Details of the extent to which different types of employers maintained these formal links are provided in Table 5.18.

The most striking difference arises between the public and private sector. Public sector employers were much more likely to treat women on leave as continuously employed, whichever indicator is taken into account. This was especially the case during periods of paid maternity absence, but applied also to periods of unpaid leave. Within the private sector, independent enterprises tended less to maintain formal links with women on leave, particularly in the very smallest workplaces with ten or fewer people. However, across both private and public sectors the likelihood of formal links being maintained increased with the size of the workplace. Indeed, respondents in the smallest workplaces – especially in the private sector – frequently did not know or were uncertain whether such links existed.

Taking workplace size into account suggests that there has been little change among private sector employers in the extent to which they treat women on maternity leave as continuously employed. For employers in both sectors, maintaining such links with women would

Table 5.18 Extent to which employers maintain formal links with women on maternity absence according to type of employer

Percentages

Formal link	All	Public sector	Private sector Part of group	Indep.	All private sector
P45 retained:					
during paid absence	77	85	62	68	65
during unpaid absence	69	80	55	54	55
Absence calculated towards pension:					
during paid leave	78	80	54	42	50
during unpaid leave	47	48	40	26	34
Absence calculated for holiday entitlement:					
during paid leave	63	78	44	48	46
during unpaid leave	35	38	32	27	30
Incremental salary rises continue:					
during paid leave	68	83	52	48	51
during unpaid leave	57	65	48	44	46
Base: all workplaces					
weighted	502	193	183	126	309
unweighted	502	189	180	124	313

appear to be a relatively simple strategy for encouraging them to return to work following childbirth, and one might, consequently, have expected greater change over the decade. However, it is probably not the case that some employers treat women as continuously employed, while others do not, because of differing levels of priority or different strategies for retaining staff. Rather, given the contrasts between public and private sector employers and, within the private sector, between larger and smaller workplaces, it seems more likely that such differences reflect the prior influence of long-standing contractual arrangements for pregnant women, brought about as a result of collective bargaining, especially in the public sector.

Fulfilment of notifications of return

We have shown that, compared with a decade ago, notifications of return have increased substantially, and that nearly three-quarters of all women who had the right to reinstatement signalled an intention to return. We have also shown that, although women who had been employed in small firms were much less likely that those in other types of workplaces to have given formal notice of return, the contrast was less marked than it was previously. In this section we examine the extent to which women fulfilled their expressed intentions and returned to work with their former employers. We also examine the extent to which women's *expressed* intentions matched their *actual* intentions and subsequent behaviour, and see how this has changed since 1979. And finally, we explore sources of variation in levels of return following notification. Our aim is to provide some measure of the incidence of failure to return following notification, and to assess which types of jobs and which types of employers appear to be most prone to such failure.

Part of our assessment of the extent of failure to return following notification is based upon a question to mothers about what their future employment intentions had been during their pregnancy. Table 5.19 provides information about women's responses to this question in relation to their subsequent behaviour and compares this information with the 1979 PSI survey.

Table 5.19 Notification and subsequent experience: 1979 and 1988 compared

		Column percentages
	1988	1979
Notified and returned to same employer	50	37
Notified and returned to different employer	9	5
Had hoped or planned to return but did not	21	22
Had no intention or expectation of returning	19	35
Base: All who gave notice of return	1,187	297

We have based Table 5.19 on all women who had given formal notice of their intention to return, on the grounds that this group of

women was the most appropriate unit of analysis from the perspective of the employer.[8] Employers who receive formal notification must be prepared – in principle if not always in practice – to have a suitable job available for a woman upon her return from maternity leave. And although some women who give notice ultimately *may not* return, an employer can normally be assured that women who do not give notice of return *will not* return.[9]

Of the women who gave notice, 50 per cent fulfilled their intentions,[10] 30 per cent had planned or hoped to return but had failed to do so, or were working for a different employer, and 19 per cent had had no intention or expectation of returning, despite having given notice. But before we consider the sources of variation among women returners, it is important to put into perspective the extent of failure to return. Table 5.19 indicates that, in 1979, 63 per cent of women who gave notice did not ultimately return to work with their former employers. Thirty-five per cent had not expected or intended to do so, but had nonetheless kept their options open. Since 1979, there has been a marked drop in non-fulfilment of notification, largely as a result of a reduction in the extent to which notification was given by women who had no intention of returning to work. Furthermore, there was an increase in the proportion of women who, although they failed to return to their former employers, did in fact return to work. We show in Chapter 6 that changes in employer were made almost exclusively by women who entered part-time employment upon their return to work. If similar opportunities had been available with their pre-birth employers, the proportion of women fulfilling their notifications would then have approached 60 per cent – a rather remarkable reversal of the situation only one decade ago.

Variations by occupation level in women's return to work following notification are examined in Tables 5.20 and 5.21. The first classifies women's pre-birth jobs according to the Standard Occupational Classification, while the second utilises the 1970 OPCS/Registrar General's classificatory system in order to make comparisons with the 1979 PSI survey. In both tables, and across the decade, the underlying pattern of return is the same: women in higher level occupations were much more likely to have returned to work than women in junior non-manual or skilled manual jobs. This pattern repeats itself in the next chapter when we analyse the return to work behaviour of all women who had been in work during pregnancy. Here

it should be noted that it is a pattern that the passage of time and an increase in the level of notifications has muted, but not fundamentally changed. However, it was also the case that women who had been employed in manual jobs during pregnancy were much more likely to change employers upon their return than women in non-manual work.

Table 5.20 **Proportion of women giving notice of return who returned to work according to occupational level**

Percentages

	All who returned	To same employer	To different employer	Base
Managers/administrators	65	57	5	99
Professionals	75	70	3	148
Associate professionals	81	75	4	210
Clerical/secretarial	46	37	8	407
Craft and skilled manual	34	21	13	38
Personal and protective services	61	52	10	93
Sales	40	29	10	73
Plant and machine operatives	59	34	20	56
Other occupations	62	49	11	55
Total	59	50	9	1,187

Base: All women who gave notice of return

Major differences in rates of return associated with type of employer and size of workplace also existed. Women who had worked in the civil service or for health, education or local authorities were all much more likely than others to have fulfilled their notice to return. Within the private sector, women who had been employed in small firms were more likely to have returned to their former employers than women in larger businesses. Forty-two per cent of women in small firms had gone back to work with their pre-birth employers, compared with only 29 per cent of women in larger businesses. Women in private sector establishments with more than 100 employees were particularly *unlikely* to have fulfilled their notification, relative to women in other size workplaces.

Table 5.21 Proportion of women giving notice of return who returned to the same employer: 1988 and 1979 compared

Percentages

	1988	1979
By job level		
I-II	68	62
IIIN	36	
IIIM	30	20
IV-V	45	34
By type of employer		
Public sector		
Civil service	70	
Local/education authority	65	
Health authority	74	47
National industry	(8)	
Private sector		
Larger business	29	18
Small firm	42	22
Former nationalised industry	59	*
By type of employer and workplace size		
Public sector:		
Under 100 employees	65	47
Over 100 employees	69	*
Private sector:		
Larger business		
Under 100 employees	33	18
Over 100 employees	25	*
Small firms		
Under 100 employees	41	28
By hours of work prior to pregnancy		
8 to under 16 hours	60	(12)
16 to under 31 hours	64	69
31 to under 36 hours	51	40
36 or more hours	47	26
By order of recent baby		
First baby	44	29
Second baby	67	66
Third or subsequent	70	53
Total	50	37
Base: All women who gave notice of return	1,187	297

* Not distinguished separately.

() denotes actual number.

Table 5.21 demonstrates that these patterns of return and non-return, like those associated with job level, tend to reflect the

findings from the earlier PSI survey, as do those associated with age, hours of work and birth order. Perhaps the most remarkable difference over time is not one that is related to the pattern of differences among women, which appears to be relatively stable, but one which we have stressed previously. The level of returns to work has substantially increased, among every category of women.

The association between entitlement to reinstatement and levels of return to work

Having an entitlement to reinstatement following childbirth is far from being the only influence on a woman's decision to return to work. The type of job a woman has, the availability of employment, her education and age, the number of other children in her family, whether she is married and what job her partner has, how much she is able to earn – all of these may influence her decision. We explore the patterns of women's return to work fully in the next chapter. First, however, we judged it worthwhile to explore the association between statutory entitlement and the level of women's return to work. We do not at this stage attempt to disentangle the importance of qualifying for reinstatement compared with other influences on women's behaviour. That is a task we reserve for the next chaper. A strong association between returning to work and qualification for reinstatement may or may not indicate a causal influence upon women's behaviour. Before detailing the nature of the association, however, we must establish whether in fact such an association exists.

Our present aim is to provide a descriptive account of the association between qualification for reinstatement and women's levels of return to work. Table 5.22 summarises the comparative experiences of women according to whether they satisfied the hours and service requirements for statutory reinstatement. In sharp contrast to the 1979 PSI survey, women with statutory entitlement were markedly more likely to have returned to work, to have returned full-time, to have returned to their pre-birth employers and to have returned to their previous or similar job. Moreover, if we take the time of stopping work into account (eleven weeks or less before the expected week of confinement), the proportion of women who qualified and were back in work rises to 53 per cent in 1988, while the proportion who returned to their previous employer rises to 43 per cent.

Table 5.22 Qualification for reinstatement and returning to work: 1979 and 1988 compared

Percentages

	1988	1979
In work		
qualified	48	22
not qualified	38	25
Over 30 hours		
qualified	20	6
not qualified	6	5
Same employer		
qualified	39	15
not qualified	21	15
Same/similar job		
qualified	36	14
not qualified	21	14
Seeking work		
qualified	21	12
not qualified	22	16
Base: Employees during pregnancy	2,514	1,100

Table 5.22 is based upon all women who had worked during pregnancy. Thus, we are comparing the experiences of women who had been in part-time employment with those of women who had worked full-time; we are comparing the experiences of women teachers and nurses with those of women who had had sales jobs in small corner shops. We are not, in other words, comparing like with like. But we make no attempt to sort out these differing strands until the next chapter. Instead, our intention is to show that over the decade there was a reversal of the rather paradoxical finding of the 1979 PSI survey, where it was found that there was, if anything, a slight tendency for those who *had not qualified* for reinstatement to have been more likely to return to work than women who qualified. It seems now, however, that there is a strong positive association between the reinstatement right and patterns of return to work. In the next chapter

we analyse the extent to which the right operated independently of other influences upon women's return to work and find that it was not a statistically significant independnet influence.

Problems associated with the right to reinstatement

We turn now to an examination of the extent to which women's right to return to work gave rise to problems, either for women themselves or for their employers. Our inquiries with respect to women and reinstatement were based upon a general question which asked whether any difficulty had occurred with their employers over their right to return to work. From the perspective of employers, however, our concerns were wider. We retained a general interest in the extent to which problems arose in relation to reinstatement and the nature of those problems, but we were concerned also with the specific issue of maternity absence. Accordingly, we examined whether the jobs women did while working had caused any problem for employers during maternity absence; which jobs represented particular sources of difficulty; and the nature of other problems associated with the temporary replacement of women on maternity absence.

Table 5.23 summarises the extent to which women had experienced problems with their employers about their right to return to work. In order to focus attention on the most appropriate group of women, our analyses were confined to women who gave their employers notice of their intention to return to work following childbirth, leaving aside those who qualified for reinstatement but showed no formal sign of wanting to return. The proportion of women who had had such problems was small, but nonetheless had doubled since the 1979 PSI survey. Surprisingly, perhaps, the women most likely to have had problems were managers and administrators; 9 per cent of these women reported some problem compared with, for example, only 2 per cent of women employed in associate professional occupations and 5 per cent of women in craft and skilled manual jobs.

Table 5.23 also indicates some variation among mothers who experienced problems over reinstatement according to the size of workplace and sector in which they were employed. In general, the smaller the workplace, the more likely women were to have had problems. For example, women in the smallest workplaces (fewer than 10 employees) were almost three times as likely as women in workplaces with over 100 employees to have run into difficulties over

Table 5.23 Proportion of women reporting difficulties with their employer about the right to return to work after childbirth

Row percentages

		Base
By occupation		
Managers and administrators	9	99
Professional occupations	5	149
Associate professional occupations	2	210
Clerical and secretarial	4	410
Craft and skilled manual	5	38
Personal and protective service	4	95
Sales occupations	5	73
Plant and machine operatives	2	56
Other occupations	5	55
By industry		
Manufacturing	6	177
Distribution	5	128
Finance and banking	5	191
Other services	3	605
Transport and communication	14	42
By size of workplace		
under 10 employees	8	133
10-24 employees	5	188
100 or more employees	3	558
By sector		
Public sector	3	543
Private sector	6	550
Other	3	70
No information	7	30
All reporting problems	4	1,187

Base: All women employees
who gave notice of return

reinstatement. And although women in the private sector tended overall to have had more problems over reinstatement than women in the public sector, women employed in transport and communication were particularly prone to difficulties in this area.

In all, however, only forty-eight women had experienced problems associated with reinstatement; the number of women involved was not large enough for us to carry out detailed analyses of the nature of the problems faced by them. Table 5.24 therefore provides only an overall account of the difficulties encountered by women over their right to return. The most common problem that arose concerned the jobs they were to do upon their return. This was expressed in uncertainty or confusion over the nature of the job or, in some cases, there being no job available. Job-related reinstatement problems accounted for half of the difficulties reported.

Table 5.24 **Nature of problems encountered by women who gave notice of return and experienced difficulties**

	Column percentages
No job to return to	1
Uncertainty/confusion about which job to return to	1
Made redundant while on leave	1
Employer lost notification of return/confused over return to work procedures (rights)	*
Part-time return requested and refused	*
Employer wanted earlier than agreed return date	*
Pressure to return despite illness	*
Dispute over holiday entitlement	*
Other problems	1
All	4
Base: All women employees who gave notice of return	1,187

* less than 0.5 per cent.

Employers' problems with the right to reinstatement

We investigated the extent to which employers had experienced any problems associated with women's right to return to work in three ways. First, we asked employers a direct question about reinstatement: *'Have you ever been caused any problems by a woman exercising her statutory right to return to work after having a baby?'*. For employers who had had such problems, the nature of the difficulty was then followed up. We also asked employers if there were any specific jobs that represented sources of difficulty when their incumbents took maternity leave, and explored both the nature of those jobs and the difficulties associated with arranging temporary cover. And finally, at a later stage in the interview, we asked employers the general question: *'Has maternity rights legislation caused you any particular problems in recent years?'*.

We have shown already in Chapter 3 that employers' responses to our general question indicated a sharp drop in the extent to which private sector employers had had any problems related to the right to reinstatement, from 9 per cent in 1980 to only 3 per cent in 1989. Here we explore employers' responses to our more direct questioning about problems linked to women's right to return. However, before proceeding to these analyses, we want to stress yet again that our method of selecting employers deliberately over-represented workplaces that were likely to have had some problem associated with women's maternity rights. As we pointed out earlier, an employer with ten employees is likely to have one stop working for childbirth every eight or nine years; an employee with ten *women* on staff will generally experience one who stops work every three or four years. But all of our employers had within the previous two years employed a woman who had stopped working, either permanently or temporarily, in order to have a baby. The rate at which problems related to reinstatement occur among these employers is likely, therefore, to exaggerate the extent to which such problems would be found among employers generally.

Tables 5.25 and 5.26 provide the results of our direct questioning of employers about whether they had ever experienced any difficulties associated with a woman taking up her statutory right to return, and are, in effect, the mirror image of our questions to mothers reported above. In asking a direct question, we found that 6 per cent of employers reported some problem associated with reinstatement –

Table 5.25 **Proportion of employers who reported ever having had problems arising from the right of women to return to work following childbirth**

Percentages

Workplace sector	Public sector	Private sector Part of group	Indep.	All private sector
1 - 24	3	–	4	2
25- 99	6	2	5	4
100-499	5	8	–	6
500+	14	15	9	13
All	6	6	4	5
Base: All				
weighted	193	183	126	309
unweighted	188	189	124	314

Note: For numerical bases see Table 5.28.

Table 5.26 **Nature of employers' problems arising from the right of women to return to work following childbirth**

Column percentages

Problems getting job done while woman absent for childbirth	2
Dispute over which job woman will return to	1
Difficulty in keeping senior job open	*
Failure to return	*
Statutory reinstatement period extended by illness	*
Other difficulties	2
All	6
Base: All employers	
weighted	502
unweighted	502

* less than 0.5 per cent.

slightly more, as would be expected, than volunteered the problem in response to our more indirect inquiries as reported in Table 3.1. The same general pattern of responses emerged: public sector employers were marginally more likely than their private sector counterparts to have reported problems associated with reinstatement; difficulties with reinstatement tended to increase with the size of the workplace, independently of sector.

The nature of the problems cited by employers (Table 5.26) anticipated our inquiries about whether managers felt that particular jobs represented potential sources of difficulty during maternity absence. The problem most likely to face managers was how to get a particular job done while the incumbent was temporarily absent; the jobs most often cited in this regard were at the supervisory or junior technical or professional level. Overall, nearly half of our managers reported that particular jobs might cause some problem, with those in the public sector more likely to suggest that this was the case. There was, however, a slight decrease in the proportion of private sector employers who reported that particular jobs were potential sources of problems, from 39 per cent in 1980 to 37 per cent in 1989. Table 5.27 summarises the employers' responses.

Changes in women's labour force participation over the decade are reflected in Table 5.27, particularly in the responses of private sector employers: secretarial work, which was cited as a potential source of problems by one in five private sector employers in 1980 who had specified that problem jobs existed, was in 1989 mentioned by only one in ten. Taking up the gap were jobs higher up the occupational ladder, at supervisory, junior management and junior professional levels. This is not to suggest that women were no longer performing secretarial jobs in 1989; clearly many were. Rather, employers' concerns about which jobs posed the greatest problem during maternity leave had shifted upwards, taking account of women's increased participation at higher occupational levels. Private sector employers were also slightly more likely to cite middle and senior managerial or professional jobs as potential problem jobs in 1989 than they had been in 1980, but here the change was less marked.

It was, however, in the public sector that managers expressed the greatest concern about the temporary absence of women who held higher-level non-manual jobs. Nearly half of all public sector managers who cited problem jobs referred to supervisory or junior

Table 5.27 **Proportion of employers who reported that there were specific jobs that represented possible sources of difficulty during maternity absence**

Column percentages

	All	Public sector	Private sector	1980
Some problematic job	43	54	37	39
No problematic job	54	46	61	61
Can't say	3	–	2	–
All answers(a)	100	100	100	100
Job level				
Middle or senior management or professional	24	25	23	21
Supervisory or junior management or professional	29	44	17	10
Secretarial	8	6	10	20
Clerical	13	6	19	18
Sales & related	6	1	10	13
Skilled manual	4	1	6	7
Other manual	8	11	6	9
Base:(b)				
weighted	217	103	114	246
unweighted	216	101	115	104

(a) the base here is all employers.

(b) the bases for both 1989 and 1980 include only those workplaces where respondents felt that there were problem jobs.

managerial or professional jobs when asked about potential problems; when taken together with middle-level and senior jobs, these two occupational levels accounted for almost 70 per cent of their expressed concerns. It is, of course, within the public sector that women are most likely to hold positions requiring a high degree of skill and expertise.

The problem confronting employers during maternity absence, in both the public and the private sector, is how to fill a vacancy that is

only temporary. Difficulties associated with replacement personnel for an employee on maternity leave dominated the employers' reports about the types of problems that they were caused by such an absence. Other problems were cited, and included disruption to teamwork (1 per cent of all employers), having no vacancy for a good temporary worker once maternity leave had ended (2 per cent), loss of client continuity (3 per cent) and increased workloads for remaining staff (4 per cent). These and other similar problems were cited by 15 per cent of employers, in contrast to 43 per cent who had mentioned problems associated with finding replacement personnel (respondents were able to mention more than one problem).

Table 5.28 summarises employers' concerns related to needing replacements for women on temporary maternity leave. Again, public sector respondents tended more often to mention potential problems associated with women in senior or specialised positions, and this largely accounts for the differences between employers by industrial sector. The financial costs of hiring replacements were mentioned by 11 per cent, with perhaps a less marked difference between the public and private sectors than might have been expected. Larger workplaces were slightly more likely than smaller ones overall to have had problems associated with finding replacements, but, as the table indicates, smaller workplaces were not free of difficulties in this area.

The way in which problems related to the right to reinstatement were explored with employers in 1989 makes it difficult to draw direct comparisons with 1980. In 1989 we approached employers directly about whether they had ever been caused any problems by a woman exercising her right to return to work following childbirth. In 1980 similar information was elicited through a general question on problems with maternity rights. Despite being unable to make an exact comparison over time, however, it seems fair to suggest that, in the private sector at least, the incidence of employers who had had problems in this area decreased over the decade. It seems likely, moreover, that any decrease in problems with reinstatement can be accounted for largely by a heightened awareness among employers of the importance of encouraging women employees to return to work. As was the case in 1980, employers in 1989 are more likely to face problems as a result of women's decisions *not* to return to work, than to be inconvenienced by a woman taking up her right to do so.

Table 5.28 Proportion of workplaces reporting problems associated with the temporary replacement of women on maternity absence

Percentages

Replacement problems concerned	Specialist/ senior jobs	General cover	Financial costs	Base	
Workplace size				Weighted	Unweighted
Public sector					
Under 25 employees	18	21	6	48	34
25-99 employees	35	12	8	54	49
100-499 employees	(5)	(5)	(1)	38	40
500 employees or more	35	15	15	53	65
All public sector	**27**	**15**	**9**	**193**	**188**
Private sector Part of group workplaces					
Under 25 employees	12	10	7	54	41
25-99 employees	9	4	9	40	46
100-499 employees	19	11	16	51	62
500 or more employees	(11)	(5)	(10)	38	40
All part of group	**17**	**10**	**14**	**183**	**189**
Private sector Independent workplaces					
Under 25 employees	6	8	4	63	48
25-99 employees	(5)	(1)	(3)	32	37
100-499 employees	(6)	(3)	(5)	21	26
500 or more employees	–	(1)	–	10	11
All independent	**13**	**8**	**9**	**126**	**124**
All private sector	**16**	**9**	**12**	**309**	**314**
Industrial sector					
Other services	27	14	9	197	187
Manufacturing	16	10	13	76	83
Distribution	16	8	13	120	119
Finance/Banking	17	13	12	60	60
Other	15	8	9	53	49
All workplaces	**20**	**11**	**11**	**502**	**502**

Notes

1. Hours and length of service are the prior conditions women need to meet in order to qualify for the statutory right to return. There are, however, further conditions that must be met and these are discussed later in the text. The data for 1979 are taken from Daniel, 1980 Chapter IV, *Extent of qualification for statutory maternity rights*, rather than the chapter on reinstatement because in 1979 qualification for maternity pay and the right to reinstatement were based upon the same statutory requirements, that is, those which in 1988 apply only to Statutory Maternity Pay at the higher rate and to the right to reinstatement. For a discussion of the qualification requirements for Statutory Maternity Pay, see Chapter 4.

2. In Belgium, Ireland, Luxembourg, the Netherlands and Portugal the requirement is six months' insured employment; in West Germany and Spain it is nine months; in France and Denmark, ten months. For full details, see *Table of Social Benefit Systems in the European Communities*, Position at 1 January 1989, International Relations (Social Security) Department of Social Security, 1989.

3. Breaking SIC 6 into its two main component parts reveals a pattern of qualification for reinstatement that is typical of other areas: there was, in other words, a somewhat higher proportion of qualifiers in distribution (49 per cent) than in hotels and catering (44 per cent).

4. Although there is no statutory right to return part-time, there have been a number of successful cases involving the right to jobshare, brought under the Sex Discrimination Act, most notably Holmes v. The Home Office 1984 EAT. This involved a civil servant successfully claiming the right to work part-time after the birth of her second child. The success of the case may explain some of the changes observed between 1979 and 1988 in rates of return among women in the civil service and in the public sector more generally.

5. Employment continuity may be jeopardised if working hours after pregnancy fall below 16 hours weekly.

6. These calculations approximate those given in Chapter 4 in relation to higher-rate SMP, where it was noted that 42 per cent of women employees reported that they had received higher-rate

SMP and 51 per cent appeared to have fulfilled the statutory requirements for the payment.

7. Under the Social Security Act 1989, all paid maternity leave will be pensionable from 1993, whether or not a woman returns to her former employer.

8. An alternative course would have been to base our analyses on information from our survey of employers. In that survey we asked questions about the number of women who had given notice, the number who had returned to work and the number who were still on leave during the previous two years. We assumed at the design stage that calculating the number of women who *failed* to return would be a simple task of arithmetic. But although we were ultimately able to make sense of answers to the first of these questions – the number who gave notice – the other calculations proved impossible. On a great many occasions, employers could provide only estimates of non-return; on others, they failed even to do this. It is likely that most of our problems in this area stemmed from employers' understandable inability to remember the details of all the women who had left their employ.

9. We should note that an employer may certainly be assured that a woman who does not give notice will not return on the basis of the statutory right to do so. But she may certainly return if she subsequently decides she wants to and her employer agrees with her decision.

10. It should be stressed that this proportion does not represent the extent of statutory reinstatement. First, included among the 50 per cent of returners are women who had not fulfilled the statutory qualifications but who had reported a right to return. Secondly, about half of the women who returned did so to reduced working hours. As discussed earlier, statutory reinstatement does not entitle women to return from full-time to part-time working hours.

6 Returning to work

We note in the Introduction that since the 1979 PSI survey there has been a marked increase in women's return to work following the birth of a baby. In 1979, of all women who worked during pregnancy, 24 per cent were in work again within eight or nine months of the birth and a further 14 per cent were looking for jobs. By 1988, 45 per cent of women who had worked during pregnancy had resumed employment within this same time period, and 20 per cent were seeking work. In one decade, then, the rate of economic activity after the birth among women in work during pregnancy increased from just less than 40 per cent to 65 per cent.

These figures relate to women who had worked during pregnancy. However, an increased propensity towards an early return to work was found even when the analysis was based upon all women who gave birth in December 1987/January 1988. Twenty-eight per cent of our full sample of women were in work by the time of the survey, some eight or nine months after the birth. An additional 18 per cent were seeking work. This compares with 15 per cent in work and 9 per cent seeking work among all women who had babies in the early spring of 1979. Tables 6.1 and 6.2 summarise the pattern of women's return to work in 1988.

Table 6.1 is based upon all women covered by our survey and categorises women according to their working status before the birth. Of the 28 per cent who were in work within eight or nine months after their baby's birth, 9 per cent had returned, on their own definition, to

full-time working hours and 19 per cent had returned to part-time hours. Women who had been in work during pregnancy were substantially more likely than other women to be economically active. But in addition, a minority of women who had never worked before the birth were now in the labour force, together with one in ten women whose most recent employment had been one or more years before the birth.

Table 6.1 Working status eight to nine months after the birth according to working status before the birth

Column percentages

| | | Working status before the birth | | |
	Total	Had never worked	Not in work 12 months before	In work during pregnancy
Status after the birth				
In work	28	8	10	45
Full-time	9	1	1	15
Part-time	19	6	8	29
Not in work	72	92	90	55
Seeking work	18	15	14	20
Base: All women	4,991	828	1,358	2,635

Table 6.1 shows the rates of return for all women in our survey. Table 6.2 is based upon women who had been in work during pregnancy and takes into account whether they previously had worked part-time or full-time. Of clear significance is the narrowing in rates of return between these two groups. Women who had been in full-time employment during pregnancy were less likely than women employed part-time to have returned to work, but the differences between the two groups of women were not great. Fifty per cent of part-time workers went back to work compared with 43 per cent of full-time workers. This is a noticeable change in women's behaviour since the 1979 PSI survey when the rate of return among women who had been in part-time work (37 per cent) was double that of their full-time

counterparts (18 per cent). In 1979 it was suggested that the greater tendency of part-time workers to return to work might be explicable in terms of such women being a self-selected group. Women in part-time employment tend already to have children and, by being in employment, tend to be women who have demonstrated an inclination or need to work while their children are young. Such women would have already established patterns of working and systems of household management that allow them to engage in both spheres of activity. Thus, it was argued that the continued employment of these women after the birth of a second or third child was hardly surprising.

Table 6.2 **Working status eight to nine months after the birth according to whether in full-time or part-time job before the birth**

Column percentages

	Total	Job before the birth	
		Full-time	Part-time
Status after the birth			
In work	45	43	50
Full-time	15	21	3
Part-time	29	22	47
Not in work	55	57	50
Seeking work	20	22	16
Base: All women in work during pregnancy	2,635	1,866	758

It is likely that these observations also apply to women in the current survey who had been in part-time jobs before their recent baby's birth, the majority of whom remained in part-time employment after the birth. There was a marked increase in the number of part-time jobs in the economy as a whole during the 1980s, and women with children continue to be the most likely incumbents of such jobs. The increased availability of part-time work, together with financial pressures on young families generated by rising house prices, rising interest rates and inflation, is likely to account for much of the observed increase among women who had been formerly employed

part-time to return to further part-time work relatively quickly after the birth.

The increased propensity for women who had previously been employed on a full-time basis to return to work relatively quickly after childbirth appears, however, to herald a distinct social change in women's behaviour. The post-war period has been marked by a continuing increase in women's labour force participation. Virtually all of this growth has come, however, through the entry of women with children into part-time work. Indeed, there had been little change in the full-time labour force participation rates of women with children, at least during the years before their children enter school (Joshi, 1985). Here, however, we see that not only were women previously employed on a full-time basis almost as likely as part-time women to have returned to work, but that they were substantially more likely to have remained in full-time work after childbirth. Such women were in fact almost equally likely to have returned to full-time jobs (21 per cent) as they were to have returned to part-time jobs (22 per cent).

The explanation for this change in women's behaviour during family formation is likely to be complex. Some women will have been concerned to maintain their occupational standing and chances for future promotion and may have feared that returning to work on a part-time basis would have deleterious consequences for their career opportunities. Other women will have been motivated by financial need, as the same pressures facing women in part-time work impinge upon them. Still others will have felt a need to take up full-time employment for egalitarian reasons, believing that it is as much their obligation as it is their husband's or partner's to contribute as fully as possible to the family economy. Some women, of course, will have been influenced by all of these considerations as well as others not mentioned here.[1]

It is apparent, then, that the trend towards an early return to work following childbirth, identified by both the 1979 PSI survey and the 1980 *Women and Employment Survey* (Martin and Roberts, 1984), has continued and indeed strengthened over the decade. Given, moreover, the increased need for women's skills in the labour force if Britain is to safeguard its position in an increasingly open and competitive European economy, it seems likely that the trend will be maintained and may even accelerate.

In the rest of this chapter we consider the sources of variation in whether or not women had returned to work. We saw at the end of Chapter 5 that women who qualified for the statutory right to return were more likely to return to work than they had been in 1979, and that they were more likely to return to work than women who did not meet the requirements for the right. Here we examine the influence of the right together with other sources of variation we have identified as important in explaining differing patterns of women's behaviour, such as occupational level, type of employer, number of children, total time spent in the labour force, education and husband or partner's income. We also examine changes in the level of jobs women held after childbirth in relation to the level held during pregnancy, and the arrangements working mothers made for childcare. But because the continuing employment of women during family formation may be facilitated or hindered by the actions of employers, we begin with an analysis of the extent to which employers expected to encounter difficulties in recruitment over the next five years and the arrangements they made that might help more women with young children to enter employment.

Employers, recruitment and the continuing employment of women

In order to place into perspective the extent to which employers provided working arrangements that might help women remain in, or return to, paid employment during the years when their children are young, we asked all respondents to our survey of employers whether they expected any recruitment problems over the next five years. Our assumption at that time was that employers who expected such problems might also have taken steps to introduce arrangements to facilitate the continuing employment of women with children. We accepted as likely the possibility that, by asking these questions in mid-1989, we might well be anticipating future changes in employers' strategies concerning the employment of women rather than measuring ones that already had taken place. It was, after all, only towards the end of the 1980s that employers began to understand the full implications of impending demographic changes and to alter their employment practices.[2] And as if in confirmation of our view that a concern with recruitment might not yet have had any measurable impact, we showed in Chapter 1 that managers' general problems with

the running of their establishments were no more likely to focus spontaneously on recruitment or staff shortages or on the recruitment of specialist or skilled staff in 1989 than they had done in 1980. When asked directly if they expected problems with recruitment over the next five years, however, almost half of our respondents (48 per cent) said that they did expect problems. More pertinent to our present concerns, workplaces that expected recruitment difficulties were more likely to have policies in place to provide positive encouragement for women to return to work after childbirth. Table 6.3 outlines the extent and nature of employers' expected recruitment problems, and shows clear differences among respondents according to type of employer.

Table 6.3 Extent and nature of expected recruitment problems over the next five years as reported by employers

Column percentages

| | Public | Private sector | |
		Part of group	Independent
Recruitment problems expected	58	43	38
No problems expected	39	53	60
Can't say	3	4	2
All answers	100	100	100
Expects shortage of:			
Skilled workers	25	16	21
Young people	26	26	17
Graduates	36	9	6
Other personnel	10	9	4
Base: All workplaces			
Weighted	193	183	126
Unweighted	188	189	124

Public sector managers were more likely than those in the private sector to expect recruitment difficulties. Nearly 60 per cent of respondents in the public sector reported that they expected difficulties over the next five years, with the most likely shortfall expected to be

in the recruitment of graduates (36 per cent). Within the private sector, managers in workplaces that were part of a group of organisations expressed a level of concern over recruitment which approached that found in the public sector (43 per cent), but tended to focus upon expected shortages of young people (26 per cent). Among private sector independent workplaces, however, expectations about recruitment difficulties were comparatively low. Only just over one-third of respondents in independent enterprises expressed any concern over future problems in recruitment. The worries that did exist among these respondents tended to centre upon the recruitment of skilled staff, perhaps reflecting continued public concern over British skill shortages.

Size of workplace was an important source of variation in the public sector and in private sector establishments that formed part of a group of organisations. In these two types of workplaces, the larger the size of the workforce, the more likely respondents were to express a concern about recruitment. Within the public sector, 35 per cent of respondents in workplaces with under 25 employees thought that they would experience recruitment difficulties, rising to 80 per cent of respondents in workplaces with 500 or more employees. In a similar fashion, 20 per cent of the smaller private sector workplaces that were part of a group of organisations reported that they expected problems in recruitment, rising to 65 per cent of the largest of these workplaces. In contrast, size of workplace had a much reduced impact upon the expectations of respondents in private sector independent workplaces. Thirty-five per cent of independent enterprises with fewer than 25 employees expected recruitment difficulties, as did 45 per cent of independent workplaces with over 500 employees.

Taking industrial sector into account provided further details about the nature of the recruitment problems expected. Managers in distribution, hotels and catering (63 per cent of those who expected shortages) and in finance and banking (57 per cent) tended to focus on expected shortages of young people, while managers in manufacturing were equally concerned with expected shortages of skilled workers (52 per cent) and young people (51 per cent). The preponderance of public sector employers among the industrial category 'other services' was reflected by the fact that 61 per cent of managers in this industrial sector who expected recruitment problems focused upon the impending shortages of graduates.

We were not, however, interested in expected recruitment problems for their own sake, but in order to gauge whether a concern about recruitment had had any impact on employers' strategies regarding the employment of women. Therefore, at another stage in the interview we asked respondents whether they had any policies which provided positive encouragement to women to return to work after having a baby. This was an open-ended question, designed to allow employers to choose which, if any, of their policies might have this effect. Not surprisingly, a wide variety of arrangements were mentioned and these are summarised in Table 6.4. Rather more

Table 6.4 Extent to which employers had policies to encourage women to return to work after childbirth

Column percentages

	Total	Public sector	Private sector Part of group	Indep.
Friendly attitude	8	12	7	2
Job guarantee/priority	6	6	9	3
Part-time/job share on return	5	10	2	2
Flexi-time	5	7	3	3
Term-time work	5	13	2	–
Contractual maternity benefits	3	7	1	1
Childcare help	2	1	5	2
Retraining	2	3	1	–
Homework	1	1	1	–
Keeps in touch during leave	1	2	2	–
Career break scheme	*	–	1	–
Temporary work during leave	*	1	1	–
Other	3	6	3	–
Base: All				
Weighted	502	193	183	126
Unweighted	502	188	189	124

Respondents may have given more than one answer.

* less than 0.5 per cent.

unexpectedly, many respondents did not mention at this stage in the interview the arrangements which they later reported having in response to a direct question on this same issue, such as career break schemes, part-time working, job-sharing and so on (see Table 2.15).

Table 6.5 examines the relationship between the provision of policies to encourage women to return to work after childbirth and managers' expectations of problems with recruitment. The majority of workplaces that had policies to persuade women to come back to work expected recruitment problems over the next five years. Indeed, in the private sector there appeared to be an almost symmetrical relationship between managers' responses to these two issues. Fifty-five per cent of respondents in private sector workplaces that were part of a group of organisations with policies to encourage women expected recruitment difficulties; 56 per cent of their counterparts in similarly sized workplaces but without such policies did not expect recruitment difficulties. The same symmetrical relationship was found in private sector independent workplaces, where 60 per cent of those with policies to encourage women's return expected problems with recruitment, while 63 per cent of those without such policies did not expect recruitment problems. In the

Table 6.5 **Relationship between expecting recruitment problem and providing positive encouragement for women to return to work following childbirth**

Row percentages

	Expects recruitment problems					
			Private sector			
	Public sector		Part of group		Independent	
	Yes	No	Yes	No	Yes	No
Had policies to encourage women to return to work	64	32	55	42	60	35
No policies	52	46	39	56	35	63
Base: All						
Weighted	112	75	79	94	48	76
Unweighted	115	67	88	94	47	73

public sector, however, the majority of managers expected problems related to recruitment whether or not their workplaces had policies to provide positive encouragement to women to return to work.

Table 6.5 suggests that an association exists between the provision of policies to influence women to return to work and the extent to which managers expect recruitment problems. Further support for this is given in Table 6.6 which summarises the relationship between the provision of flexible working arrangements that might also help women with young children, and managers' expectations of difficulties with recruitment. The extent to which these working arrangements were provided by different employers was outlined earlier in Table 2.15.

Table 6.6 Relationship between expecting problems with recruitment and providing flexible working arrangements

Column percentages

	Expects recruitment problems					
			Private sector			
	Public sector		Part of group		Independent	
	Yes	No	Yes	No	Yes	No
Part-time	86	87	81	66	78	60
Job-share	64	51	30	14	7	11
Flexi-time	73	68	38	26	33	25
Shiftwork	34	22	33	14	10	9
Homeworking	8	2	6	7	7	10
Career break	27	25	14	6	4	2
Help with childcare	27	20	6	–	6	3
Base: All						
Weighted	112	75	79	94	48	76
Unweighted	115	67	88	94	47	73

With only a few exceptions, the overall pattern of Table 6.6 is one which supports the association between managerial concern with recruitment and the provision of arrangements that might facilitate the employment of women. Differences in the provision of flexible

working arrangements according to whether managers expected recruitment difficulties were most marked in the private sector. In private sector workplaces that were part of a group of organisations, for example, 81 per cent of managers who reported that they expected recruitment problems over the next five years, but only 66 per cent of managers who did not expect recruitment problems, also reported that part-time working hours were available to employees. Similarly, 14 per cent of managers who reported problems in private sector workplaces that were part of a group of organisations, but only 6 per cent of their counterparts who did not expect recruitment problems, also reported that they offered career break schemes.

Private sector workplaces that were part of a group of organisations provided the clearest links between managerial expectations of problems with recruitment and the provision of flexible working arrangements. In the public sector, differences in the provision of flexible working arrangements were relatively muted. Conditions and terms of employment are quite similar across the public sector and, more importantly perhaps, tend to be embodied in collective agreements. Arrangements of the kind shown in Table 6.6 are thus more generally available than in the private sector (see Table 2.15) and less subject to managerial discretion. Where differences exist in the public sector in the provision of arrangements such as opportunities to work from home, shiftwork and job-sharing, it is possible that managerial discretion and perceptions of problems with recruitment have had some impact.

Our final look at the association between provisions to help the employment of women with children and managers' expectations of problems with recruitment concerned whether workplaces offered maternity rights or benefits in addition to the statutory minimum. First, Table 6.7 summarises the extent to which workplaces with contractual maternity benefits also provided flexible working arrangements. Table 6.8 subsequently outlines the association between contractual maternity benefits and managerial expectations of recruitment problems.

Twenty-eight per cent of employers, largely in the public sector, extended the statutory provisions for maternity rights and benefits in some way. Table 6.7 suggests that flexible working arrangements and extended maternity benefits jointly form part of an employer's range of options available to employees. In all cases, workplaces with

Table 6.7 **Extent to which employers who offer maternity benefits in addition to statutory minimum also provide flexible working arrangements**

Column percentages

	Has contractual maternity benefits	
	Yes	No
Part-time hours	91	74
Flexitime	74	35
Job-sharing	67	21
Help with childcare	28	5
Career break scheme	31	9
Shift work	29	23
Paternity leave*	26	15
Base: All		
Weighted	139	348
Unweighted	137	350

* as part of men's contractual entitlements

contractual maternity benefits were more likely also to offer flexible working arrangements, including paternity leave. In relation only to the provision of shift work were the differences between workplaces with or without contractual maternity benefits relatively muted. Workplaces with contractual maternity benefits also were more likely to expect recruitment difficulties over the next five years. Two-thirds of workplaces with extended maternity benefits expected such problems compared with less than half of workplaces where maternity rights had not been extended beyond the statutory minimum. This was not an unexpected result. Contractual maternity pay, the most important part of extended maternity benefits, was initially introduced in the public sector in response to severe staff shortages, particularly in education and the health service. For that reason it tended to be made conditional upon returning to work. We consider later in the chapter whether it has had the desired effect of encouraging women in receipt of contractual maternity pay to return to work after having a baby.

Table 6.8 **Extent to which employers who offer maternity benefits in addition to statutory minimum expect recruitment difficulties over the next five years, and nature of difficulties expected**

Column percentages

	Has contractual maternity benefits	
	Yes	No
Expects recruitment problems	65	45
No problems expected	31	52
Can't say/no answer	4	3
All answers	100	100
Expects shortage of:		
skilled workers	27	20
young workers	32	24
graduates	38	12
other workers	7	8
Base: All		
Weighted	139	348
Unweighted	137	350

It does appear to be the case, then, that an association exists between managerial perceptions of future recruitment difficulties and the provision of working arrangements or policies which might encourage women to remain in, or return to, employment after having a baby. Our analyses throw no light, however, on the causal direction of this association; on, that is, the question of which came first, worries about recruitment or policies to encourage women's employment. In a great many workplaces – perhaps the majority, particularly in the public sector – policies to encourage women's employment and flexible working arrangements that might facilitate that employment will have been introduced some years ago. They may have been introduced in response to earlier concerns about shortages of suitable workers, including women. Or they may have been introduced because these workplaces, as employers of women, are aware of the need for flexible working arrangements in order to maintain an adequate workforce. But, especially in the private sector, our evidence suggests

that the provision of arrangements which facilitate the continuing employment of women with young children is in many instances, at least, a response to managerial assessments of labour market conditions. It is likely, therefore, that should problems with recruitment deepen over the next five years, more workplaces will seek to overcome their problems through the introduction of increased flexibility in working arrangements.

Women's employment intentions during pregnancy

We began this chapter with an analysis of women's return to work after childbirth according to their employment status before the birth and for women who had been in work during pregnancy, whether they had worked full-time or part-time. It was also part of our research to examine to what extent women *intended* or *expected* to return to work within about eight or nine months of their baby's birth. We wished to know how far women's subsequent labour force behaviour reflected their intentions during pregnancy, whether any substantial number of women had been unable to fulfil their intentions, and, if this was the case, which women and why. Accordingly, we asked all women the following question: '*When you were pregnant with your recent baby did you, at that time, expect to be in paid work about now?*' In response, 40 per cent of women reported that they had intended (or hoped) to be in paid work and 60 per cent reported that they had not intended (or expected) to be working. The contrast between these figures and those presented in Table 6.1 where it was shown than 28 per cent of all women were in work after the birth suggests that not all women had ultimately been able to fulfil their intentions.

Table 6.9 summarises the intentions of women who had been in work during pregnancy according to whether or not they subsequently returned to work. For both outcomes, the majority of women appear to have acted in accordance with their prior intentions. In each case, however, there was a substantial minority – particularly among women who did not return to work – whose original plans had changed.

Eighty per cent of the women who were back in work had intended or expected to be working within about eight or nine months of their baby's birth. However, also in work by this time were 19 per cent who had not expected nor intended to be working. Similarly, 61 per cent of non-returners had acted in accordance with their intentions during

Table 6.9 Employment intentions during pregnancy according to whether woman returned to work after childbirth

Column percentages

	Total	Returned to work	Did not return
Did not intend to work	22	7	34
Did not expect to work	20	12	27
Intended to work	33	56	13
Hoped to be working	24	24	24
Not stated	1	1	2
	100	100	100
Base: All women in work during pregnancy	2,635	1,188	1,447

pregnancy to remain out of the labour force, while 37 per cent had wished to return to work but had not done so by the time of our survey. From the perspective of working women's intentions during pregnancy, then, there appear to have been two broad groups of women among those who had been in work during pregnancy: women who had had similar intentions – to return or not return – but who experienced different outcomes, and those who experienced the same outcome despite differing intentions. Casting our analyses into this perspective allowed us to identify two special groups of women, whose characteristics we now examine before turning to consider more fully the sources of variation among women in work after childbirth.

The first of the two special interest groups included women in work during pregnancy who intended to return to work after the birth but who did not return. Over one-third of women in work during pregnancy but not in work after the birth had thought that they would be in jobs by the time of our survey. Thirteen per cent had *fully intended* to be working, and a further 24 per cent had *hoped* to be working. Table 6.10 summarises the reasons given by these women for not working after the birth and provides a comparison with women who had had no intention of returning to employment.

As might be expected, women not in work after childbirth gave very different reasons for their non-participation according to whether

Table 6.10 Reasons for not working after the birth according to employment intentions during pregnancy

Column percentages

	Total	Hoped/ intended to be in work	Did not expect/ intend to be in work
Cannot find a job	12	26	4
Cannot find a job with preferred hours or location	7	12	4
Cannot find childcare	12	16	10
Cannot afford childcare	11	13	10
Wanted to care for child(ren) herself	48	16	67
Other domestic reasons	5	7	3
Pregnant	2	4	1
Illness/disability	2	4	*
Employers reluctant to hire women with young children	2	4	1
Other reasons	9	13	6
No answer	8	5	10
Base:	1,447	534	913

Note: The total column includes all women in work during pregnancy who did not return to work after the birth. Columns sum to more than 100 because more than one answer was possible.

they had in fact intended to return to work. Among women who had planned on staying out of the labour force, the wish to care for their recent baby was paramount and was cited by two-thirds of such women. An inability to find, or afford, alternative childcare was also an important consideration, with about one in ten women giving each of these reasons for remaining at home. However, even these reasons were largely overshadowed by the evident wish of many women to be full-time carers of their new babies.

In contrast, no single explanation dominated the responses of women who were not in work despite having intended to return to employment after their baby's birth. Just over one quarter of these women reported that they had been unable to find work, while 12 per

cent could not find jobs in the right location or with the hours of work they preferred. A further one-quarter could not find or afford childcare. Fewer than one in five, however, reported that they were not working because they had changed their minds about going out to work after the baby's birth. Sixteen per cent of women at home despite an earlier intention to return to work gave as their reason the wish to provide full-time care for their child.

Table 6.11 indicates the occupational level of the jobs held during pregnancy by women who had intended to return but who had not returned. In this instance, our comparison is with women in work during pregnancy who had shared their intention to return to work and who had in fact returned.

Table 6.11 **Job held during pregnancy by women who hoped or intended to return to work after the birth according to whether they did return to work**

Column percentages

	Did not return	Did return
Managers/administrators	7	9
Professionals	6	15
Associate professionals	8	20
Clerical/secretarial	32	25
Craft and skilled manual	7	3
Personal and protective services	11	10
Sales	10	5
Plant and machine operatives	9	4
Other occupations	8	5
Base:	534	967

Note: The table includes all women in work during pregnancy who reported that they had hoped or intended to return to work after the birth.

Table 6.11 shows that among women with similar employment intentions during pregnancy, higher-level occupational groups tended to be under-represented and lower-level occupational groups over-represented among women whose intentions to return had not been fulfilled. That is, women who had been employed in professional

Table 6.12 **Reasons for not returning to work given by women who had intended or hoped to return**

Column percentages

	Total	Managers/ administrators	Prof- essional	Assoc. professional	Clerical/ secretarial	Craft & related	Personal & protective service	Sales	Plant & machine operatives	Other occup.
Cannot find job	26	26	30	20	29	33	22	29	17	27
Cannot find job in preferred location/ with preferred hours	12	13	9	13	13	10	7	21	13	10
Preferred to stay at home	16	24	18	24	13	15	12	20	13	22
Childcare too expensive	13	16	12	9	8	18	27	11	15	7
Cannot find childcare	16	18	3	20	14	21	20	16	19	20
Ill health/ disability	4	–	3	–	4	5	7	5	6	–
Pregnant again	4	–	–	2	5	3	8	2	2	5
Other domestic reasons	7	13	15	13	5	5	8	5	10	2
Other reasons	13	13	24	22	15	8	10	7	8	12
Not stated	5	–	3	2	5	3	3	4	13	7
Base	534	38	33	45	171	39	60	56	48	41

and associate professional occupations (in particular) during pregnancy appeared to have been relatively more successful in fulfilling their pre-birth employment intentions, and sales workers, plant and machine operatives and skilled craft workers relatively less successful.

The reasons given by women for not returning to work despite having intended to return showed no particular pattern in relation to their previous occupation, however. Their reasons are summarised in Table 6.12. Women who had worked in sales occupations were the most likely to have been unable to find either a job (29 per cent) or a job with the preferred hours or in the preferred location (21 per cent). Not being able to find an appropriate job was the most common reason given by sales workers for being unable to fulfil their intention to return to work. But it was also the most common reason given by women who had been employed previously in professional (39 per cent), associate professional (33 per cent) and craft (43 per cent) occupations.

A lack of appropriate or affordable childcare was particularly important for women who had been employed previously as personal and protective service workers (47 per cent) and unskilled workers (39 per cent), but they too reported being unable to find suitable jobs. Just less than one third of women who had held these occupations during pregnancy had been unable to find work after the birth of their babies.

The second group of special interest highlighted by Table 6.9 concerns women in work during pregnancy *and after the birth* who had intended to remain out of the labour force. This group included 19 per cent of women in work after the birth, 7 per cent who had not intended to be in work and 12 per cent who had not really expected to work. Table 6.13 sets out their reasons for returning to the labour force, and provides a comparison with women in work who had intended to resume employment after their baby's birth.

As we saw with women whose intentions to return to work had been thwarted, one particular reason dominated the responses of women who had intended to remain at home. Financial need was cited by 42 per cent of women in the labour force despite their intentions before the birth. Almost one in five women said that they had returned because they had found, or been offered, a job, but this response was accompanied frequently by expressions of financial need. In contrast, only one quarter of women who, in returning to work, had acted in

accordance with their intentions during pregnancy reported financial need as their reason for working after the birth. For these women, personal choice and the ending of maternity benefits tended to be equally salient reasons for returning to work.

Table 6.13 Reasons for returning to work according to employment intentions during pregnancy

Column percentages

	Total	Did not expect/ intend to be in work	Hoped/ intended to be in work
Maternity Leave/pay ended	25	7	29
Financial Need	28	42	25
Personal Choice	20	13	22
Found/Offered Job	9	18	6
Employer asked her to return	4	5	4
Baby old enough to leave	4	2	5
Job with preferred hours/ Location came available	3	5	3
Returned to self-employment	2	*	2
Recovered from ill health	1	–	1
Other reasons	7	9	6
Not stated	6	4	6
Base	1,188	226	954

Note: The total column refers to all women in work during pregnancy who had returned to work after the birth. Columns sum to more than 100 because more than one answer was possible.

* less than 0.5 per cent.

Table 6.14 indicates the occupational level of the job held during pregnancy by women back in work after the birth despite having intended not to work. This time the table provides a comparison with women who had shared their employment intentions but who had remained out of the labour force. Rather unexpectedly, however, few differences of interest emerged between these two groups of women when prior occupational level was taken into account. Women who

had worked during pregnancy as personal and protective workers tended to be slightly under-represented among those who had returned to work, while women employed as plant and machine operatives tended to be slightly over-represented. But the proportionate differences were not great. Indeed, little difference at all was found in the overall occupational distribution of these two groups of women.[3]

Table 6.14 **Job held during pregnancy by women who had *not* expected or intended to return to work after the birth according to whether they did return**

	Did return	Did not return
		Column percentages
Managers/administrators	4	6
Professionals	8	6
Associate professionals	7	8
Clerical/secretarial	31	36
Craft and skilled manual	3	5
Personal and protective services	9	12
Sales	11	14
Plant and machine operatives	10	6
Other occupations	6	8
Base:	338	886

Note: The table includes all women in work during pregnancy who reported that they had not intended or expected to return to work after the birth.

The timing of women's return to work

Table 6.13 summarised women's reasons for returning to work according to their employment intentions during pregnancy. In this section, we examine the reasons for returning to work as reported by all women in work after childbirth and the timing of their return to work. The main source of variation as regards reasons for returning to work was occupational level. Differences by occupation were reflected also in the reasons given by women according to type of employer and industry. There were only minor variations among women in relation to the timing of their return to work, although it was clear that women who had not intended to return to work had returned

– not unexpectedly perhaps – more slowly than other women. Table 6.15 summarises women's reasons for returning to work according to the occupational level of the job held during pregnancy.[4]

Immediately apparent from Table 6.15 are marked differences in the likelihood of women returning to work because of financial need. For women who had worked previously in manual or sales jobs, and those who had not been in work during the year before the birth, financial need was the primary reason cited for returning to work. No other reason given by women in these occupational groups approached the level of reports which concentrated on money and finances. Financial need was important also for women who had worked in associate professional occupations. This is likely to reflect the prevalence among this occupational group of women who had been employed by the health authorities. Thirty-one per cent of health workers reported that they had returned to work because of financial need, as did 35 per cent of women employed in medium and large private sector businesses and 33 per cent of women in small firms.

In general, however, women who had been employed in higher-level white-collar and professional employment were less likely to cite financial need and more likely to report that their maternity pay or leave period had ended or that they had returned to work through personal choice. This was particularly the case for women who had been employed in the public sector. Forty per cent of civil servants and 39 per cent of education and local authority employees said that they had returned to work because their maternity benefits had ended. Even among health workers, the ending of maternity benefits was an important influence. Just over two-thirds of women employed by health authorities gave this reason for the timing of their return to work.

In contrast, only 13 per cent of women who had been employed in larger private sector businesses and 7 per cent of those who had worked in small firms returned to work because their maternity pay or leave period had come to an end, reflecting their reduced likelihood of qualifying for these benefits. Within the private sector, industry was also an important source of variation in women's reasons for returning to work. Women who had been employed in distribution, hotels and catering (40 per cent) and manufacturing (37 per cent) were the most likely to cite financial reasons for returning and the least likely to cite personal preference (14 per cent in each occupational group) or the

Table 6.15 Reasons for returning to work according to job held during pregnancy

Column percentages

	Total	Managers/admin-istrators	Prof-essional	Associate prof-essional	Clerical/secre-tarial	Craft & related	Personal/protective service	Sales	Machine/plant operatives	Other occu-pations	Not in work
Maternity pay/leave ended	22	20	38	30	20	8	15	9	15	16	6
Financial need	30	18	12	28	32	45	36	44	42	32	41
Personal choice	20	24	21	24	21	3	17	17	9	22	21
Found/offered job	9	6	10	5	11	18	7	10	13	12	14
Employer asked her to return	4	4	5	3	4	5	2	6	4	1	–
Baby old enough to leave	4	5	3	6	4	5	2	7	8	4	5
Job with preferred hours/location came available	4	2	3	3	4	5	3	5	5	6	3
Returned to self-employment	2	10	2	1	1	–	3	6	–	–	2
Recovered from ill health	*	1	1	2	–	–	1	–	–	–	–
Other reasons	7	8	9	7	8	–	6	3	4	5	8
Not stated	7	8	4	3	5	11	14	8	8	8	10
Base: Women in work after the birth	1,419	113	185	237	371	38	143	88	79	77	63

* less than 0.5 per cent.

Note: Columns sum to more than 100 because more than one answer was possible.

217

ending of maternity benefits (14 per cent of women in manufacturing and 7 per cent of women in distribution, hotels and catering). In contrast, personal choice was the most common reason given by women who had worked in finance and banking (28 per cent), although financial need was also salient (23 per cent) as was the ending of maternity benefits (18 per cent).

Occupation together with type of employer and industrial sector proved again to be the most important sources of variation in the reasons given by women for their return to work. The number of children women had was relevant only as regards the ending of maternity benefits. Women who had become mothers for the first time were more likely to have returned to work because their maternity benefits had ended. Twenty-five per cent of first-time mothers gave this reason. This was in contrast to 19 per cent of women with two children, 10 per cent of women with three children and 15 per cent of those with four or more children after the birth of their recent baby.

Women who had become mothers for the first time tended to return to work more slowly than other women, however. The median number of weeks first-time mothers spent out of the labour force was 20 weeks, compared with a median of 18 weeks for women who already had at least one child at the time of their new baby's birth.

Prior employment intentions also appeared to have an influence on the timing of women's return to work. Not unexpectedly, women who had not intended nor expected to work after the birth of their baby went back to work more slowly than women whose intentions matched their subsequent behaviour. The median number of weeks out of the labour force for the former group of women was 24 weeks. Women who had hoped to return went back after a median 23 weeks, while women who had fully intended to return returned after a median 18 weeks, no doubt reflecting the ending of their maternity pay period.

Table 6.16 summarises the timing of women's return to work according to type of employer. The main points of interest that derive from the table, and indeed from our preceding analyses, are, first, that the differences between women in the timing of their return to work were not great and could reflect any number of influences outside those considered here; and, secondly, that in each case, the majority of women who went back to work returned well within the statutory 29 week period.

Table 6.16 Number of weeks after the birth women started work according to type of employer in pre-birth job

Column percentages

	Total	Public sector				Private sector				
		Civil service	Education/ local authority	Health authority	nationalised industry	Large/ medium businesses	Small firms	Other	Former nationalised industry	Not in work
1-9 weeks	16	13	9	15	(3)	14	19	17	(1)	16
10-20 weeks	36	37	33	45	(7)	33	40	40	(5)	27
21-25 weeks	9	9	16	8	(1)	8	7	3	(1)	9
26-28 weeks	10	8	11	10	(4)	14	4	10	(8)	9
29 weeks	6	4	12	8	(1)	4	2	5	(4)	1
30-39 weeks	17	28	15	10	(2)	19	18	15	(4)	28
Over 40 weeks	4	1	4	3	–	4	5	6	–	6
Not stated	3	–	1	1	–	4	4	5	(1)	8
Median number of weeks	19	21	23	17	18	21	16	16	27	23
Base: Women in work after the birth	1,419	78	232	225	18	356	182	111	24	193

* less than 0.5 per cent.

() denotes actual number.

219

Women in work after the birth who had not worked during the year before the birth

Before turning to our detailed examination of the sources of variation among women according to whether they returned to work, it is worth considering the characteristics of women who, following the birth, entered the labour force either for the first time or after an absence of one or more years. Just over 200 women came into this category, representing 14 per cent of women in work within eight or nine months after the birth. Almost one third of these women had never held a paid job in Britain before the birth.

The average duration out of the labour force for those who had been employed previously was just over three years, although a small minority (3 per cent) had not worked for over ten years. Three-quarters had worked full-time before leaving the labour force. Their last jobs tended to reflect the distribution of women in work generally (see Table 1.10) except that women who had been employed as associate professionals were slightly under-represented among their number, while women sales workers and machine operatives were slightly over-represented.

Only rarely, though, did these women return to jobs at the same level as the ones they had left. The large majority (83 per cent) had returned to part-time employment, particularly in sales and unskilled manual occupations. Only 8 per cent took up higher-level non-manual or professional jobs upon their return, even though 14 per cent had held these types of jobs when they were last in the labour market.

Over half (53 per cent) had had no intention of working after the birth of their recent baby. Thus, it was hardly surprising that the single most important reason that they gave for returning to work was financial need. Forty-one per cent said that they had returned to work because of financial pressures, in contrast to one in five who returned because they wished to work.

Characteristics of women in work after the birth

We turn not to an examination of the post-birth working status of women who had worked as employees during pregnancy. First, we examine the main sources of variation in returning to work as they emerged from tabular analyses. Secondly, we use logistic regression to determine the significance of the many influences on women's return to work behaviour. Women's return to work after childbirth

was a key area of concern in the research, and is known to be subject to a great variety of influences. We know from other research, for example, that the level of a woman's occupation has a significant impact on whether she returns to work within one year of childbirth. The 1979 PSI survey and a re-analysis of the *Women and Employment Survey*, for example, both showed that women who had worked in higher-level occupations were the most likely to return to work and women in clerical jobs were the least likely to do so (Daniel, 1980; Martin, 1986).

In addition, the number of years women previously spent in employment before a birth also influences their return-to-work behaviour. Our own analyses show that the longer women had been in the labour force before the birth, the more likely they were to have returned to work afterwards. The association between duration of labour force participation and return to work was found whether women had worked part-time or full-time in their pre-birth job.

Of those whose last job had been full-time, 27 per cent with between two and five years' previous employment were back in work compared with 38 per cent of women with between five and ten years' previous employment and 47 per cent of women who had worked for more than ten eyars. The corresponding figures for women whose last

Table 6.17 **Association between total duration of labour force participation and returning to work after the birth, according to status in pre-birth job**

Percentages

Total labour force duration	Total	Status in pre-birth job	
		Full-time	Part-time
Less than 2 years	(21)	(14)	(7)
2-5 years	32	27	41
Over 5-10 years	41	38	46
More than 10 years	49	47	55
Base: Employees during pregnancy	2,514	1,794	714

() denotes actual numbers. Only 39 women had been in employment for less than two years.

jobs before the birth had been part-time were 41 per cent of women with between two and five years' employment experience; 46 per cent of those with between five and ten years' experience; and 55 per cent of those with more than ten years' experience. Table 6.17 summarises this association between duration of labour force participation and return to work.

Hours of work

Our earlier analysis of women's return to work in relation to the status of their pre-birth job was based upon women's own definition of their jobs as part-time or full-time. Table 6.18 takes into account the number of weekly hours women had worked before the birth and shows that, in general, the fewer hours they worked, the more likely they were to

Table 6.18 Working status eight to nine months after the birth according to hours of work in pre-birth job

Column percentages

| | | Hours of work in pre-birth job | | | | |
	Total	Under 8	8 - under 16	16 - under 20	20 - under 30	30 - under 36	36 or more
Status after the birth							
In work	44	58	50	47	45	46	42
Over 30 hours	15	3	1	3	3	27	19
8-30 hours	23	19	38	38	36	14	19
Under 8 hours	3	32	9	3	2	3	2
Different employer	11	24	16	12	13	7	12
Same employer	33	34	34	35	32	39	30
Same job	23	26	29	26	24	27	21
Similar job	7	7	5	6	6	8	7
Different job	3	1	–	3	2	4	3
Not in work	56	42	50	53	55	54	58
Seeking work	21	12	13	19	23	18	24
Job arranged	1	–	*	2	*	1	1
Base: Employees during pregnancy	2,514	69	232	194	214	271	1,487

* less than 0.5 per cent.

continue working after the birth. Our analysis also shows that women tended to have returned to the same, or similar, hours of work as they had worked before the birth. Women who had worked for thirty-six or more hours were an exception to this because of the movement from full-time to part-time work.

Table 6.18 also shows whether women returned to their pre-birth employers. Just over one in ten women changed employers upon their return to work. This was particularly the case for women who had worked for less than eight hours per week. Indeed, one of the main reasons women gave for changing employers was their wish to work part-time. One half of the women who worked part-time after the birth changed employers upon their return to work, compared with just over one in five women who returned to work on a full-time basis. Of those women who remained with their pre-birth employers, the large majority returned to the same, or a similar, job. Only 3 per cent of women who went back to the same employer had changed to a new job on returning.

Level of job done during pregnancy

Table 6.19 summarises women's return-to-work behaviour according to the occupational level of their former job and provides comparative information from the 1979 PSI survey. In this case, the table is based upon full-time employees during pregnancy.

In both surveys, women who had been employed in higher-level non-manual work (classes I and II) stood out as the category more likely to return to work and most likely to remain with their pre-birth employers. They were also the most likely to work full-time after the birth, and to remain in their pre-birth job.

The effect of occupational level on women's return to work is brought out again in Table 6.20 which categorises full-time employees according to the Standard Occupational Classification. Here the differences between women professionals and associate professionals and women in all other occupational groups are striking. About two-thirds of women in these two occupational groups had returned to work by the time of our survey. About one third had returned to full-time work. Over half had remained with their pre-birth employers.

However, it is the case that differences among women according to occupational level become less marked when the proportions who were seeking work are taken into account. In no category were less

Table 6.19 Working status eight to nine months after the birth according to level of pre-birth job: 1979 and 1988 compared

Column percentages

	Total	I or II	IIIN	IIIM	IV	V†
			Job level during pregnancy			
In work						
1988	42	59	35	29	31	(7)
1979	18	32	14	19	16	(3)
Over 30 hours						
1988	19	30	15	8	13	(2)
1979	7	13	5	8	11	–
Same employer						
1988	31	49	23	14	17	(4)
1979	11	26	6	11	8	(1)
Same/similar job						
1988	28	45	21	14	17	(4)
1979	11	24	5	11	7	(1)
Not in work						
1988	58	41	65	71	69	(21)
1979	82	68	86	81	84	(5)
Seeking work						
1988	23	15	25	27	30	(10)
1979	15	10	15	14	26	(2)
Base: Full-time employees during pregnancy						
1988	1,794	606	770	119	255	28
1979	791	176	429	36	129	8

† 1970 OPCS/Registrar General social classes.
() denotes actual number.

than one half economically active (working or seeking work). Indeed, in many instances as many or more women were looking for work at the time of our survey as already held jobs.

Table 6.20 Working status eight to nine months after the birth according to full-time job level in pre-birth job

Row percentages

	In work	Over 30 hours	Same employer	Same/ similar job	Not in work	Seeking work	Base
Managers/ administrators	48	23	39	33	52	21	150
Professionals	65	37	56	53	35	11	177
Associate professionals	64	33	54	50	36	13	240
Clerical/secretarial	36	17	24	23	64	25	651
Craft and skilled manual	25	10	11	11	75	31	88
Personal and protective services	36	11	24	24	64	24	142
Sales	25	7	16	14	75	29	138
Plant and machine operatives	35	12	16	15	65	34	123
Other occupations	29	9	16	14	71	26	69
Total	42	19	31	28	58	23	1,794

Base: Full-time employees during pregnancy

Table 6.21 examines variations in women's return-to-work behaviour among women whose pre-birth jobs were part-time. The same general pattern was found, although the contrasts between different occupational groups were less marked. Nonetheless, women professionals and associate professionals remained the most likely to return to work and to return to their former employers. In all occupational groups, however, proportionately more part-time workers than full-time workers had returned to work. Substantial numbers of part-time workers were also looking for work. Indeed, it was again the case that occupational differences among women lessened when the proportions who were looking for work were taken into account.

Table 6.21 **Working status eight months after the birth according to part-time job level in pre-birth job**

Row percentages

	In work	8 - 30 hours	Under 8 hours	Same emp- loyer	Same/ similar job	Not in work	Seeking work	Base
Managers/ administrators	(10)	(5)	(1)	(8)	(9)	(10)	(3)	20
Professionals	66	31	21	56	54	34	10	61
Associate professionals	70	56	2	59	61	30	7	94
Clerical/secretarial	51	34	10	32	31	49	18	146
Craft and skilled manual	(19)	(6)	–	(2)	(3)	(13)	(6)	38
Personal and protective services	48	33	9	31	31	52	12	123
Sales	30	25	2	15	15	70	24	103
Plant and machine operatives	(17)	(13)	(1)	(11)	(11)	(18)	(8)	35
Other occupations	44	34	5	26	26	56	23	109
Total	49	35	7	33	34	51	17	714

Base: Part-time employees during pregnancy

() denotes actual number.

Type of employer

There also were striking differences in the proportion of women who had returned to work in relation to the type of employer for whom they had worked during pregnancy (Table 6.22). Over 60 per cent of women whose pre-birth job was in the public sector had returned to work. Over half had returned to their former employers. In contrast, less than one-third of women in the private sector were in work after the birth and fewer than one in five had returned to their previous employers. In this instance, differences between women employed in private sector small firms or larger businesses were not as pronounced as those that were found between the public and private sector generally. Even when the analysis was confined to establishments with

Table 6.22 Working status eight to nine months after the birth according to type of employer

Column percentages

	Total	Public sector				Private sector			
		Civil service	Education/ local authority	Health authority	Nationalised industry	Large/ medium businesses	Small firm	Former nationalised industry	Other
In work	42	61	61	62	(13)	32	29	(21)	45
Over 30 hours	19	32	37	27	(8)	13	9	(11)	21
Same employer		56	53	52	(9)	19	16	(17)	31
Same/similar job	52	47	49	50	(10)	17	16	(15)	30
Not in work	58	39	39	38	(25)	68	71	(13)	55
Seeking work	23	12	13	12	(7)	28	31	(5)	25
Base: Full-time employees during pregnancy	1,794	113	236	216	38	699	287	34	108

() denotes actual number.

fewer than twenty-five employees, the greatest contrasts in women's return-to-work behaviour remained those between the public and private sector. Fifty-six per cent of women in public sector workplaces with fewer than twenty-five employees had returned to work, compared with 34 per cent of women who had worked in larger businesses of a similar size in the private sector and 31 per cent of women who had worked in small firms.

Contractual maternity pay

We noted earlier that contractual maternity pay benefits were introduced as a way of combatting severe staff shortages, particularly in the public sector. Contractual maternity pay was seen as a means whereby women might be encouraged to return to work after childbirth and for this reason full payment tended to be made conditional upon returning to work. In this section, we assess whether recipients of contractual maternity pay were more likely to return to work than other

Table 6.23 The extent to which women who received contractual maternity pay returned to work after the birth

Column percentages

	CMP recipients	Professional & associate professional employees	Public sector employees	All(a) employees
In work	74	65	60	44
Over 30 hours	37	26	23	15
8-30 hours	30	29	29	23
Under 8 hours	3	4	4	3
Same employer	68	55	50	31
Same/similiar job	62	53	47	30
Not in work	26	35	40	56
Seeking work	10	11	13	21
Base	867	2,514	351	572

(a) All employees refer to women employees in work during pregnancy. The remaining columns are confined to those women whose characteristics correspond to the column headings.

women. The majority of women who received contractual pay worked in the public sector, frequently in professional and associate professional occupations. Our method of analysis was to compare the rates of return among these three groups of women. This analysis is summarised in Table 6.23 which suggests that the receipt of contractual maternity pay had a substantial effect on the chances of women returning to work and one which exceeded the impact of either occupation or public sector employment.

Almost three-quarters of women who received CMP had returned to work within eight or nine months of the birth. Over two-thirds had returned to their pre-birth employer, largely to the same or a similar job. Over one-third had returned full-time. In all of these respects, the proportions who went back to work exceed those shown for women professionals and associate professionals and for employees in the public sector. It seems likely, then, that, in many cases, contractual maternity pay fulfilled its intended objective of encouraging women to come back to work.

Birth order
Table 6.24 summarises variations in the return to work of all women in work during pregnancy according to the birth order of their recent baby. As might have been expected from our earlier analyses in relation to hours of work, women who had at least one child at the time of their recent baby's birth were more likely to return to work than first-time mothers. This reflects decisions taken earlier by these women to combine paid employment with being a mother, and the likelihood of such women having already in place arrangements to facilitate their continuing employment. Perhaps more unexpectedly, the presence of more than one other child at the time of the new birth did not alter the likelihood of women returning to work. There were few differences among women who had two, three or more children in terms of returning to work. Proportionately more first-time mothers were looking for work, however. Once again, differences among women tended to lessen when those who had not yet been able to find suitable employment were taken into account.

Table 6.24 Working status eight or nine months after the birth according to birth order of recent baby

Column percentages

	Total	First baby	Second baby	Third or subsequent baby
In work	45	40	56	55
Over 30 hours	15	16	14	12
Same employer	35	27	45	47
Same/similiar job	31	26	41	40
Not in work	55	60	44	45
Seeking work	20	24	14	11
Job arranged	1	1	1	1
Base: Women in work during pregnancy	2,635	1,793	564	275

Looking for work

Our analyses show a considerable gap between women's desire to work after childbirth and their opportunities in the labour market. This gap was particularly apparent in the private sector. One in five women not in work after the birth were looking for jobs at the time of our survey, rising to almost one in three who had previously been employed in the private sector. Almost half (47 per cent) of these women were looking for part-time jobs, 27 per cent wanted to work full-time while the rest had no preference in relation to hours of work. Abundant scope exists, seemingly, for employers to draw a great many more women back into the labour force.

Statistically significant influences on women's return to work after childbirth

Our analyses so far in relation to the influences on women's return to work following the birth of a baby have focused upon the differing proportions of women who were in work according to specific characteristics. In this section, we address the issue of whether these influences had a statistically significant effect upon the likelihood of women returning to work and, in doing so, introduce further potential

influences on women's behaviour into our analyses. The method of analysis we undertook to establish the significance of these various influences was logistic regression.[5] This method allowed us to take account simultaneously of continuous variables such as hourly pay and age, and categorical variables such as education, number of children and occupational level. Other likely influences on women's return-to-work behaviour that were brought into our analyses were number of years in the labour force and in the last job held before the birth, qualification for statutory reinstatement, type of employer, hours of work and whether women received maternity pay.

Our choice of potentially significant influences upon women's return-to-work behaviour was based upon a number of considerations including analyses presented in earlier sections of this report. We have seen throughout our report that the type of employer for whom a woman worked had importance for her experiences during and after pregnancy. Further, our analysis in Chapter 5 suggested that qualification for statutory reinstatement was strongly associated with the likelihood that women would return to work after childbirth, while Chapter 6 indicated the importance of contractual maternity pay in encouraging women to return. Women's education, the length of time they had spent in the labour market and in their last job, and the job level attained in their pre-birth job were assumed to represent differing aspects of their 'human capital' investments in their labour market careers. Women's hourly pay represented the financial gains of returning to work.

In the event, age was dropped from the analysis because of high collinearity with the total duration of women's labour force participation. The substantive effects of age were captured in the analysis through the number of years in total that women had spent in paid employment. Perhaps more unexpectedly, the number of hours women worked before the birth had no significant effect upon their return to work when number of children was taken into the analysis. Hours of work showed a significant impact until number of children was introduced. With the addition of number of children, the effect of hours of work was suppressed.

Occupation had a significant effect on the likelihood of women returning to work but nonetheless was not included in our final analysis. The chances of returning among women who worked in higher-level non-manual and professional occupations were higher

than those of women in all other occupational groups, including secretarial, sales and manual work. These differences in women's return-to-work behaviour were not unexpected. Our own evidence, and that of others (Daniel, 1980; Martin, 1986), suggested that there would be differences according to occupational level, and that these would be in the direction observed. But, we were also able to measure the impact of women's hourly pay rates upon the chances of their returning to work, and this proved to be a much stronger predictor than occupational level. Accordingly, we included hourly pay rather than occupational level in our final analysis.

Table 6.25 presents the results of the analyses. Coefficients are reported in their exponentiated form and may be taken to represent the *odds*, or chances, of a woman returning to work after childbirth. Odds are simply another way of expressing probabilities. If the probability of returning to work is 90 per cent, then the odds are nine to one *on*, or in favour of a woman returning to work. If the probability is only 10 per cent, then the odds are nine to one *against* a woman returning. In the case of categorical variables, such as whether or not women received maternity pay, one category is chosen as the base category and the coefficient for this is set to 1.00, while the coefficients in the remaining categories are interpreted relative to this base category. To take an example from the table, the coefficient of 2.56 for contractual maternity pay may be interpreted to mean that, holding constant all other variables included in the analysis, the odds (chances) of returning to work were over two and one-half times greater for women who received contractual maternity pay than they were for women who received only Statutory Maternity Pay (the base category). The T statistic indicates whether the association between the (predictor) variable in question and (the outcome) returning to work is significant. Values of two and above for the T statistic indicate that the association is significant. To continue with the example of maternity pay, the T statistic of 6.43 for contractual maternity pay shows that the receipt of such pay had a significantly positive effect upon the likelihood of women returning to work. Indeed, contractual maternity pay was the most significant variable included in our model.

The other significant influences on women's return-to-work behaviour include having educational qualifications above A level, having more than one child, average hourly pay and working for a public sector employer. In large measure, the impact of number of

Table 6.25 Logit model for returning to work after the birth: all women in work before the birth (N=2,471)

	Mean	Coefficient	T statistic
Number of children	1.44		
One		1.00	
Two		1.88	5.34*
Three		1.98	3.74*
Four or more		2.16	3.89*
Qualifications			
Higher-level	0.24	1.65	3.68*
A level	0.21	0.92	-0.61
O level	0.63	1.04	0.34
GCE ungraded	0.43	1.00	-0.04
Vocational	0.30	0.94	-0.62
None	0.16	1.00	-0.01
Years in labour force	8.67	1.01	1.23
Hourly pay (logged)	2.88	1.73	3.98*
Maternity Pay	1.93		
SMP		1.00	
Contractual pay		2.56	6.43*
Maternity allowance		0.70	-2.34
No pay		0.90	-0.76
Type of employer	2.06		
Public sector		1.00	
Private corporate sector		0.67	-3.53
Small firms sector		0.75	-2.00
Other employers		0.87	-0.94
Statutory right to return	1.40		
Not qualified		1.00	
Qualified		1.33	1.79
Interaction terms:			
1. Not qualified for statutory reinstatement and months in pre-birth job		1.01	1.82
2. Qualified for statutory reinstatement and months in pre-birth job		1.00	1.00
Months in pre-birth job	52.10		

* Significant.

children confirms our earlier suggestion that part-time women workers are a self-selected group in relation to re-entering the labour market after a birth. Women with children tend to work part-time because reduced working hours allow them to manage both spheres of activity. Once in work on a part-time basis, they are able to maintain their employment after the addition of a new child to their family. What we may note here is that it is the stage at which women are in the process of family formation which is the pivotal influence on their return to work rather than the number of hours they worked prior to a birth. In other words, the causal direction is from becoming a mother to part-time employment and, with the addition of a new baby, to returning to work after the birth. The significant association between number of children and returning to work, and the suppression of the impact of hours of work when number of children is taken into account, provides confirmation that the apparent correlation between hours of work and return to work noted earlier was in fact spurious.

We were particularly concerned to determine whether qualification for statutory reinstatement had an independent and significant effect on the chances of women returning to work following a birth. A woman must have worked for the same employer for at least sixteen hours a week for at least two years in order to qualify for reinstatement. There are other statutory requirements, as outlined in Chapter 5, but these were not taken into account in the present analyses as they have only a marginal impact in practice. Table 6.25 shows that qualification for reinstatement was not significantly associated with returning to work (the T statistic is less than 2), whether or not length of service in the pre-birth job was taken into account. Preliminary analyses had shown qualification for reinstatement to have an independent and significant impact but, as with hours of work, when a further variable was introduced into the analysis, its significance was suppressed. In this case, however, it was the introduction of maternity pay that caused the change in the analysis. We have already noted that the chances of women in receipt of contractual maternity pay returning to work are highly significant. And, to repeat, its inclusion in the analysis had the effect of reducing the impact of the right to reinstatement on the chances of returning (unlike type of employer, which did not suppress the effect on the right to reinstatement).

Taken as a whole, our analyses present an intuitively plausible explanation of women's return-to-work behaviour. The more highly paid a woman was in her pre-birth job, the more likely she was to return to work. Women in the public sector, women who received contractual maternity pay and women with higher-level qualifications were particularly likely to return to work, as were women who had recently had their second or subsequent babies. It should be noted that these comments are based only upon a consideration of the characteristics included in Table 6.25 and that other, possibly significant influences on women's return to work, such as husband's occupation and income, might also have been taken into account. Here we have chosen to focus upon influences which relate directly to women's personal characteristics and experiences in the labour market and we would wish simply to note that scope remains for more detailed analyses in this area.

Occupational change over childbirth

Tables 6.20 and 6.21 indicated considerable variation in the proportions of women who returned to the same, or a similar, job with their previous employers. It is also of interest to examine the extent to which women in work as a whole maintained or changed job level following childbirth. Other research suggests (Martin and Roberts, 1984; Dex, 1987; Brannen, 1989) that women's return to work following childbirth is often associated with a downgrading in occupational status. The *Women and Employment Survey* (WES), for example, showed that downgrading was particularly likely when women returned to work on a part-time basis. Of all women covered by WES who returned to work within one year of the birth of their first baby (our nearest comparator from WES), over one-quarter of part-time, and 15 per cent of full-time, returners went back to jobs below the level that they had held before the birth (Martin and Roberts, 1984:147).

Our own analyses of occupational change following childbirth are hindered by the small number of women returners in sales and manual jobs. Where sufficient numbers of women did return to work, the large majority of both full-time and part-time returners went back to jobs that fell within the same occupational group as their previous job. This was especially the case for women who were employed in professional

and associate professional occupations. We were unable, however, to measure changes of job grade *within* occupational categories.

Managers and administrators
Sixty-nine women who had worked full-time during pregnancy in managerial or administrative jobs had returned to work by the time of our survey.[6] Of these, thirty-four remained in full-time work and thirty-five changed to part-time hours. All but two of the managers and administrators who returned full-time maintained their occupational level upon their return to work. Of the two, one returned to work as an associate professional, the other returned to clerical or secretarial work. Of those who returned part-time, however, only twenty-five remained in managerial or administrative work. Six took up clerical or secretarial jobs, three became personal and protective service workers and one entered an unskilled manual job.

Professionals
One hundred and seven full-time professionally employed women returned to work within eight or nine months of their baby's birth, seventy full-time (65 per cent) and thirty-seven part-time (35 per cent). All but one full-time returner stayed in professional work. The one woman who did not return to work at this level had moved into managerial or administrative work. Similarly, all but three of the professionals who took up part-time work on their return remained in professional work. The three part-time workers who left professional employment moved downwards occupationally, one into clerical or secretarial work, one into personal and protective service and one into sales work.

Associate professionals
There were 145 returners among women who had held full-time associate professional jobs during pregnancy; 51 per cent returned to full-time work and 49 per cent changed to part-time hours. The large majority of both groups (99 per cent of full-time and 91 per cent of part-time) retained their occupational level upon return. Of the rest, all but one of the part-timers experienced occupational downgrading into clerical, sales or manual work; the one part-time returner entered a managerial or administrative job upon returning, as did the one full-time returner who did not resume associate professional status.

Clerical and secretarial workers

Women who had been employed full-time in clerical or secretarial jobs constituted the largest group of returners and experienced the greatest amount of downgrading among part-time returners. Two hundred and twenty-five clerical and secretarial workers had returned to work by the time of our survey, 49 per cent full-time and 52 per cent part-time. The large majority of women who returned full-time (95 per cent) re-entered clerical or secretarial work, while 4 per cent moved into personal and protective service or manual jobs, 1 per cent into managerial or administrative work.

Of those who returned part-time, however, just over one-quarter (26 per cent) moved into sales, personal and protective service or manual jobs. Of these, 20 per cent went into two occupational groups: sales and personal and protective service. Two-thirds of clerical and secretarial workers remained in this type of work after the birth, while 5 per cent moved into higher-level white-collar or managerial work.

Sales and manual workers

The small number of returners among women who had worked full-time during pregnancy in craft, sales, personal and protective service jobs, as plant and machine operatives or in jobs which fell into the unskilled residual 'other occupations' category sharply restricted our analyses of occupational change over childbirth. In total, only 152 women who were back in work had held these jobs. In no occupational category did the number in work reach as many as 50 women and, in the majority of cases, fewer than 35 of each occupational group were in work after the birth. Nevertheless, the following patterns emerged from our analysis.

First, the majority of women employed during pregnancy in sales and manual jobs returned to jobs that fell into the same occupational category. This was the case whether they returned part-time or full-time. Secondly, there was nonetheless considerable movement between these occupations, especially among part-time returners. Of the 97 women who returned part-time, 42 per cent moved from one to another of these five occupational levels upon their return. Seven per cent of the 55 women who returned full-time moved between these occupations. One full-time and ten part-time returners entered clerical or secretarial jobs after coming back to work.

The question arises whether this movement constituted occupational downgrading. In some instances it must have been. The move from full-time craft and related manual work into a plant or machine operative's job or into sales is likely to entail a lost opportunity to use valuable skills, but was experienced by only 3 craft workers who returned part-time (and no full-time returners). It is not clear, however, whether the same could be said about the more common moves, such as that between sales jobs and personal and protective service occupations, for example. It seems more likely that these occupations constitute a type of lower-level labour market for women who wish to work part-time during family formation. Here we see considerable mobility between these various job groups by women who returned part-time. We saw earlier, in relation to our analyses of statistically significant influences on the chances of women returning to work, that few differences existed between women who had been employed previously in these particular jobs. We show below (Table 6.26) that the average hourly pay available to women in, say, sales varied by only a few pence from that available to women in personal and protective service jobs or semi-skilled and unskilled manual jobs. With the exception of craft and related skilled manual jobs, moreover, relatively similar levels of general education and competence are required for the performance of jobs within these categories.[7] The evidence suggests, then, that for part-time returners at least, these occupations provide a range of jobs from among which women may choose on returning to work.

In summary, our analysis of occupational change over childbirth allows us to make the following observations. First, the amount of downgrading after childbirth among women who were employed in higher-level non-manual and professional occupations appeared to have been minimal and may well have lessened since the 1980 *Women and Employment Survey* and the 1979 PSI survey. The large majority of women in these occupational groups maintained their occupational level after returning to work whether that return was on a full-time or a part-time basis. This is, perhaps, a finding that might have been expected in light of the increased presence of women in the labour market and of the awareness among some employers, particularly in the public sector, of the importance of retaining qualified, highly skilled staff. Moreover, as returners within a relatively short time

following a birth, these women were in a good position to maintain their occupational level. A break of eight or nine months – or, as in many cases, of much shorter duration – has little or no impact upon women's skills and expertise. Thus these women were, by and large, able to step back into jobs that they had only briefly left.

Our second observation concerns women in clerical and secretarial work. Here too the majority of full-time returners maintained their occupational level upon returning to work. A considerable amount of downgrading was found, however, among those who returned part-time. It may be the case that there are fewer part-time clerical and secretarial jobs available. The work of Dex (1987) showed a clear predisposition among women who had entered clerical and secretarial work to return to such work after breaks from employment for childbirth or other reasons. Dex argued cogently (1987:47-52) for the existence of a 'clerical profile' among women's career options; it therefore seems unlikely that many of the women covered by our own survey had left clerical or secretarial work by choice.

Finally, we may note that it was also the case that the majority of full-time returners among women employed in sales or as manual workers before the birth went back to jobs in the same occupational group. We have suggested, however, that, with the exception of craft occupations, there may be a common labour market among these occupational groups for women who wish to return to work on a part-time basis. Relatively similar hourly rates of pay are available to women within this common labour market; relatively similar standards of general education are needed to perform the associated work tasks. Thus it is unclear whether changes between these job groups constituted occupational downgrading.

Changes in hourly pay over childbirth

Table 6.26 summarises the average hourly rates of pay before and after the birth. The table is based upon only those women in each category who provided information about both income and hours of work. This included only a small number of women in the case of craft and related workers and the hourly pay figures provided for this occupational group should therefore be viewed with some caution. In all cases women's hourly pay rates increased after their return to work.

Table 6.26 Average hourly pay before and after the birth according to occupational level (£)

	Pay before	Pay after	Base[a]
Managers/administrators	3.49	3.98	82
Professionals	4.80	5.34	155
Associate professionals	3.82	4.04	219
Clerical/secretarial	3.04	3.12	310
Craft and related	2.64	3.41	28
Personal and protective service	2.52	2.63	109
Sales	2.22	2.72	65
Plant/machine operatives	2.19	2.99	60
Other occupations	2.14	2.61	67
All women	3.18	3.24	1,094

(a) the table is based upon all women in work after the birth.

Childcare arrangements

We asked all women in work after the birth about the arrangements they made for the care of their new baby while they were at work. Tables 6.27 and 6.28 summarise our findings about the usual provider of childcare and the usual place where childcare was provided according to whether the mother worked full-time or part-time after the birth. It was possible for more than one usual carer to be mentioned. For each group of women the same three usual carers were cited most frequently: fathers, grandmothers and childminders. When working hours after the birth were taken into consideration, however, different carers assumed differing importance. Childminders, for example, were cited by 36 per cent of women in full-time work, but only 16 per cent of part-time workers. Fathers, in contrast, were cited by 51 per cent of part-time workers, but only one in five women in full-time employment. Overall, however, fathers were the most likely providers of childcare while mothers were at work. This was found to be the case also in the 1979 PSI survey when 35 per cent of all women in work after the birth reported that the usual carer was the baby's father.

Table 6.27 Childcare arrangements according to full-time or part-time in job after the birth

Column percentages

| | Total | Job after the birth | |
		Full-time	Part-time
Person who usually provides childcare			
Baby's father	41	20	51
Baby's grandmother	36	33	38
Other relative	8	9	8
Friend/acquaintance	7	5	8
Childminder	22	36	16
Nursery staff	2	4	1
Au pair/Nanny	4	10	2
Baby's mother	11	9	12
Base: Women in work after the birth	1,419	449	956

Table 6.28 Place where baby is usually cared for according to full-time or part-time in job after birth

Column percentages

| | Total | Job after the birth | |
		Full-time	Part-time
Baby's home	61	45	68
Someone else's home	49	63	44
Local authority nursery	*	*	*
Private nursery	1	2	1
Workplace nursery	1	1	1
Base: Women in work after the birth	1,419	449	956

* less than 0.5 per cent.

Women employed part-time were more likely to cite more than one usual carer, and more likely to have their babies cared for in their own homes. Indeed, women chose mirror-opposite places for their babies to be cared for, depending upon their hours of work after the birth. Sixty-eight per cent of women who worked part-time had their babies cared for in their own homes and 44 per cent had their babies cared for in the home of someone else. For women in full-time work, the corresponding proportions were 45 per cent in their own homes and 63 per cent in the home of someone else. Other locations, such as local authority or workplace nurseries were used by only a handful of women, whatever their working hours.

Sixty-four per cent of women had to make childcare arrangements for only one child. Sixty-two per cent arranged childcare in ways that did not require cash payments. Tables 6.29 and 6.30 summarise our findings in relation to the number of children cared for and the cost of care according to occupational level after the birth and whether the woman returned to work full-time or part-time.

Table 6.29 **Cost of childcare arrangements according to occupation in pre-birth job for women who returned to work full-time**

Percentages

	More than one child in care %	Pays for child-care %	Median weekly cost (£)	Base
Managers/administrators	15	52	35	52
Professionals	33	85	44	86
Associate professionals	21	64	39	81
Clerical/secretarial	15	62	30	124
Craft and skilled manual	(2)	(3)	20	11
Personal and protective services	(9)	(13)	28	30
Sales	(6)	(6)	30	16
Plant and machine operatives	(5)	(12)	23	19
Other occupations	(5)	(8)	36	11
Not in work before	(5)	(4)	47	10
All full-time	23	63	37	449

Base: Women in full-time work after the birth

Table 6.30 Cost of childcare arrangements according to occupation in pre-birth job for women who returned to work part-time

Percentages

	More than one child in care %	Pays for child- care %	Median weekly cost (£)	Base
Managers/administrators	28	34	28	61
Professionals	52	53	24	98
Associate professionals	36	37	19	154
Clerical/secretarial	39	23	20	244
Craft and skilled manual	(8)	(9)	16	26
Personal and protective services	45	21	16	111
Sales	48	14	13	71
Plant and machine operatives	49	20	13	59
Other occupations	51	17	7	65
Not in work before	55	16	15	51
All part-time	43	27	19	956

Base: Women in part-time work after the birth

() denotes actual number.

Women employed full-time in professional occupations, who were among the highest earners among women who returned to work, were also the most likely to pay for childcare and paid the highest median weekly amount. On average, they paid £44 per week for the care of their children. It is one measure of the nature of the changes that have taken place in the economy since the 1979 PSI survey that the median weekly payment at that time was £9 a week. For women in work in 1988, the median weekly payment made by women in full-time employment was £37 a week, and £19 a week for women in part-time employment. Women who were employed part-time in sales, personal and protective service and semi-skilled or unskilled manual jobs were (together with women professionals) the most likely to have had more than one child who needed care while they were at work. They were also among the least likely to have had to pay for this care.

Notes

1. It is worth noting that fully 95 per cent of the women in full-time work after the birth had been in full-time work before. There was, in other words, only a slight movement from part-time to full-time employment among women returning to work. Overall, only 3 per cent of women who had been employed previously on a part-time basis moved into full-time work upon returning to the labour market. Given the arguments made in the text about women in part-time employment tending to be ones who would have already in place arrangements to support their participation on a part-time basis and the age of their new baby at the time of our survey, it is not surprising that we found only a slight tendency for these women to take up full-time work.

2. Research carried out in 1989 suggests that employers remain slow to introduce changes in employment practices, especially those of an innovative nature such as career breaks, school-term time working, optional working from home and job-sharing. As in our own research, part-time working and flexi-time were the two most common practices which allowed workers flexibility over their working time. (See Metcalf, 1989).

3. Birth order appeared to have had no impact on women's ability to act in accordance with their prior intentions. Fifty-five per cent of women who had returned to work and 75 per cent of women who did not return were first-time mothers. These proportions change by only one or two percentage points if women's employment intentions during pregnancy are taken into account.

4. Ideally, the analysis of women's reasons for returning to work should be based on both the job held before and the job held after pregnancy. In that way, the resources a woman had built up in the labour market before the birth – both financial and in terms of human capital – and those she would either retain or forfeit by her decision to return or not would be taken into account. However, having also to take account of changes in women's occupational level after having a baby (discussed below in the text) would entail, at best, 27 different occupational categories. It was our judgement that the resulting analysis would border on the incomprehensible. We chose women's occupations before the birth as the focus of our analyses because they represented the resources women

commanded in the labour market up to the time of the birth. It seemed reasonable to assume that these resources would have had an important effect on women's decisions to return. However, analyses could have been carried out equally well based upon women's occupations after the birth.

5. We are very grateful to our colleagues Michael White and Joan Payne for help in interpreting and presenting our logistic analysis.

6. We focus on full-time workers during pregnancy because it is possible that women who were in work part-time before the birth of their recent baby had previously experienced downgrading.

7. One of the criteria for the grouping of jobs into the categories of the Standard Occupational Classification was the standards of education, training and competence needed for job performance. The standards required for personal and protective service workers, sales occupations, plant and machine operatives and the residual 'other occupations' (and, indeed, clerical and secretarial workers) vary slightly, but not to an extent that would prohibit job mobility. At most, a good standard of general education is required, and at least, the knowledge and experience necessary to perform most simple and routine tasks. See Thomas and Elias, 1989.

8. From October 1987 to October 1988, average gross hourly earnings without overtime increased by 6.3 per cent for women in manual jobs and by 11.4 per cent for women in non-manual jobs ('Pay in Britain', *Employment Gazette*, November 1988).

7 Suggestions for change

In this chapter we review the extent to which women and their employers would like to see changes made to maternity rights legislation. At the end of our self-completion questionnaire to women, we made two pages available for them to add comments. We asked them, first, to write in any changes they would like to see in order to make it easier for women with children to return to work. Secondly, we asked them to include any suggestions they had for changes to maternity rights legislation or arrangements for maternity pay. Thirdly, we asked them to write in any changes they would like to see to make it easier for fathers to take time off work around the time of the birth. And finally, we gave them an opportunity to comment on anything else concerning the subject.

Similarly, during the course of our telephone interviews with employers, we asked respondents if their organisation had made any changes as a result of maternity rights legislation, and if there were any changes to the legislation they would like to see in order to make things easier for employers. About two-thirds of women said that there were changes they would like to see. About two-thirds of employers said that things were fine as they were.

Changes women would like to see
As in 1979, the majority of women covered by our survey added comments and suggestions of considerable substance to our analyses. Their views were highly relevant and were often expressed strongly

and at some length. Many of these women would have already completed more than thirty pages of questions before they began to add their own suggestions for change. Their efforts in this regard illustrated the benefits that may be reaped in investigating topics of particular concern to the people studied and we are immensely grateful for their interest. The range of topics they covered was enormous. Nevertheless, it was possible to reduce them to manageable, meaningful and non-repetitive groups.

Several conclusions of substance emerged from our analysis. First, it was clear that issues concerning the relationship between women and paid work are matters of widespread and continuing interest to women who have recently had babies. In light of the increased tendency for women to remain in paid work after a recent birth, this was hardly surprising. Secondly, as in 1979, better and more extensive childcare facilities for women who go out to work was the single most important change that women spontaneously reported they would like to see to help them remain at work throughout their childbearing and childrearing years.

Thirdly, there is a demand for improved maternity rights, especially for an extension to the period of maternity absence. The demand for a longer time away from work, sometimes expressed as a wish for a greater length of time in which to decide whether to return to work, was a rather surprising finding. We saw earlier that the majority of women who returned to work did so well within the statutory twenty-nine week reinstatement period. The answer seems to be that, among women who had not yet returned to work by the time of our survey, the statutory reinstatement period is seen as too short, while at the same time it offers ample time for early returners to make their arrangements to go back to work. Fourthly, there was a spontaneous demand for more flexible working arrangements to help women combine childcare with paid work. This demand is given added force by our earlier analyses which showed a substantial gap between women's intentions to work after the birth and their opportunities for suitable employment. One in five women not in work after the birth were looking for jobs at the time of our survey. Increased flexibility on the part of employers would be likely to draw many of these women back into the labour force.

Finally, the substantial minority of 'counter-revolutionaries' identified in the 1979 PSI survey who expressed the feeling that

mothers with young children should not go out to work has diminished. In 1979 many respondents took the opportunity to write at length that the place for women with young children was in the home and that such women should be actively discouraged from working. Women with these views were still to be found and they continued to express their opinions forcefully, but in 1988 they represented only 4 per cent of all women covered by the survey and only 2 per cent of those who had been in work during pregnancy.

We now turn to our detailed examination of the changes women would like to see to make it easier for them to return to work after having a baby. Nine per cent of the women covered by our survey took the opportunity to say that, in their view, no changes were needed. Twenty-eight per cent made no response at all, leaving blank the pages provided for them to write about any changes. Women who worked as professionals and associate professionals were the least likely to have suggested that no changes were needed and, together with managers and administrators, were less likely not to have made any suggestions for change. In contrast, women who had worked during pregnancy as plant and machine operatives or as sales or personal and protective service workers or in the residual unskilled category 'other occupations' were more likely not to have written in any suggestions. This means that our analyses are slightly biased towards the 'articulate middle-classes', at least as measured by women's occupations. It should be remembered, however, that just over 60 per cent of women who had been employed in sales and manual occupations did answer our questions and provide suggestions as regards changes they would like to see to make it easier for them to continue working after childbirth.

Table 7.1 summarises the changes wanted by women who had worked during pregnancy according to the occupational level of the job they held at that time. The table also shows the distribution of women who felt no changes were needed and the proportions who did not respond to the opportunity to write in their suggestions for change.

As noted above, improved childcare facilities were the single most important change women wished to see, whatever their occupational level. Proportionately more women employed in higher-level non-manual and professional work said that they wanted better and more extensive facilities for the care of their children, but the issue was also of considerable importance to women in other occupations.

Table 7.1 Changes wanted by women in work during pregnancy to make it easier to return to work after having a baby

Column percentages

	Total	Manager/ admin.	Professional	Assoc. prof.	Clerical/ secretarial	Craft works	Personal protection service	Sales	Machine/ plant operatives	Other occup.
Flexible working hours	20	22	24	33	20	16	12	18	15	9
Improved childcare facilities	50	53	64	69	48	49	45	42	34	38
Improved maternity rights	26	29	35	32	22	22	22	22	29	24
Miscellaneous changes	11	16	17	12	8	11	12	11	9	8
No changes needed	10	9	7	5	12	11	10	11	10	15
No answer	23	19	15	13	24	23	28	28	28	32
Base: Women in work during pregnancy	2,635	190	255	351	813	114	290	250	163	182

We discuss the specific types of changes related to childcare in more detail shortly. Similarly, the wish to see improvements to maternity rights legislation was mentioned more often by women in higher-level occupations, but nonetheless had salience for women in sales and manual jobs. Added details about women's suggestions for changes to the legislative provisions are also provided later in the chapter.

One in five women wished to see changes in the organisation of work that would help them to continue working after having a family. Nine per cent wanted to see employers introduce more flexible working hours. In particular, women who were employed in associate professional occupations were likely to want more flexible hours of work. Nineteen per cent of associate professionals mentioned this change compared with, for example, 7 per cent of professionals and 11 per cent of sales workers.

Part-time employment (6 per cent) and job-sharing arrangements (5 per cent) were mentioned by just over one in ten women, particularly professionals and associate professionals. Almost half of the women who thought that part-time or job-sharing arrangements would make it easier for women to return to work after childbirth had been employed during pregnancy as professionals or associate professionals.

Flexi-time, part-time work and job-sharing were the most common changes wanted as regards the organisation of the workplace. Other changes included a shorter working day for parents of young children (1 per cent), evening hours or special shifts (1 per cent) and opportunities to work at home (1 per cent). A small number of women (thirteen) mentioned weekend or term-time working arrangements as the change that would most help them to remain in employment.

Just over one in ten women in work during pregnancy mentioned a host of other 'miscellaneous' changes that they wished to see. Included among these were 2 per cent who felt that women with young children ought to stay at home; 1 per cent who thought that more provision should be made for women to have unpaid time off work for family reasons; and 3 per cent who felt that employers needed to show more consideration towards women during pregnancy and to be more understanding of the responsibilities women have towards their families.

Women in work during pregnancy were not, however, the only ones to make suggestions about changes that would ease their dual

roles as mothers and workers. Table 7.2 focuses upon the single most important change wanted by all women – improved childcare facilities – and summarises the views of all women in our survey according to their employment status before the birth of their recent baby.

The provision of childcare facilities

Our analyses in Chapter 6 showed that only 2 per cent of women in work after the birth used workplace or private nurseries. Less than 0.5 per cent used local authority nurseries. We also showed in Chapter 6 that 12 per cent of women not in work at the time of our survey were unable to find suitable childcare and 11 per cent could not find childcare they could afford. In a stark complement to these figures, Table 7.2 shows that 54 per cent of women in work during pregnancy wanted to see extensions to the childcare facilities currently available.

Table 7.2 Changes wanted in childcare arrangements according to working status before the birth.

Column percentages

	Total	In work during pregnancy	In work one or more years before the birth	Not in work before the birth
More workplace creches/ nurseries	31	35	31	15
More state funded/local authority nurseries	10	9	12	6
More childcare facilities generally	9	10	9	8
Financial help with childcare costs/cheaper childcare	6	6	7	6
Tax relief on childcare costs/ workplace nurseries	2	2	2	*
Help finding childcare	2	2	2	1
Nurseries that accept children under age 3	2	2	2	1
Base: All women	4,991	2,635	1,528	828

* Less than 0.5 per cent.

Their views were shared by 52 per cent of women whose last job was one or more years before the birth and almost one-third of women who had never worked in Britain up to the time of the birth. Women who had held jobs, either before the birth or at some time previously, were concerned especially with improvements to workplace childcare facilities. More than one in three women in work after the birth referred to improvements in the provision of workplace nurseries or creches. This was particularly true for women whose pre-birth jobs had been in our three higher-level non-manual categories. Fifty-four per cent of associate professionals, 46 per cent of professionals and 36 per cent of managers and administrators mentioned improved workplace childcare facilities among their suggested changes. In comparison, women employed as plant and machine operatives (16 per cent), in personal and protective service (26 per cent) or sales occupations (30 per cent) were less likely to refer to workplace facilities. Indeed, women in the three latter occupational groups were less likely generally to have mentioned that they would like to see an increase in childcare facilities. Only 41 per cent made this suggestion, in contrast to 74 per cent of women in higher-level non-manual or professional work. This is likely to reflect the differing tendencies of women in these occupational groups to return to work after having a baby. We saw in Table 6.19 that women in sales, personal and protective service and operative jobs were substantially less likely to go back to work after childbirth than women in higher-level jobs. When, moreover, we confined our analysis to women in work after the birth, only women in plant and machine operative jobs or in the unskilled residual category 'other occupations' reported comparatively less interest in extended childcare facilities. Table 7.3 summarises the changes women in work after the birth would like to see in the provision of childcare facilities according to the job held after the birth, and illustrates the particular demand for more workplace childcare facilities.

Table 7.3 Changes wanted in childcare facilities by women in work after the birth according to occupational level

Column percentages

	Total	Manager/ admin.	Professional	Assoc. prof.	Clerical/ secretarial	Craft works	Personal protection service	Sales	Machine/ plant operatives	Other occup.
More workplace creches/nurseries	35	36	46	54	34	33	26	30	16	18
More state funded/ local authority nurseries	12	11	20	9	8	19	14	9	–	5
More childcare facilities generally	10	4	21	12	7	4	10	9	5	6
Cheaper childcare/ financial help with costs of childcare	7	4	7	8	8	15	9	4	9	8
Tax relief in childcare costs workplace nurseries	3	4	9	3	3	–	1	–	2	–
Help finding childcare	2	4	5	1	3	–	4	2	2	–
Nurseries that accept children under age 3	2	3	4	2	2	4	1	2	2	2
Base: Women in work after the birth	1,419	96	169	220	280	27	137	96	58	85

Maternity rights legislation

Table 7.4 summarises the changes women would like to see in maternity rights legislation and presents the views of all women covered by our survey. Among the many changes mentioned by women, the wish to have a longer period of maternity absence stood out, particularly among women who had been in work during pregnancy. Women in the other two categories shown were less likely both to have mentioned changes in maternity rights legislation and to have wanted an extended period of maternity leave.

Table 7.4 Changes women would like to see in maternity rights legislation

Column percentages

	Total	In work during pregnancy	In work one or more years before the birth	Not in work before the birth
Longer maternity leave	17	22	13	9
Paid time off to care for children when ill	2	3	2	1
Rights available to all women	2	3	2	1
Rights transferable between employers	1	1	*	–
Better rights for part-time employees	1	1	1	*
More information about rights	1	1	*	*
Better rights for self-employed women	*	*	*	–
Other answers	4	5	3	2
Base: All women	4,991	2,635	1,528	828

* less than 0.5 per cent.

We note above that women who returned to work on average returned well within the statutory twenty-nine week period and suggest that women who had not yet returned to work were more likely to want a longer period of maternity leave. Among women who had returned to work by the time of our survey, the demand for extensions

to maternity leave was less, except in relation to women professionals and associate professionals. Women who were employed in these occupations were both more likely to return to work and more likely to want longer periods of maternity leave. Of all professionals and associate professionals in work after the birth, one-third of the former group and almost one half of the latter (47 per cent) said that they would like a longer time away from work after having a baby. Otherwise, women in work after the birth as clerical and secretarial workers, or in craft, sales and personal and protective service occupations were generally unlikely to have reported that they wanted longer maternity leave. Fewer than one in seven of such women said that extended maternity leave would make it easier for them to return to work after having a baby.

Little variation according to occupational level was found in relation to the remaining changes women reported as regards maternity rights legislation.

Changes wanted by employers

Respondents to our survey of employers were asked two sets of questions related to changes in maternity rights legislation. The first concerned changes made by their organisations as a result of the legislation and the second focused on any changes they might wish to see in order to make things easier for employers. In both areas, our questions were open-ended and allowed employers to bring to light the issues which most concerned their organisations. Public sector managers were the most likely to report that changes had been made in their organisations to take account of the legislation (19 per cent) and private sector independent workplaces were the least likely to report such changes (5 per cent). Thirteen per cent of workplaces within the private corporate sector reported organisational changes. Within the private sector, workplaces with over 100 employees were more likely to have made changes, while within the public sector size of workplace had little impact on managers' responses.

The most common change mentioned by respondents involved alterations made to ensure that their organisations complied with the legislation. Seven per cent of all respondents reported that changes of this nature had been made, including 2 per cent who reported that their own maternity benefits scheme had been altered to comply with the legislation. In addition, 3 per cent reported that their own schemes had

been altered in order to extend the provisions set out in the legislation and a further 2 per cent had introduced some incentives to encourage women to return to work after childbirth. There was little variation according to type of employer in the nature of the changes made within the organisation.

In the 1980 PSI survey only 3 per cent of employers had made changes to their organisations as a result of maternity rights legislation. This survey, of course, focused primarily upon employers in the private sector. Our own survey provides more evidence of changed practices among employers in both public and private sectors alike. This may be accounted for as follows. The 1980 PSI survey took place shortly after the introduction of maternity rights legislation. Employers consequently would have been in the process of making any changes necessary to comply with the legislation. Ten years later, the changes occasioned by the legislation would have been made and thus we might have expected a decrease in the proportions who reported that they had made organisational changes. Towards the end of this ten-year period, however, Statutory Maternity Pay was introduced (in 1987), thus necessitating a new round of changes for employers. And indeed, the large majority of the changes recorded by our current survey of employers referred to maternity pay. These latter changes will now have been made by most employers. A tiny minority (1 per cent) asked us to ensure that no further changes to the legislation occurred.

But while it is the case that a few employers would like no further alterations to the legislation, a larger number reported a wide variety of changes they would like to see to make things easier for employers. Table 7.5 summarises the changes wanted and shows little variation according to type of employer, either in our present survey or in relation to changes within the private sector since the 1980 PSI survey of employers.

The change most commonly reported by managers concerned women's right to return to work after childbirth. In total, 13 per cent of workplaces mentioned a change related to reinstatement. Independent workplaces were the most likely to report this change (17 per cent), particularly those with fewer than 100 employees (18 per cent). Fourteen per cent of public sector workplaces also reported that they would like to see changes in the right to reinstatement, as did 11 per cent of private sector workplaces that were part of a group of

Table 7.5 Changes sought by employers to maternity rights legislation

Column percentages

	Total	Public sector	Private sector Part of group	Independent	1980
Yes, like to see changes	29	30	31	28	27
No	68	68	65	70	64
Can't say	3	2	4	2	8
All answers	100	100	100	100	100
Nature of changes sought					
Scrap the lot	2	1	3	2	5
Scrap right to reinstatement	2	1	3	5	9
Penalise failure to return	1	1	1	–	4
Reduce reinstatement period	4	3	3	6	3
Reduce red tape	5	5	7	1	1
Require definite commitment to return	6	9	4	6	‡
Increase provisions/ extend rights	2	1	3	2	1
Paternity leave should be a right	1	2	–	–	‡
More creches/nurseries	2	3	1	2	‡
More incentives for women to return to work	1	2	–	–	‡
Return to old maternity pay system	1	1	2	3	‡
Other answers	5	7	7	4	3
Can't say	1	4	4	4	1
Base: All					
Weighted	502	193	183	126	715
Unweighted	502	188	189	124	302

‡ response not distinguished separately in 1980.

organisations. Respondents were concerned about the right in various ways. Six per cent wished to see the introduction of a requirement which would force women to give a definite commitment to return. Four per cent wanted the reinstatement period to be reduced. Two per cent wanted to abolish the right completely. And one per cent wished to see arrangements that would penalise women for a failure to return. Of these differing aspects, public sector workplaces in particular were concerned that women should be required to give a firm commitment to return, while private sector independent workplaces were equally concerned with this change and with reductions in the length of the reinstatement period.

The wish to see a reduction in the amount of 'red tape' associated with maternity rights legislation was expressed by 5 per cent of managers. This was a particular concern of managers in private sector workplaces that were part of a group of organisations. Seven per cent of these managers said that they would like to see fewer bureaucratic procedures, in contrast to only 1 per cent of their private sector counterparts in independent workplaces.

Variations by industrial sector added few additional points of interest to the analysis. Again, changes associated with reinstatement stood out and managers in each of the industries identified were more or less in equal agreement about the need for change. Managers in banking and finance, however, had no wish to see the right abolished or reduced but preferred the introduction of arrangements that would require women to give a commitment to return. These managers were equally concerned to see a reduction in red tape.

Negotiations with unions or staff associations over issues concerning the employment of women

Many, but by no means all, of the suggestions made by respondents to our survey of employers concerned changes that would be unlikely to be to the benefit of women in employment. Six per cent of employers did suggest changes that would be likely to help women to remain in the labour force during family formation, such as extended maternity rights, the introduction of paternity leave, the provision of additional nursery facilities and other incentives to encourage women to return to work. We asked employers if they had had any negotiations with unions or staff associations over issues that concerned the employment of women. In total, 18 per cent of workplaces where there

was a union or staff association had had such negotiations and these are summarised in Table 7.6.

Table 7.6 Extent and nature of trade union/employer negotiations over issues concerned with women's employment

Column percentages

	Total	Public sector	Private sector	
			Part of group	Independent
Had negotiations	18	20	6	2
No negotiations	78	78	91	98
Can't say	4	2	3	–
All answers	100	100	100	100
Nature of negotiations+				
Workplace childcare	3	4	2	–
Equal opportunities/pay	3	4	–	1
Equal pension age	3	3	2	1
Other childcare help	2	3	1	–
Career break scheme	2	1	2	–
Extended maternity leave	2	2	2	–
Parental leave	*	–	1	–
Other issues	4	4	2	1
Base: Workplaces with trade unions or staff associates				
Weighted	299	193	183	126
Unweighted	306	188	189	124

+ Percentages sum to more than 100 because more than one type of negotiation may have taken place.

* less than 0.5 per cent.

Public sector workplaces were substantially more likely than those in the private sector to report that negotiations had taken place on issues specifically concerned with the employment of women. Twenty per cent of public sector workplaces reported such negotiations,

compared with only eleven private sector workplaces that were part of a group of organisations (6 per cent) and three independent workplaces (2 per cent). Workplaces where negotiations had taken place tended to be larger ones, especially in the private sector. Only one workplace with fewer than 100 employees in each of the two private sector categories had had such negotiations. Help with childcare was the one single issue which stood out as regards the subject matter of any negotiations in the public sector. Seven per cent of public sector workplaces reported negotiations related to childcare assistance, at the workplace and in other forms.

Changes wanted by women to make it easier for fathers to take time off around the time of a birth

One of the concerns of our research was the extent to which fathers took time off work during pregnancy and around the time of the birth. As part of this, we asked women to write in any suggestions that they wished to see in order to make it easier for fathers to take time off around the time of the birth of a baby. In response, women simply wrote that they wished fathers were more able to take time away from work, whether paid or unpaid. Only a small number offered suggestions about how this might be possible, such as through flexible working hours (3 per cent) and extra holiday entitlements (1 per cent). Table 7.7 summarises variations among women as regards this issue according to their employment status before the birth.

Forty-one per cent of women said that they would like to see more opportunities for fathers to take time off work, rising to 46 per cent of women in work during pregnancy. Twenty-five per cent wanted this time to be separate paid leave, while 16 per cent did not specify whether they thought that the time off work should be paid or unpaid. Table 7.8 summarises the extent to which respondents to our survey of employers reported that men in their workplaces were allowed time off work when they became fathers and categorises workplaces according to occupational sector. Only about one half of workplaces reported that men were able to take time away from work for this reason. Of these, 60 per cent reported that time off was granted at management's discretion rather than being embodied in collective or contractual agreements.

Twenty-six per cent of workplaces in our survey of employers reported that the time off work allowed to their male employees was

Table 7.7 Changes wanted by women to make it easier for fathers to take time off work

Column percentages

	Total	In work during pregnancy	In work one or more years before the birth	Not in work before the birth
Paid time off at or after the birth	25	28	24	15
Unpaid time off at or after the birth	*	–	*	*
Time off at/after the birth (payment not specified)	16	18	16	8
Time off for family illness or problems	9	9	11	5
Extra holiday time at/after the birth	1	11	1	1
Flexitime	3	4	4	2
Improved attitude by employers towards fathers	3	3	3	2
Payment for self-employed men	1	1	2	1
Other changes	4	5	4	3
No changes needed	10	9	10	11
Base: All women	4,991	2,635	1,528	828

* less than 0.5 per cent.

paternity leave. This accords well with a survey carried out by the CBI which found that 26 per cent of manufacturing companies and 40 per cent of service sector employers offered paid paternity leave (CBI, 1989). However, as we show below, it differs from the reports given by women in our survey of mothers, where only 9 per cent of fathers were said to have taken paternity leave. It seems likely that many women designated the time, taken away from work by fathers as 'paid leave' in cases where employers considered such leave specifically as 'paternity leave' because of the reason why the leave was granted.

Table 7.8 **The extent to which employers allow male employees time off work when they become fathers**

Column percentages

	Total	Manu-facturing	Distri-bution	Finance/banking	Other services	Other ind.
Time off	48	58	50	44	43	51
No time off	43	32	36	51	48	47
Can't say	9	10	14	5	9	2
All answers	100	100	100	100	100	100
Form of leave						
Holiday time	13	16	16	13	10	24
Paid paternity leave	26	29	28	22	26	20
Unpaid time off	4	7	5	2	5	4
Other leave	3	4	3	2	3	–
Not stated/Can't say	3	4	4	5	3	4
Median no. of days	5	4	4	7	3	6
Base: All						
Weighted	502	76	120	60	197	49
Unweighted	502	83	119	60	187	53

The large majority of women reported that their husbands or partners took time away from work either during the pregnancy or around the time of the birth, although only about one half of workplaces in our survey of employers reported that male employees were allowed to take time off work when they became fathers. Seventy-seven per cent of men who were in work at the time of the birth took time off work at or after the birth. Twenty-four per cent had taken time off work during the pregnancy. Table 7.9 summarises the extent to which fathers took time off work according to their occupational level.[1]

Some variation according to occupation was found. Men who were employed in associate professional (84 per cent), clerical and

Table 7.9 **Proportion of fathers taking leave associated with the birth, and when leave was taken**

Row percentages

	Took leave	During+ pregnancy	At/after birth+	Base
Managers/Administrators	76	22	74	589
Professional occupations	80	21	78	458
Associate professional occupations	86	27	84	290
Clerical/secretarial	90	30	88	250
Craft and skilled manual	81	26	77	887
Personal and protective service occupations	86	21	85	197
Sales	74	23	71	136
Plant and machine operatives	78	21	74	457
Other occupations	79	18	76	265
Not stated	68	27	63	200
All occupations	80	24	77	3,729

Base: All women who judged the question to be appropriate *

+ The time leave was taken sums to more than the proportion taking leave because leave could be taken on both types of occasion.

* Excludes unmarried women and women without partners, and women whose husbands/partners were not in work during the pregnancy or around the time of the birth.

secretarial (88 per cent) or personal and protective service (85 per cent) occupations were the most likely to have taken time off work at or after the birth, while men in the two former occupational groups were the most likely to have taken time off during the pregnancy. Men in sales occupations were among the least likely to have taken time away from work at or after the birth, in many cases because they were self-employed.

Our analyses revealed a gap between the extent to which mothers reported that fathers had taken time off work and employers' reports of the extent to which their male employers were allowed such time off. Accepting that the accounts given by our mothers were likely to

reflect accurately the proportion of fathers who took time away from work, there are a number of possible explanations for the gap in reports. First, it may have been that some men took paid holiday leave without informing their employers of the reason for the timing of their holidays. Others may have been granted special compassionate leave on a discretionary basis from employers who do not have formal arrangements in place for granting such time off. Alternatively, some men may simply have taken time off work, giving a reason for their absence (such as sick leave) or not, as they felt appropriate. Whatever the explanation, it appears to be the case that a variety of arrangements exist which allow men to take time off work when they become fathers.

Table 7.10 indicates the form of time taken off work by fathers and provides a comparison with the 1979 PSI survey. The base of Table 7.10 was reduced to take account of the fact that some fathers took time away from work both during the pregnancy and at or after the birth.

The first point of interest that arises from the table is the relative stability over time both in the extent to which fathers took time away from work and as regards variations by occupational group. For example, in 1988, 83 per cent of men who were employed in social class I occupations had taken time off work compared with 82 per cent of similarly employed men in 1979. There does appear, however, to have been an increase in the proportion of men in social class V occupations who took time away from work, from 62 per cent in 1979 to 79 per cent in 1988. In 1979, the chances of such men taking time away from work when they became fathers were comparatively less than those of other men; by 1988 these men hardly differed from the majority.

The most common form of leave taken by fathers was holiday time. This was unchanged from 1979 when just less than one half of the men taking leave used part of their holiday entitlements. In 1988, just over one half had taken holiday leave. Nine per cent of women reported that their husbands or partners had taken paid paternity leave. This form of leave was not distinguished separately in the 1979 PSI survey so that we are unable to judge the extent to which this may represent an increase in employers' provision of paternity leave. It is likely, though, that many fewer men would have taken this form of leave in 1979.

Table 7.10 Extent to which fathers took leave *at or after* the time of the birth: 1979 and 1988 compared

Column percentages

		Total	I	II	IIINM	IIIN	IV	V
					Social class of father			
Took leave:								
	1988	**77**	**83**	**76**	**88**	**77**	**73**	**79**
	1979	81	82	81	88	83	77	62
Form of leave:+								
Part of holiday	**1988**	**54**	**62**	**52**	**72**	**43**	**48**	**44**
	1979	47	57	51	72	42	37	26
Paternity leave	**1988**	**9**	**8**	**12**	**10**	**1**	**6**	**4**
Other paid leave	**1988**	**7**	**6**	**9**	**7**	**6**	**6**	**5**
	1979	13	17	21	15	9	7	9
Unpaid time off	**1988**	**15**	**6**	**6**	**6**	**23**	**14**	**25**
	1979	17	3	2	4	28	28	25
Other time off	**1988**	**4**	**5**	**4**	**5**	**3**	**3**	**2**
	1979	5	5	6	3	5	5	6
Not stated	**1988**	**1**	**1**	**1**	**1**	**1**	**1**	**1**
	1979	1	1	1	–	1	1	–
Median number of days leave :								
Paid		6	6	6	6	6	5	7
Unpaid		5	5	5	5	4	6	6
1979		7	5	6	7	7	7	7
Base*		2,878	371	909	371	1,223	476	135
1979		2,134	186	446	250	759	254	68

+ Total forms of leave sum to more than the proportion who took leave because more than one form of leave was possible.

* Base: All women, married or living as married, whose husbands/partners were in paid work at the time of the birth.

265

The median number of paid days taken away from work was six days, with little variation by occupation. The median number of unpaid days' leave was five days. In 1979, no distinction was made between paid and unpaid days away from work, so it is unclear whether there has been an increase or decrease in the total number of days' leave available to men at the time they become fathers.

Note

1. To be exact, our occupational data for fathers refer to the period eight or nine months after the birth when we carried out the survey of women.

Appendix

Occupational and industrial classification schemes

The following classification schemes were used for the survey of women and the survey of employers.

The survey of mothers
The Standard Occupational Classification (SOC)

1. Managers and administrators
General managers and administrators in national and local government, large companies and organisations; Production managers in manufacturing, construction, mining and energy industries; Specialist managers; Financial institution and office managers; Civil service executive officers; Managers in transport and storing; Managers in farming, horticulture, forestry and fishing; Managers and proprietors in service industries; Managers and administrators nec.

2. Professional occupations
Natural scientists; Engineers and technologists; Health professionals; Teaching professionals; Legal professionals; Business and financial professionals; Architects and surveyors; Librarians and related professionals; Professional occupations nec.

267

3. Associate professional and technical occupations
Scientific technicians; Draughtspersons, quantity surveyors and other surveyors; Computer analysts/programmers; Ship and aircraft officers, air traffic planners and controllers; Health associate professionals; Legal associate professionals; Business and financial associate professionals; Social welfare associate professionals; Literary, artistic and sports professionals; Associate professional occupations nec.

4. Clerical and secretarial occupations
Administrative/clerical officers and assistants in civil service and local government; Numerical clerks and cashiers; Filing and record clerks; Clerks (not otherwise specified); Stores and despatch clerks, storekeepers; Secretaries, personal assistants, typists, word processors operators; Receptionists, telephonists and related occupations; Clerical and secretarial occupations nec.

5. Craft and related occupations
Construction trades; Metal machining, fitting and instrument-making trades; Electrical/electronic trades; Metal forming, welding and related trades; Textiles, garments and related trades; Printing and related trades; Woodworking trades; Food preparation trades; Other craft and related occupations nec.

6. Personal and protective service occupations
NCOs and other ranks, armed forces; Security and protective service occupations; Catering occupations; Travel attendants and related occupations; Health and related occupations; Childcare and related occupations; Hairdressers, beauticians and related occupations; Domestic staff and related occupations; Personal and protective service occupations nec.

7. Sales occupations
Buyers, brokers and related agents; Sales representatives; Sales assistants and check-out operators; Mobile, market and door-to-door salespersons

8. Plant and machine operatives
Food, drink and tobacco process operatives; Textiles and tannery process operatives; Chemicals, paper, plastics and related process

operatives; Metal making and treating process operatives; Metal working process operatives; Assemblers/lineworkers; Other routine process operatives; Road transport operatives; Other transport and machinery operatives; Machine and plant operatives nec.

9. *Other occupations*
Other occupations in agriculture, forestry and fishing; Other occupations in mining and manufacturing; Other occupations in construction; Other occupations in transport; Other occupations in communication; Other occupations in sales and service; Other occupations nec.

Registrar General/OPCS Social Classes (1970, 1980)

	Descriptive definition	SEG numbers
I	Professional, etc. occupations	1,2,3,4,13
II	Intermediate occupations	5
III	Skilled occupations	
	(N) non-manual	6
	(M) manual	8,9,12,14
IV	Partly skilled occupations	7,10,15
V	Unskilled occupations	11

Socio-economic Groups (SEG)
The socio-economic groups with brief definitions are:

1. Employers and managers in central and local government, industry, commerce, etc. – large establishments
1.1 Employers in industry, commerce, etc.
Persons who employ others in non-agricultural enterprises employing 25 or more persons.
1.2 Managers in central and local government, industry, commerce, etc.
Persons who generally plan and supervise in non-agricultural enterprises employing 25 or more persons.

2. *Employers and managers in industry, commerce, etc. – small establishments*
 2.1 Employers in industry, commerce, etc. – small establishments. As in 1.1 in establishments employing fewer than 25 persons.
 2.2 Managers in industry, commerce, etc. – small establishments. As in 1.2 but in establishments employing fewer than 25 persons.

3. *Professional workers – self-employed*
 Self-employed persons engaged in work normally requiring qualifications of university degree standard.

4. *Professional workers – employees*
 Employees engaged in work normally requiring qualifications of university degree standard.

5. *Intermediate non-manual workers*
 5.1 Ancillary workers and artists
 Employees engaged in non-manual occupations ancillary to the professions, not normally requiring qualifications of university degree standard; persons engaged in artistic work and not employing others therein. Self-employed nurses, medical auxiliaries, teachers, work study engineers and technicians are included.
 5.2 Foremen and supervisors non-manual
 Employees (other than managers) engaged in occupations included in group 6, who formally and immediately supervise others engaged in such occupations.

6. *Junior non-manual workers*
 Employees, not exercising general planning or supervisory powers, engaged in clerical, sales and non-manual communications occupations, excluding those who have additional and formal supervisory functions (these are included in group 5.2).

7. *Personal service workers*
 Employees engaged in service occupations caring for foid, drink, clothing and other personal needs.

8. *Foremen and supervisors – manual*
Employees (other than managers) who formally and immediately supervise others engaged in manual occupations, whether or not themselves engaged in such occupations.

9. *Skilled manual workers*
Employees engaged in manual occupations which require considerable and specific skills.

10. *Semi-skilled manual workers*
Employees engaged in manual occupations which require slight but specific skills.

11. *Unskilled manual workers*
Other employees engaged in manual occupations.

12. *Own account workers (other than professional)*
Self-employed persons engaged in any trade, personal service or manual occupation not normally requiring training of university degree standard and having no employees other than family workers.

13. *Farmers – employers and managers*
Persons who own, rent or manage farms, market gardens or forests, employing people other than family workers in the work of the enterprise.

14. *Farmers – own account*
Persons who own or rent farms, market gardens or forests and having no employees other than family workers.

15. *Agricultural workers*
Persons engaged in tending crops, animals, game or forests, or operating agricultural or forestry machinery.

16. Members of armed forces

17. Inadequately described and not stated occupations

The survey of employers
The following information was sent to all workplaces with more than 100 employees in order to facilitate the collection of labour force data. In addition, the telephone interviewers who carried out the survey on behalf of PSI used the information as a guide in obtaining labour force data from smaller workplaces.

<div align="center">Job groups for the Employers' Survey</div>

The workforce data requested refer to your specific workplace only, and to the time at which you complete the data sheet: we have not added questions on seasonal variations.

'Employees' should be understood in its strict sense of people with a contract of employment. The term *excludes* any free-lance workers, home or out workers, and casual workers who do not have a contract of employment. Sales personnel should be included if yours is the organisation to which they principally report.

'Part-time' employees are those your organisation defines as such.

The following occupations should be included under the group headings shown overleaf:

Middle/Senior Management or Senior Professional/Technical
Academics at universities; polytechnics; and head teachers at schools; civil servants (assistant secretary and above); qualified engineers; and any other professionally qualified occupations.

Foreman/Supervisors or Junior Technical/Professional
Teachers; nurses; administrative staff with supervisory duties; laboratory technicians; civil servants (executive officer to Senior Principal level); health visitors; midwives.

Clerical
Administrative staff without supervisory responsibilities; receptionists; non-retail cashiers (bank clerks including tellers); office machine operators; computer operators; data processors; accounts and other clerks; clerk typists.

Secretarial
Shorthand typists; secretaries; personal assistants.

Sales and Related Occupations
Wholesale or retail sales clerks/assistants; check-out and cash and wrap operators; sales representatives; demonstrators; insurance agents.

Skilled Manual (with formal training through apprenticeship or equivalent)
Police; firemen; traffic wardens; security guards; hairdressers; manicurists; beauticians; nursery nurses; van drivers; bakers; knitters, menders; instrument makers and assemblers; driving instructors.

Other Manual (semi- and unskilled workers)
Waitress; barmaid; canteen assistant; cleaner; charwoman, messenger.

Standard Industrial Classification
Employers were classified by industry according to the Standard Industrial Classification, 1980 as follows.

Broad groupings
0 Agriculture, forestry and fishing
1 Energy and water supply industries
2 Extraction of minerals and ores other than fuels; manufacture of metals, mineral products and chemicals
3 Metal goods, engineering and vehicles industries
4 Other manufacturing industries
5 Construction
6 Distribution, hotels and catering; repairs
7 Transport and communication
8 Banking, finance, insurance, business services and leasing
9 Other services

Collapsed groupings

Manufacturing (3,4) including mechanical engineering, manufacture of office machinery and data processing equipment, metal goods manufacture, motor vehicles and parts, other transport equipment, instrument engineering, food, drink and tobacco manufacturing, textiles, leather and leather goods, footwear and clothing, timber and wooden furniture, paper and paper products, printing and publishing, rubber and plastic processing, other manufacturing industries.

Distribution, Hotels & Catering (6) including wholesale distribution, commission agents, retail distribution, hotels and catering, repair of consumer goods.

Banking & Finance (8) including banking and finance, insurance, business services, owning and dealing in real estate, renting of movables.

Other Services (9) including education, public administration, social security, national and local government nec, research and development, medical and other health services, social welfare, charitable and community services, recreational and other cultural services, personal and domestic services.

Other Industries (0,2,3,5,7) including agriculture, forestry and fishing; energy and water supply industries; extraction of minerals and ores; construction; transport and communication.

Bibliography

Birth Statistics, England and Wales, OPCS, 1988.

Brannen, Julia, 'Childbirth and Occupational Mobility: Evidence from a Longitudinal Study', *Work, Employment and Society*, Vol 3, No 2, June 1989.

Career Breaks and Childcare Provisions in the Civil Service: A Review of Progress, 1989, Cabinet Office, May 1989.

Confederation of British Industries (CBI) *Holiday arrangements in British business*, 1989.

Cohen, Bronwen, *Caring for Children: Services and Policies for Childcare and Equal Opportunities in the United Kingdom*, Commission of the European Communities, 1988.

Daniel, WW, *Maternity Rights: The experience of women*, PSI Report No 588, Policy Studies Institute, June 1980.

Daniel, WW, *Maternity Rights: The experience of employers*, PSI Report No 596, Policy Studies Institute, 1981a.

Daniel, WW, 'A clash of symbols: the case of maternity legislation', *Policy Studies*, Vol. 2, Part 2, October 1981b.

Dex, Shirley, *Women's work histories: an analysis of the Women and Employment Survey*, Department of Employment Research Paper No 46, 1984.

Dex, Shirley, *Women's Occupational Mobility: A lifetime perspective*, Macmillan Press, 1987.

Equal Opportunities in the Civil Service: Progress Report 1984-1987, Cabinet Office, 1988.

Employment Gazette, 'Standard Occupational Classification – a proposed classification for the 1990s', April 1988.

Employment Gazette, 'Pay in Britain', November 1988.

General Household Survey 1987, OPCS, Social Survey Division.

Haskey, J., 'The ethnic minority populations of Great Britain: their size and characteristics', *Population Trends*, 54, 1988.

Institute for Employment Research, *Review of the Economy and Employment: Occupational Update 1988*, University of Warwick, 1988.

Joshi, Heather, 'Motherhood and employment: change and continuity in post-war Britain', OPCS Occasional Paper No 34, 1985.

Labour Force Survey, 1987.

Martin, Jean, 'Returning to work after childbearing: evidence from the Women and Employment Survey', *Population Trends*, No 43, Spring, 1986.

Martin, Jean and Ceridwen Roberts, *Women and Employment: A Lifetime Perspective*, Department of Employment and OPCS, 1984.

Metcalf, Hilary and Patricia Leighton, *The Under-Utilisation of Women in the Labour Market*, IMS Report No 172, September 1989.

Metcalf, Hilary, *Retaining Women Employees: Measures to Counteract Labour Shortages*, IMS Report No 190, April 1989.

Penhale, B., *Associations between unemployment and fertility among young women in the early 1980s*, Working Paper No 60, Social Statistics Research Unit, City University, February 1983.

Population Trends 53, 'Live Births in 1987', OPCS, Autumn 1988.

Social Trends 20, OPCS, 1990.

Table of Social Benefit Systems in the European Communities, Position at January 1, 1989, International Relations, Social Security, Department of Social Security, 1989.

Thomas, Roger and Peter Elias, 'Development of the Standard Occupational Classification', *Population Trends*, Spring 1989.